PENGUIN BOOKS

VALUES OF ART

Malcolm Budd is the author of *Music and the Emotions* and *Wittgenstein's Philosophy of Psychology*. He is Professor of Philosophy at University College London and is a Fellow of the British Academy.

D0906007

MALCOLM BUDD

Values of Art

PICTURES, POETRY AND MUSIC

PENGUIN BOOKS

PENGUIN BOOKS

Published by the Penguin Group
Penguin Books Ltd, 27 Wrights Lane, London W8 5TZ, England
Penguin Books USA Inc., 375 Hudson Street, New York, New York 10014, USA
Penguin Books Australia Ltd, Ringwood, Victoria, Australia
Penguin Books Canada Ltd, 10 Alcorn Avenue, Toronto, Ontario, Canada M4V 3B2
Penguin Books (NZ) Ltd, 182–190 Wairau Road, Auckland 10, New Zealand

Penguin Books Ltd, Registered Offices: Harmondsworth, Middlesex, England

First published by Allen Lane The Penguin Press 1995
Published in Penguin Books 1996
1 3 5 7 9 10 8 6 4 2

Printed in England by Clays Ltd, St Ives plc

In Memory of Flint Schier

Contents

Preface

I would not have written this book but for the painfully early death of Flint Schier in 1988 at the age of thirty-four. I came to know Flint through becoming the supervisor of his Oxford University D.Phil. thesis when his research underwent a change of direction and he moved from the topic of persons to that of pictures. By this time he was already a lecturer in philosophy at the University of Glasgow, and my supervision of his work took place mainly through correspondence. Although we met only a handful of times, Flint made a vivid impression on me. He was a delightful person to be with, friendly, humorous, confident and full of intellectual curiosity. Wherever he went he would send me postcards with pictures of works of art he admired and a lively description of his travels, his impressions of where he was staying, and of the new directions of his thoughts. He was, of course, an outstanding 'student' and I did not so much direct the research for his D.Phil. thesis as engage with him in a collaborative pursuit of the truth. After he had published a version of his thesis as *Deeper into Pictures*, on my recommendation he was commissioned to write a work on aesthetics for Penguin, but he had time to write only what would have been the first chapter. I inherited the challenge. This is a very different book from the one that Flint would have written, both in content and style: it does not range nearly as widely and the writing contrasts markedly with Flint's highly personal, flamboyant manner. But I hope he would have liked what I have written, especially my attempt to lay to rest the main problem in the aesthetics of pictorial art — the art that perhaps meant most to him.

I am grateful to the Cambridge University Press for permission to make use of rewritten material from my 'Belief and Sincerity in Poetry', published in *Pleasure, Preference and Value* (ed. Eva Schaper), and to the *Journal of Aesthetics and Art Criticism* for permission to include reworked portions of my 'Music and the Communication of Emotion', which was published in Vol. 47, No. 2, Spring 1989.

I

Artistic Value

We all think that the quality of a work of art, or an artist, is proved if it seizes and deeply affects us. But *our own quality* of judgement and feeling would first have to be proved: which is not the case.

Nietzsche, *Human, All Too Human*, I, §161

ARTISTIC AND NON-ARTISTIC VALUES

The central question in the philosophy of art is, What is the value of art? Philosophical reflection on art would be idle unless art were valuable to us, and the significance of any question that arises in philosophical reflection on art derives directly or ultimately from the light that its answer throws upon the value of art. But if this is so, What is the value of art? If we construe art as the totality of (actual or possible) works of art, the value of art is the sum of the individual values of these various works of art. What, then, is the value of a work of art?

However, it would be premature to attempt to answer this question as it stands, because its meaning is indeterminate. For whatever can be evaluated, can be evaluated from different points of view, and corresponding to the point of view from which it is assessed, the value attributed to it will be of a different kind. So a work of art can have many different kinds of value – a cognitive value, a social value, an educational value, a historical value, a sentimental value, a religious value, an economic value, a therapeutic value; it can possess as many kinds of value as there are points of view from which it can be evaluated. Now an artist is someone who practises an activity as an art. What an artist tries to do is to create a product with a distinctive kind of value. She attempts to make something that is valuable *as art*, or, more specifically, *as art of*

such-and-such a kind. I shall call this value 'artistic value' or 'the value of a work of art *as a work of art*'. So artistic value is just the value referred to in such judgements as these: James Joyce's *Ulysses* is a better novel than D. H. Lawrence's *Kangaroo*, Grünewald's *Christ on the Cross with the Virgin, St John and Mary Magdalen* is a finer painting than Salvador Dali's *Christ of St John of the Cross*, and Beethoven's last piano sonata (Op. iii) is finer than his first (Op. 2, No. i) – if not finer as a sonata, certainly finer music. Thus 'artistic value' signifies a value that has degrees: some works of art have more of it than others, some lack it entirely, and some have it to the same degree. The prime task of a theory of value in art is to elucidate the distinctive value of art – the value of a work of art as a work of art.

It will be as well to deal at once with an objection that is likely to be brought against this idea of the value of a work of art as a work of art. The objection is aimed at the implication that the value is unitary, and it exists in two related forms. The first maintains that it is necessary to give an irreducibly disjunctive account of value *across* the arts, because for each art form – music, painting, sculpture, architecture, literature, dance – there is a distinct kind of value: the value of a work of art of a particular art form *as* of that form is different for each art form. According to this version of the objection, there is the value of music as music, the value of painting as painting, the value of sculpture as sculpture, and so on, and there is no overarching value that unifies this set of values, which form a heterogeneous collection. The second version presses the point further by claiming that it is necessary to give an irreducibly disjunctive account of value *within* each art, since each art form admits works of art of different natures and aims and these various kinds of work have values specific to them. So within the art of music, there is the value of a song as a song, the value of a symphony as a symphony, and so on for the other musical genres; and within each of the other arts, there is a distinct kind of value for each artistic genre that falls within that art.

Now for either of these versions of the objection to assume a definite form, it would be necessary for it to indicate criteria for the identity and

difference of the kinds of art to which it assigns distinct kinds of value; and if the second version is to stop short of assigning distinct kinds of value to each particular work of art, the individuating criteria it specifies must, without being arbitrary, allow different works to possess the same kind of value. But there is no need to pursue the issue, for neither form of the objection is persuasive, and each is open to the same response. It is true that the features of a work of art that make it good as music are different from those that make a work good as literature, that what makes a painting a fine landscape is not what is responsible for the value of a painting of the Annunciation (its value *as* such a painting), and that there are different varieties of artistic value. But this shows only that artistic value can be realized in many different ways, not that it lacks an essence. So much for this blunt rejection of the idea of a work's artistic value.

Three linked issues immediately arise about artistic value: its individuation, its status and its epistemology. First, it is necessary to identify artistic value by answering the question, What is the value of a work of art *as* a work of art? Second, the status of the value must be elucidated. Is artistic value relative or absolute, subjective or inter-subjective, a real property of works of art or a projection on to them of the responses they arouse in us? And a constraint on satisfactory solutions of the first two issues is that they should deliver the correct solution of the third, the epistemological issue. What is the fundamental procedure for finding out what the artistic value of a work of art is? Is it necessary to be acquainted with the work, and, if so, what explains the necessity?

It will quickly become clear that in answering the initial question I do not attempt, first to present a definition of a work of art or a philosophical theory of art or a statement of its supposed essence, then to derive from the definition a conception of artistic value, the value of a work of art *as such*, that is, as satisfying the definition. Given what has happened to the concept of art, especially in this century, it would be fruitless to proceed in this way: an account of artistic value cannot be extracted from the present concept of art. Instead, I specify a distinctive

value – a value that works of art can possess, and which is possessed to a high degree by all great works of art; I then count an evaluation of a work of art as an evaluation of it *as art* in so far as the work is being evaluated with respect to the distinctive value I have specified. My answer to the question will demonstrate the unity of the concept of artistic value, or, more accurately, will give unity to it.

INTRINSIC AND INSTRUMENTAL VALUES

A perspicuous elucidation of the concept of artistic value is possible in terms of what I shall call 'the experience a work of art offers'.[1] Although what is involved in understanding a work of art varies from art to art and also within each art, it is definitive of a work of art that it can be understood; and I mean by 'the experience a work of art offers' an experience of the work in which it is understood. So the experience a work offers is an experience of interacting with it in whatever way it demands if it is to be understood – reading it, looking at it, listening to it, performing it or in some other way appreciating it. For you to experience a work with (full) understanding your experience must be imbued with an awareness of (all) the aesthetically relevant properties of the work – the properties that ground the attribution of artistic value and that constitute the particular forms of value the work exemplifies. The experience a work of art offers is an experience *of* the work itself: it does not have a nature specifiable independently of the nature of the work. It is also not any person's actual experience, but a type, one that can be multiply instantiated, and more or less closely approximated to. It can be such that the order of its parts is fully determined by the nature of the work (as with music), or not so (as with painting and architecture).

My claim is that the value of a work of art as a work of art is intrinsic to the work in the sense that it is (determined by) the intrinsic value of the experience the work offers (so that if it offers more than one experience, it has more than one artistic value or an artistic value composed of these different artistic values). It should be remembered

that the experience a work of art offers is an experience *of the work itself*, and the valuable qualities of a work are qualities *of the work*, not of the experience it offers. It is the nature of the work that endows the work with whatever artistic value it possesses; this nature is what is experienced in undergoing the experience the work offers; and the work's artistic value is the intrinsic value of this experience. So a work of art is valuable as art if it is such that the experience it offers is intrinsically valuable; and it is valuable to the degree that this experience is intrinsically valuable.

By the intrinsic value of an item I do not mean a value that depends solely on the intrinsic nature of the item – a value that depends solely on its internal properties (its qualities and inner relations) – as contrasted with an extrinsic value – a value that depends, wholly or in part, on its external properties (its relations to other things). My conception of intrinsic value opposes it, not to extrinsic value, but to instrumental value, and I do not assume that something's intrinsic value is dependent solely on its intrinsic nature.[2] By the instrumental value of a work of art I mean the value, from whatever point of view, of the actual effects of the experience of the work on people or the effects that would be produced if people were to experience the work. (I do not mean the *suitability* of the work, in virtue of its nature, to produce valuable or harmful effects on certain kinds of people as a result of their experience of the work.) My claim therefore implies that the instrumental value of a work of art, its beneficial or harmful, short- or long-term effects or influence, either on a given person or people in general – where the effects are consequences of the experience and not elements or aspects of the experience itself – is not the value of the work of art *as* a work of art.

If a work possesses artistic value, this does not consist in the work's actually accomplishing some valuable end in the case of one, some or many of us, or in the fact that it would, if experienced with understanding, accomplish such an end. This is easy to see, for what is achieved by experiencing a work of art depends not only on the experience that its appreciation yields but also on the character, attitude and will of any

person who experiences it. There is only a personal answer to the question whether the appreciation of a work of art kindles or dampens a desire to enhance the lives of other people, whether it is a stimulus to, or a safety-valve which prevents, immoral action, or whether it infects with, or inoculates against, a mood of despair, for example. The influence of a work of art is not like the operation of certain drugs which, independently of the subject's attitude, character and will, produce their distinctive effects regardless.

It counts in favour of the identification I propose that there is a conspicuous mismatch between our opinions about the artistic value of a work and our opinions about the instrumental value of the experience it offers. The instrumental value of the experience of a work of art is in fact many-headed and ill-defined, and it can be considered at an individual or a more general level. But at whatever level it is considered, there is unlikely to be a correspondence between the strength and nature of your opinion about the artistic value of a work and the strength and nature of your opinion about the instrumental value of its experience. The fact is that most of us, perhaps all of us, know very little about what the beneficial or harmful effects of the experience of a particular work of art, or particular kinds of work, on particular people or people in general, are or would be. Think of the difficulty of trying to establish the effects of the appreciation of a particular work of art, such as Titian's *Bacchus and Ariadne*, Defoe's *Robinson Crusoe*, or Bruckner's Seventh Symphony.

But we do have a general knowledge of the kinds of relation that can hold between people's experience of a work of art and their later psychological condition and behaviour. We know that the gratification some people derive from works of art – even the finest works of art – leads them only to seek out the experience of more fine works of art; along other paths, their experience of art is sterile. Such people have an exceptional capacity to isolate or compartmentalize their appreciation of art. At bottom, they are unconcerned that the works of art they admire should affect their lives in any way that will be beneficial to themselves or others. Their approach to art is unreflectively or self-consciously

'aesthetic' or sentimental; the denial of this possibility is itself a form of sentimentalism.

The question whether an experience is worth undergoing for its own sake is not the same as the question whether the experience is in other ways beneficial to those who find the experience enjoyable, exciting or in some other way rewarding, even if in many cases the two questions may receive the same answer; and the evaluation of a work of art as a work of art must be based on an assessment of the intrinsic value, not the instrumental value, of the experience the work offers. It is vital to see that we can evaluate – we usually must evaluate – the character of the experience a work offers independently of any opinion about whether the experience will in fact have desirable or undesirable effects on the mind, character and behaviour of an individual or a group of people. The effects of the experience of a work of art on an individual (its individual instrumental value) or on people in general (its overall instrumental value) are certainly of great importance; but it is the character of the experience the work offers, in conjunction with the nature of those who undergo it, that determines what these effects are likely to be; and it is not these effects themselves, but the character of the experience, that determines the artistic value of the work.

There are two further considerations that should facilitate acceptance of my claim about artistic value. The first is that many of what are thought of as benefits of the experience of art are intrinsic to the experience, not merely products of it. The experience a work of art offers can involve the invigoration of one's consciousness, or a refined awareness of human psychology or political or social structures, or moral insight, or an imaginative identification with a sympathetic form of life or point of view that is not one's own; it can be beneficial in these and countless other ways. But since such benefits are aspects, not consequences, of the experience the work offers, the irrelevance of the actual effects of the experience to the work's artistic value does not imply the irrelevance of these kinds of benefits. On the contrary, such benefits contribute to making the experience intrinsically valuable and partly constitute the ways in which it is so.

The second consideration is that an experience can be *such as* to be conducive to a beneficial[3] effect on people – people who are concerned to profit from the work that affords the experience.[4] This is what Yvor Winters had in mind when thinking of poetry as a moral discipline:

Poetry, if pursued either by the poet or by the reader, in the manner which I have suggested, should offer a means of enriching one's awareness of human experience and so of rendering greater the possibility of intelligence in the course of future action; and it should offer likewise a means of inducing certain more or less constant habits of feeling, which should render greater the possibility of one's acting, in a future situation, in accordance with the findings of one's improved intelligence. It should, in other words, increase the intelligence and strengthen the moral temper; these effects should naturally be carried over into action, if, through constant discipline, they are made permanent acquisitions.[5]

Although the appreciation of poetry does not automatically result in improvements of the kind Winters indicates, the nature of fine poetry is such as to help to induce them in those who apply themselves in the manner he advocates.[6]

AESTHETICISM, ARTIST AND SPECTATOR

It would be a misunderstanding of my account of artistic value to object to the implied downgrading of the instrumental value of the experience of a work of art. For my identification of the artistic value of a work of art with the intrinsic value of the experience it offers carries no such implication. The identification of artistic value is not a matter of weighing one kind of value against another, but of discriminating the one from the other. I have made no claim about the difficult topic of the comparative ranking of different kinds of value. Measured by a certain yardstick (a moral yardstick, for example),[7] the value of a work of art as a work of art will not be the most important kind of value that a work of art can possess. But the issue of the identification of artistic value is, What is artistic value?, not, What is the worth of artistic value? The

answer I have given to the constitutive question identifies the value of a work as a work of art with the intrinsic, not the instrumental, value of the experience it offers, and this implies nothing about the importance of artistic value relative to other kinds of value. Accordingly, my identification of artistic value is not equivalent to and does not imply a downgrading of the instrumental value of art.

There are two further misunderstandings to which my account of artistic value is liable. The first misconstrues it as an unacceptable form of aestheticism. The charge of aestheticism is likely to arise if it is thought that the identification of a work's artistic value with the intrinsic value of the experience the work offers is tantamount to the doctrine of 'Art for Art's Sake'. But this doctrine is strikingly equivocal: many different views have sought shelter under its banner, and the force of the charge varies accordingly. Here it will be sufficient to dissociate my account from four dogmas and one ethical stance, none of which it implies.

The first dogma is the existence of a specifically aesthetic emotion, which it is the artistic function of art to arouse. But it is clear that this does not follow from my claim about artistic value; and the emotion it posits is only a myth. The second is the irrelevance of a work's subject-matter to its artistic value. According to this doctrine, it does not matter what a work represents, only how it represents it. But not only is this doctrine not implied by the conception of a work's artistic value as the intrinsic value of the experience it offers, it is shown to be false in the examination of pictorial value I undertake in the second part of the book. The third dogma is the requirement that the spectator's response to a work of art should be disconnected from her attitude to the moral or other evaluative point of view that the work expresses. But it is not necessary to accept the theory of a work of art as a *sui generis* world, to be experienced and valued independently of whether it accords or conflicts with one's own beliefs and values, and only in terms of whether it creates a coherent and satisfying world of its own – the theory that was held up by adherents of the doctrine of 'Art for Art's Sake' against the demands for truth and morality in art – in order to restrict artistic

value to the nature of the experience in which the work of art is understood, so as to exclude any further separable effect. It is not necessary to embrace the theory of a work of art as an autonomous world in order to maintain the thesis that the value of a work of art as a work of art is the intrinsic value of the experience it offers. The final dogma is the complete lack of determination of a work's artistic value by any values that are not specifically artistic or aesthetic values. But the claim that a work's artistic value is determined by the intrinsic, not the instrumental, value of the experience it offers does not imply that its artistic value is independent of any values it may possess that are not art-specific or specifically aesthetic. Values that are not specific to art or the aesthetic are not thereby essentially unrelated to artistic value. The truth is that artistic value does not exist in a watertight compartment impermeable by other values; on the contrary, other values can be determinants of artistic value, as when a novel's value is a function of its intelligence, wit, imagination, knowledge and understanding of human life.

The ethical stance that is not implied by my conception of artistic value assigns supreme importance to art in human life, claiming that life should be lived for art's sake, or that the highest form of life is devotion to art, or, rather differently, that, in Nietzsche's words, 'we have our highest dignity in our significance as works of art – for it is only as an *aesthetic phenomenon* that existence and the world are eternally *justified*'.[8] As with the comparative ranking of different values of art, so with the place of art in human life, no conclusions flow from the identification of artistic value with the intrinsic value of the experience a work of art offers.

The second misunderstanding I wish to protect my claim against represents it as being a spectator-oriented aesthetics that denies the true significance of the artist. Am I not placing the artistic value of a work in the experience of the spectator, neglecting both the value to the artist of the work she produces and the way in which the idea of the artist should occur in the spectator's appreciation of the artist's work? No. In the first place, it should be remembered that not only do 'artist' and

'spectator' refer to roles, rather than people, but that the role of the artist, properly understood, requires the artist, in the creation of her work, to adopt or bear in mind the role of the spectator. A so-called 'artist' who is unconcerned about the character of the experience her work offers is thereby unconcerned to endow her product with a distinctive kind of value – the one I have identified as the value of a work of art as a work of art. This consideration is reinforced by the fact that a work of art is intended to be understood *as* a work of art; the experience a work of art offers is one in which the work is understood; the meaning of a work of art – how it should be inter-preted – is tied to the conception of the work under which the artist created it,[9] the style in which it is executed, the works of art to which it alludes and the view of the world and life out of which it arose; and the appreciation of a work of art is the appreciation of the artistry of the artist, which requires an appreciation of the artistic achievement the work represents,[10] so that experience of the work must be informed by an understanding of the aesthetically relevant facts about the work's history. Finally, it is a confusion to introduce the idea of the value to the artist herself of the work she produces and to complain that my account of artistic value neglects this. For a work never has a single value to the artist, and there are many values to the artist it might have that are irrelevant to its assessment as a valuable work of art. The objection would be sound only if a work has a value to the artist which is ignored in my account and which determines, wholly or in part, the value of the work as art. But this is not so. The fact is that the account of artistic value I have presented is neither spectator- nor artist-oriented, but assigns due weight to both roles.

ACQUAINTANCE

An elucidation of artistic value is correct only if it yields the right answer to the question, What is the fundamental procedure, the canonical method, for finding out what the artistic value of a work is? Clearly, the

basic way of determining the value of a work of art requires you to experience the work with understanding – to undergo the experience the work offers. Although, contrary to what has sometimes been maintained, you can form a judgement on the merits of a work you are not acquainted with, this involves trust in the judgement of someone who is acquainted with it, an attempt to imagine what it would be like to experience it, or an extrapolation from the works with which you are acquainted.[11] Leaving these possibilities on one side, you can find out what the artistic value of a work is only by experiencing it in the relevant manner. This conclusion flows easily from the identification of artistic value with the intrinsic value of the experience a work offers. For what this identification requires you to find out is whether this experience is intrinsically valuable to undergo, and, if it is, to what degree and in what manner. The experience that a fine work of art offers must be such that it deserves to be found intrinsically rewarding. What could be a better way to find this out than to undergo the experience? As John Stuart Mill insisted, the only evidence for whether an experience is worth having for its own sake is the verdict of those who are familiar with the experience. Of course, the satisfaction of the requirement that the work is experienced with understanding is a matter of degree, and you can misunderstand a work you think you understand. But these facts do not imply that you are never justified in taking yourself to experience a work with understanding. If you are justified, you are then in the best possible position to judge the intrinsic value of the experience. For whether you find it interesting, amusing, exciting, poignant or in any other way intrinsically rewarding is in general a matter that your experience declares to you. Admittedly, you may not endorse your first-order response to a work of art, and even if you do, the fact that *you* find the work intrinsically rewarding in some way does not imply that the experience it offers is intrinsically valuable. But all that is required for the implication to hold is that when you experience the response indicated by the term expressing the variety of intrinsic value, your response should be appropriate or justified, perhaps justified above all other responses. If you find the work intrinsically rewarding

and you are right to do so, then the experience it offers is intrinsically valuable.[12] So the identification of artistic value with the intrinsic value of the experience the work offers yields a simple explanation of why acquaintance must play the fundamental role that has always been assigned to it in the determination of artistic value, without disallowing value judgements that are not immediately based on acquaintance with the work.

ART AND COMMUNICATION

I now need to refine the idea of assessing the intrinsic value of the experience offered by a work of art. In undergoing such an experience either you find it in some way rewarding or you do not. Given that you endorse your response, only if you find it in some way rewarding do you have reason to consider the experience intrinsically valuable. But the reward given by the experience can be related to the experience in two different ways. On the one hand, it can be such that in principle it is possible to obtain that reward without undergoing the experience of the work.[13] On the other hand, undergoing the experience of the work is partly constitutive of the reward. In a case of the first kind, it is not essential to the reward given by the experience that you should undergo the experience, just as it is not essential to the valued state of sleep that it should be induced in you in one way rather than another. If the experience is valuable to you only for this detachable reward, so that there is no conceptual constraint on the character of any experience that gives you exactly the same reward, you are not finding the work valuable *as a work of art*. You are valuing the work as you value a drug, for the effect it produces, the only difference from the artistic case being that there is a noticeable temporal gap between the effect caused by the drug and the ingestion of the drug. For you to find a work valuable as a work of art, what you find intrinsically rewarding in your experience of the work must not be something that could be present even if your experience lacked the character of the experience the work offers: your experience must not consist of two separable components, the

intrinsically rewarding component being a mere effect of an intrinsically unrewarding component – the experience of the work itself.

This conclusion receives clarification and support from a consideration of the doctrine that art is essentially a form of communication.[14] An extreme version of this thesis conceives of the act of communication supposedly integral to the creation and appreciation of art as the transference of the artist's experience in a particularly strong sense – the sense in which a football player might be transferred from one team to another. This renders the idea incoherent: it makes no more sense to think of transferring an experience from one person to another than it does to think of transferring a goal scored in one match to another match. To obtain a coherent form of the doctrine it is necessary to understand the concept of communication in its usual sense, as in the conveyance of information from one person to another. Suppose I have received a letter from a friend in which she communicates her thoughts about the value of art. Here we can distinguish the vehicle of communication from the 'message' communicated. On the one hand, there is the sheet of paper with ink marks inscribed on its surface which has travelled from my friend to me. This is the means by which whatever is communicated to me is communicated to me. On the other hand, there is what is communicated – my friend's thoughts.[15] Now the vehicle is not identical with the message. There are many other ways in which the same message could have been communicated. If the message had been communicated by means of speech, semaphore or morse code, for example, a different vehicle would have been used to communicate the same message. Rather than the inscribed sheet of paper, the vehicle would have been a sequence of sounds or positions of flags held in the hands or short and long flashes of light, say. This distinction between vehicle and message can be drawn in all cases of communication, no matter whether the message – what is communicated – is a thought, an emotion, an attitude or an experience.

The relevance of this distinction to the doctrine that art is essentially a form of communication emerges at once if this doctrine is understood as a thesis about the value of art, to the effect that when we value

a work as a work of art: (i) it communicates something to us; (ii) we value it only because it communicates this to us; and (iii) we value it to the degree that we value what it communicates. In other words, the value of a work of art is the value of the thoughts, emotions or whatever else it communicates, so that a work of art that fails to communicate anything lacks artistic value, and the task of the artist is to create a vehicle adequate to convey a valuable message. But it is clear that this conception of the value of art misrepresents our attachment to works of art when we value them *as* works of art. For the distinction between vehicle and message intrinsic to the concept of communication means that for any message there are in principle many vehicles capable of communicating that message. So this conception of artistic value implies, first, that we must assign the same artistic value to anything else that communicates exactly the same message as the one communicated by a work we value, and, second, that from the point of view of our interest in art, for any work of art we must be indifferent between experiencing it or something else that communicates the same message (and so, according to this conception, possesses the same artistic value). Yet neither implication is correct. If our sole reason for valuing a work of art is that it communicates a particular message, so that the manner in which the message is communicated does not matter to us, our attachment to the work is wrongly described as our valuing it *as* a work of art. The moral is clear: the communication conception of artistic value misrepresents the importance of the experience of the work, crediting it only with an instrumental role in the production of what is valuable in the experience of art, rather than locating the reward in the experience itself.[16] It is, of course, true that what a work of art communicates can be *integral* to its value as a work of art, for it may be integral to the experience the work offers. But it is the message *as communicated by the work*, the message *as realized in the experience of the work*, that determines the work's artistic value, not the message itself. If you value Munch's *The Scream* as a work of art, and you value it because it conveys a sense of intense fright, it is the picture – the picture perceived as expressive of intense fear – that impresses you, not merely

an impression of fear caused by it. Our attachment to the works we value as art is an attachment to the very experiences they offer, not to something detachable from them. To appreciate the value of a work of art it is necessary to undergo the experience it offers.

HUME AND KANT

The two classic accounts of the status of artistic value are those of David Hume and Immanuel Kant. Both Hume and Kant deny that artistic value, which they conceive of as a species of beauty, is a quality of an object or a quality in an object itself; each sees the problem of artistic value as stemming from the way in which judgements of artistic value are rooted in an essentially subjective, non-representational state (pleasure); and they maintain that the idea of beauty has to be elucidated in terms of the pleasure that would be experienced by a human being of a certain kind in a certain condition and situation. But their conceptions of the problem are rather different and the solutions they present differ markedly, Hume's being naturalistic and Kant's transcendental. Furthermore, their treatments of the problem differ in that, whereas Hume's thought is centred upon the idea of artistic value, Kant's is centred upon natural beauty; and this introduces a complexity into Kant's treatment of artistic value that is lacking in Hume. I shall attempt to show that neither treatment is successful.

HUME'S STANDARD OF TASTE

In his celebrated essay 'Of the Standard of Taste',[17] Hume addresses a problem that arises for those (like himself) who found taste – the evaluation of art in general, and especially the perception of literary merit – on agreeable and disagreeable 'sentiment', rather than 'judgement'. On the one hand, it appears 'to be fruitless to dispute concerning tastes', since sentiments, unlike judgements about matters of fact, do not represent the world as being one way rather than another. Accordingly, sentiments cannot be shown to be correct or incorrect by holding them

up against the world and examining the world to determine whether it is in conformity with them. Indeed, it makes no sense to suppose that the world conforms to or conflicts with a sentiment, for there can be conformity or conflict between the world and a mental item (or its expression in language) only if the mental item is a representation of the world, as a sentiment is not. Although pleasure is an intentional state – pleasure is always pleasure *in* or *at* something or *that* something is the case – it is a reaction to how the world is represented to the subject, rather than a representation of a possible state of affairs. So there is nothing to dispute about – there is nothing *in* dispute – when opposite sentiments are occasioned by the same object, unless there is some disagreement about the object other than the disagreement in sentiment, a factual disagreement that might explain the disagreement in sentiment. On the other hand, comparative evaluations of literary merit are not always immune to criticism. If the preferences they express are considered to be preposterous (as sometimes they are), the sentiments they are founded upon are condemned as absurd; and such a condemnation does not present itself as being merely an expression of the judge's individual sentiments, which have no more weight than those she rejects, her adverse judgement aspiring to nothing more than subjectivity. So the problem, as Hume sees it, is to reconcile the assumption that taste is grounded on sentiment – a non-representational mental state – with the seeming fact that it is possible to be better or worse at the appreciation of artistic value, and, accordingly, to possess good or bad taste. How can one person's taste be better than another's when each is founded on a state that indicates nothing about what it is directed at, but is indicative only of the subject's personal nature? What is required, Hume believes, is a 'Standard of Taste' by reference to which conflicting tastes can be assessed; and for this to be possible, the authority of such a court of appeal must be justified, not arbitrary. Hume's distinctive contribution to the philosophy of art is his attempt to establish the source and nature of this authoritative standard.

A standard of taste could be established or defended only by showing that all and only those works that meet the standard are fine works of

art, which requires the availability of judgements of artistic value whose reliability is not secured by conformity with the standard. There are two kinds of ground on which principles of taste might be erected: a priori and experiential. Hume rejects the a priori alternative and proposes to base both principles of taste and the standard of taste on human experience.[18] His leading idea is that certain qualities of objects are, by the structure of the human mind, 'naturally fitted to excite agreeable sentiments', as is shown by the existence of works that are objects of admiration throughout great stretches of time and in very different cultures; and conflicts of taste are to be explained in terms of human imperfections that render the sentiments of those subject to these defects unreliable indicators of what is truly beautiful. He seeks to exploit a supposed parallel between artistic beauty and colour (and other so-called secondary qualities, such as taste and smell). Although colour is, according to Hume, only 'a phantasm of the senses',[19] and a coloured object can present a different appearance to different observers or to the same observer in different conditions, that does not prevent there being such a thing as the true colour of an object, namely the colour it appears in daylight to the eye of a healthy man.[20] Similarly, although beauty is 'no quality in things themselves', but 'belong[s] entirely to the sentiment', the fact that an object can give rise to a variety of sentiments is consistent with just one of these being the true indicator of the object's beauty, namely the sentiment that arises in a person whose engagement with the object satisfies certain conditions. Just as the standard of colour is the colour-phantasm-of-the-senses induced in a certain kind of observer when perceiving an object in certain circumstances, so the standard of taste is the nature of the sentiment felt by a certain kind of person (a true judge or critic) who attends to the work of art in the appropriate manner. What Hume sets himself to do is to specify the conditions that must be satisfied by someone whose sentiment is justly deemed to be a true index of artistic merit.

Hume requires the true critic, the litmus-paper of artistic value, to be endowed with a sound understanding, to possess in a high degree a certain discriminatory capacity, to exercise it upon the object she is

responding to, to have a wide-ranging knowledge of works of art, to approach the object in a certain frame of mind, and to consider the object from a certain point of view. The high degree of the discriminatory capacity is described by Hume as delicacy of taste or imagination (which can be fortified by practice); the frame of mind is one free from any kind of prejudice; and the point of view from which a work of art must be considered is its success or failure in achieving the end to which it is directed. The underlying idea is that the sentiment that is a true reflection of the artistic value of a work of art is that which is felt by one who, familiar with what can be achieved in art, and uninfluenced by anything else, perceives and grasps the work in its full particularity: the true sentiment of beauty must be a product of every relevant feature of the work, and it must be unaffected by any irrelevant consideration.[21] It is for this reason that the true critic must have an accurate and detailed understanding of the work she judges, and her sentiment must be due to the nature of the work itself, rather than some personal idiosyncrasy. In other words, the proper sentiment of beauty is an unprejudiced, fully informed and maximally sensitive response to the individuality of the work. So the title of true judge of literary merit should be conferred only on a person who is endowed with 'Strong sense, united to delicate sentiment, improved by practice, perfected by comparison, and cleared of all prejudice'; and the standard of taste is the joint verdict of such true judges.[22]

HUME AND HUMAN NATURE

Despite its obvious merits, Hume's account suffers from a number of weaknesses. The principal weakness is his blithe optimism about the uniformity of response of his true judges of artistic value. Hume's standard of taste is given by the sentiment felt by a certain kind of person who engages with a work in a particular way. Accordingly, there will not be a (single) standard of taste unless, for any particular work of art, this kind of person – a true judge – responds in a uniform manner. But there is no reason to believe that someone who satisfies the

conditions Hume imposes on the true judge is likely to feel the same sentiment as any other true judge towards the same work. Hume repeatedly claims that certain forms or qualities are 'naturally calculated to give pleasure' or 'fitted by nature' to provide pleasure, and this is an expression of his assumption of a common human nature which – although subject to variations in the degree to which it is sensitive to the presence of these forms or qualities – will (in a healthy state) be emotionally affected in the same way by the same forms or qualities in objects if it detects their presence. Hume's solution requires human sentimental nature to be uniform within and across cultures and unchanging over time. But in the absence of convincing a priori considerations or a plausible psychological theory, this is no more than an article of faith.[23] More important, even if there should be 'a considerable uniformity of sentiment' among the true judges, this would not be enough to establish a standard of taste that ought to be acknowledged by those whose sentiments diverge from it, and in particular by those true judges whose sentiments are not in conformity with the majority's.

The problem facing Hume is this. Either his true judges must respond to a particular work in the same manner or it is possible for their responses to diverge. But if the responses of true judges can diverge and be opposed to one another, Hume lacks the resources to explain how one response can justifiably be approved and the other condemned. Now Hume is not unaware that the requirements a true judge must satisfy fail to ensure uniformity of response. He believes, however, that these conditions rule out all but two sources of variation – 'the different humours of particular men' and 'the particular manners and opinions of our age and country' – and these two sources, he asserts, can affect only the degree of the sentiment, not its agreeable or disagreeable nature. If this were true, Hume's standard of taste could still function as a rule for adjudicating rival tastes, although there would be a certain amount of tolerance in its verdicts in some cases. Hume recognizes that a difference in response that is due only to one or both of these sources of variation cannot properly be approved or condemned.[24] So Hume's strategy could be successful only if the conditions a true judge must satisfy guarantee

sameness of response, given that the response is not affected by one or the other of these allowable sources of variation.[25] This would be so only if the conditions imposed on his true judges were to ensure that the sentiment occasioned by a particular work is the result of the work's engaging with some element of a true judge's nature common to all true judges: the sentiment must be the effect of the work on this common nature – on this and nothing else. If the conditions were to allow that a work, regarded in the appropriate aesthetic manner, could engage with more than what must be in common to the true judges, it would be possible for a work to affect different judges differently. But Hume's conditions do not rule out such a possibility.[26] Hume's standard of taste is therefore no more secure than John Stuart Mill's criterion for the relative intrinsic value of pleasures:[27] In each case the standard is set by the preferences of individuals who satisfy a certain condition; satisfaction of this condition does not ensure identity of preference; the suggestion that majority preference is binding on the minority lacks any force, because the response of the majority cannot properly be thought *better* merely in virtue of being experienced by a greater number, and the minority are not *wrong* merely because they are out of step; and so even if there were unanimity amongst the competent judges, their agreement would constitute, not a normative standard, but only a natural or fortuitous coincidence of preferences.

This conclusion is underscored by a crucial disanalogy between the appreciation of artistic value and the perception of such a secondary quality as colour, the alleged kinship of which Hume uses as the basis of his solution of the problem of taste. Whereas the perception of a secondary quality is solely a matter of the exercise of a particular discriminatory capacity, the appreciation of literary merit involves also an evaluation. Hume attempts to overcome this difference by identifying the evaluation with a sentiment, which he conceives as brought about in the subject by the influence of the nature of the object the subject is attending to, just as the perception of colour is conceived as an effect in the subject of the object's true nature. But colour perception is a form of sensitivity to the world precisely because it enables us to detect

differences between objects in situations where, lacking colour perception, we would be unable to distinguish them – we discriminate objects *on the basis* of the colour appearances they present. Hume has built a discriminatory capacity into the nature of his true judges, and he is right to do so; but this capacity is his 'delicacy' of taste or imagination, and there is no room for a further discriminatory capacity, issuing in an agreeable or disagreeable sentiment, which might be identified with a judge's evaluation. Blindness and colour-blindness are disabilities which prevent those who suffer from them from detecting differences between objects that are manifest to those with normal sight. But the sentiment felt by one of Hume's true judges does not record the presence of an otherwise undetected feature; it is merely an index of the fact that the structure of her 'internal fabric' is pleasantly affected by the features she has detected, so that another true judge – who must of course detect the same features, in virtue of possessing the perfect delicacy of taste that is partly constitutive of a true judge's nature – another true judge who has a relevantly similar make-up will share her delight. The supposed community of sentiment of the true judges could show only that their affective constitution is at bottom the same, not that the deliverances of this common nature are the reflection of a feature hidden from those who are unlike the true judges. Of course, Hume embraces this conclusion, since he does not regard beauty as being a quality in objects themselves, and thinks of the sentiment of beauty as revealing only a natural affinity between certain qualities and the structure of the human mind. But although this may conceal, it does not remove, the crucial difference between the appreciation of literary merit and the perception of colour.[28]

There is a further way of exposing the flaw in Hume's strategy, and this is to highlight the ambiguity that Hume's conception of delicacy of taste or imagination suffers from. Consider the story from *Don Quixote* that Hume uses to illustrate his idea of delicacy of taste. Each of Sancho's kinsmen pronounces the wine to be good, although each identifies in its taste a small amount of an unwelcome quality that those with less delicate palates cannot detect. But it is important not to run together

two different notions of good taste, each of which might be labelled 'delicacy of taste'. Excellence of taste can be understood either as the ability to discern small differences between objects (or small amounts of a quality) or as the ability, not only to discern, but also to respond in the right manner to the perceptible features of things. It cannot be denied that Sancho's kinsmen possess a superior sense of taste in virtue of their capacity to distinguish minute quantities of a particular flavour; but nothing immediately follows about the status of their verdicts that the taste is good. In fact, their verdicts do not have the same authority as their vindicated claims about the composition of the taste. For their verdicts are expressions of the agreeable sentiments induced in them by their finer awareness of, their awareness of greater detail in, the wine's taste, but their claims about the wine's composition, as indicated by its taste, are expressions of their more finely detailed awareness of the taste. In consequence, whereas the expression of a more finely detailed (veridical) awareness is thereby *correct* with respect to that detail, and the expression of a less finely detailed awareness – if this takes the form of a *denial* of the presence of the detail – is thereby *incorrect*, the expression of a sentiment induced by a finer awareness is not thereby correct, appropriate or warranted. Furthermore, unless it is assumed that those with the most discriminating sense of taste must react with the same hedonic response to the same flavour, there is the possibility that the finest judges of the qualities contained in a certain taste will disagree about its merits. Without the assumption, *delicacy* of taste (understood as finely discriminating taste) is admittedly a necessary condition, but not a sufficient condition, for *good* taste (where this imports approval of the hedonic response). But now the argument can be pushed further. For if there is the possibility that the finest judges might have opposed sentiments towards the same taste, it seems that there is no content to the idea that one of the sentiments is better than the other. So even if there is in fact uniformity of response, this uniformity cannot provide a normative standard of taste. Indeed, as Kant forcefully maintained, it would be folly to quarrel about preferences of lingual taste with the intention of condemning a preference as incorrect.[29] In the light of 'The

great resemblance between mental and bodily taste' that Hume insists upon, and his desire to find some means of deciding a disagreement about literary value, it is no wonder that Hume prevents the issue of the *correctness* of the true judges' responses from arising – the issue that a lack of uniformity of response really does no more than emphasize – by the introduction of the postulate of a natural relation between certain qualities of literary works and the structure of the human mind. But this reflects, not an insight into human nature, only an unwillingness to recognize that in fact the concept of a true judge contains an ineliminable normative component.

WARRANTED SENTIMENT

If, like Hume, you believe that the recognition of artistic value is founded on a non-representational state, and you wish to maintain that an evaluative response to a work of art can have full interpersonal validity, the options are few. One is to attempt to show that anyone who is fully aware of the nature of a certain object would respond to it in the same way if she were to adopt towards it the specifically aesthetic or artistic attitude and were to be influenced by all, and only by, the aesthetically relevant features of the object. Another is to claim that there is something *wrong* with one or the other of two opposed responses, each of which is a product of a complete awareness of the object's aesthetically relevant features and the subject's nature, each subject's approach to the object being properly aesthetic. Whereas on the first alternative a deviant response is indicative of a lack of awareness or a failure of the subject to engage with the object in the right manner, on the second alternative a deviant response may indicate only a lack of appropriateness in a fully aware and properly and completely aesthetic response.

The second alternative, which is congruent with my specification of artistic value, is open, since it by no means follows from the fact that a response is non-representational that there is no substantial sense in which it can properly be thought of as right or wrong, appropriate or

inappropriate, warranted or misplaced. Although the response is not the representation of a possible state of affairs, neither is it merely an effect of the work on the subject. The response is directed to the work; the work is not merely the cause but the object of the response; the subject delights *in* the work or is displeased *by* it. Pleasure and displeasure are not always either merited or unmerited responses, no matter what their objects may be, for their objects may be such that the question of the fittingness of these affective responses does not arise.[30] But when they are experienced in response to a work of art, the question is always appropriate; and whenever the question can be decided, it is decided in the same way – by reference to the nature of the work.

Despite what I have said it is possible that this is not too far from Hume's own position. For there are elements of Hume's thought that I have passed over or done little justice to and which, given a sympathetic interpretation, align him with this position. It is part of Hume's argument that there must be rules or principles of literary art, which endow works composed in accordance with them with literary value. The foundation of these rules is experience, and they give expression to 'what has been universally found to please'.[31] Hume does not offer any illustration of these rules, and there are many forms they might be supposed to take, but at least it is clear that what he has in mind are principles that specify 'particular forms or qualities' which are 'naturally fitted' to please. Now there are two ways of understanding Hume's claim that certain forms or qualities, in virtue of the structure of the human mind, are naturally fitted to excite agreeable sentiments. The first construes the relation between the forms or qualities and the pleasure they are naturally fitted to excite as merely causal. This is how Hume himself appears to have understood the relation. But it would be possible to construe it normatively, so that the forms or qualities are suitable or appropriate objects of pleasure, or such that delight in them is warranted; and a normative relation is more suitable than a purely causal relation to bind the qualities of Hume's true judges to the forms and qualities they delight in.

KANT'S DEDUCTION OF JUDGEMENTS OF TASTE

The great difficulty of the first suggestion for reconciling the non-representational basis of a judgement of artistic value with the universal validity of that evaluative response is to carry out the required demonstration. This is something Kant attempted in the *Critique of Aesthetic Judgement*, where he tried to show that any human being who satisfies the conditions necessary to make a true judgement of taste (by Kant's lights) must experience the same hedonic response to a certain object as any other human being who also satisfies those conditions.

Whatever its merits, this is a major advance from Hume, who merely helped himself to the conclusion. But there are difficulties in evaluating Kant's enterprise, notably the hasty composition of the work, carelessness, traces of abandoned early views, incoherences, fallacious inferences, the usual casualness with technical terms, a preoccupation with architectonic considerations and reliance on dubious, unacceptable or obscure conclusions of Kant's thoughts about metaphysics and morality. A further obstacle is the principal focus of Kant's aesthetics, which is natural beauty, not artistic value (although the theory Kant puts forward with natural beauty in the front of his mind is extended and modified to cover art as well as nature). In fact, the interpretation of Kant's *Critique of Aesthetic Judgement* remains controversial.[32] The account I present is highly selective, introducing only those elements that are most relevant to Kant's attempt to validate the claim to universal agreement built into a judgement of artistic value.

Kant's superior treatment of the issue derives from the analysis he undertakes of aesthetic experience and singular judgements of taste, judgements that a particular object is beautiful. According to Kant, beauty is not a perceived feature of objects in the world, as colour and shape are. So your experiencing something as being beautiful does not consist in your perceiving a quality of the object. Rather, it is a matter of your deriving a *disinterested* pleasure from the perceived *form* of the object – the form considered in abstraction from the nature of the object that manifests it, from the kind of object you are

perceiving or the concept under which you perceive it (and so from what the function of the object is or what the object is intended to be). For your pleasure in experiencing the object to be disinterested is, principally, for it not to be the result of the satisfaction of a desire that there should be such an object or the thought that it is a good thing that the object exists.[33] Kant's notion of the perceptual form of an object is problematic, but here it will be sufficient to construe it as covering only relations amongst elements of the object, not the object's possession of any intrinsic non-relational characteristics. A judgement of taste is an expression of such a disinterested pleasure in an object's perceptual form and it lays claim to universal validity in that judgements opposed to it are thought of as being awry.

The problem Kant sets himself is to effect a 'deduction' of judgements of taste. By a deduction of the judgement of taste Kant means an explanation of the possibility of such a judgement, which is to say, a justification of the claim to universal validity intrinsic to a judgement of taste, a proof that the claim to intersubjective validity can be well founded. What entitles someone to demand universal agreement with her judgement, a judgement founded in pleasure but that lacks a basis provided by a concept of the kind of object the judgement is about? Kant's solution exploits the defining characteristics of the pleasure expressed in such a judgement – that it is both disinterested and derives from an object's form. These conditions ensure, Kant believes, that the pleasure cannot be due to anything that might distinguish one person from another: if you derive disinterested pleasure from your experience of an object's form, this cannot arise from some feature that might be specific to you, that might possibly be lacked by someone who also experiences that object's form.

Kant envisages two kinds of explanation for a divergence in people's pleasurable or painful responses to the perception of an object, and the two conditions ensure that the experience of beauty is not susceptible to variation across people for reasons of these kinds. Consider, first, the condition of disinterestedness. When the sight of an object delights or pains you but not me, the reason might be that you want to use the

object for some purpose, or you want it to be used by others, or you want it not to be used, or you wish that it had never been made (given the suffering involved in its construction), and so on, but my desires or wishes are different. In these cases, our different responses are due to differences in what we want or wish. But pleasures or displeasures of this sort are not disinterested in Kant's sense, so that if our judgements of an object's beauty were not to coincide although properly based, the explanation could not reside in our different desires or wishes. Now consider the condition that the experience of beauty is a delight in an object's form. For any intrinsic, non-relational perceived characteristic of an object – for any feature of its appearance other than its form – Kant claims, first, that different people might perceive this characteristic by means of different experiences ('sensations'), and, second, even if this is not so, that their affective responses to it might well diverge.[34] Hence the requirement that an experience of beauty is a delight taken in an object's form, not its 'matter', removes a further possibility of variation in people's responses to an object, if these responses are to be foundations of a judgement of taste.

But this cannot be sufficient, for it does not immediately follow from the exclusion of interest and sensuous qualities ('matter') that each person who perceives objects as having the same forms as do others will delight in the same objects. For even if, as is not so, each of us had the same natural endowment at origin, we have been shaped by our pasts in innumerably different ways, in ways that, leaving aside the different desires and sensuous preferences engendered in us, might find expression in the different kinds of objects that delight us – in the forms we experience with delight, the forms that seem to us peculiarly well suited to exercise our perceptual powers on, independently of any other interest.

Kant's deduction of judgements of taste is based on a doctrine about perceptual experience and judgement. In brief, Kant conceives of perceptual judgement as being the product of two faculties of the mind, the imagination and the understanding, the first connecting and arranging data provided by the senses and the second introducing unity into this

synthesis of the sensory manifold by bringing it under a concept in the subject's judgement that there is an object of such-and-such a kind before her. Each of these faculties is operative when you look at an object and see it as beautiful, or look at an object to see if it is beautiful, or look around to see if there is anything beautiful nearby, but the goal of the operation is not to discover the nature of the object or objects, and when you see an object as being beautiful the faculties of imagination and understanding interact in a special manner. Your aim is not to obtain information about the world that confronts you, information that might have a practical significance; it is to determine how suited an object is to your taking delight in its form – in its having the form you perceive it to have. This is determined by the capacity of the object's form to capture your attention with delight, to encourage you to dwell upon its appearance; or, in other words, by the capacity of the way in which the object's matter is formed to draw you away from an interest in what the object is to a preoccupation with the combination of unity and variety in its form, which invites and sustains contemplation. To the degree that an object encourages such a displacement or redirection of your attention, so that it is as if the function or purpose of the object's form is to elicit delight through engaging your perceptual faculties, to that degree you experience the object as beautiful. The object of the pleasure you experience is a perceptual form which 'seems to be, as it were, preadapted to' your power of perceptual judgement,[35] and the source of your pleasure is your perceptual faculties, this pleasure consisting, Kant maintains, in the 'free play' of the imagination in harmony with the general requirements for perceptual judgement that stem from the understanding. Of course, your imagination is not really free, since you are face-to-face with an object whose form constrains the operation of your imagination. But the form of the object is of a kind that your imagination would itself freely project when restricted only by the general conditions necessary for the understanding to unify the manifold with a concept.[36] And since your experiencing an object as being beautiful does not consist in your perceiving a quality of it, your understanding is free in that your concern with the object is not to

classify it as a thing of a certain kind.[37] So the imagination has the maximum possible freedom from the constraints of the understanding consistent with the object's being perceived, and the understanding has the maximum possible freedom with respect to what is presented to it by the imagination, since the aim is not to acquire information about the nature of the object so presented by bringing it under a concept it exemplifies. The result is that your imagination and understanding engage in free and harmonious activity, each exciting or quickening the activity of the other, this mutual quickening being inherently pleasurable.

Kant maintains that the implicit claim to the intersubjective validity of the affective response expressed in a judgement of taste is justified because and only because (i) delight in the beautiful is a disinterested pleasure in the form of an object, (ii) a disinterested pleasure in the form of an object is experienced when and only when the two components of the common perceptual structure of the human mind, imagination and understanding, interact in a particular way, i.e. play freely and harmoniously together, and (iii) any object that engages one person's imagination and understanding in free harmonious activity is such that it will engage any other person's perceptual faculties in equal harmonious activity if the person perceives the object's form and engages with the object in the manner necessary to make a judgement of taste about it. If, therefore, you consider your pleasure in an object to be a disinterested pleasure in its form, you are justified in maintaining the universal validity of the pleasure that a judgement that the object is beautiful commits you to; and if the pleasure you derive from the object really is a disinterested pleasure in its form, the pleasure really is universally valid.[38]

Although the intersubjective validity of the pleasure expressed in a judgement about the beauty of a work of art is secured in exactly the same way as that of the pleasure expressed in a judgement of natural beauty, Kant needs to introduce a qualification into his account in order to accommodate judgements of artistic value, judgements of the value of a work of art *as* a work of art. For, according to Kant, such judgements are judgements, not of free, but of dependent beauty, and judgements of

dependent beauty require you to take into account not just the object's form but also what kind of object it is and whether it is a good instance of this kind. Unless a thing of kind K is a good or satisfactory instance of that kind, even if it is a beautiful thing it is not beautiful *as* a K; and characteristics of an object's appearance that are not consonant with an object's function detract from the object's beauty *as* an object with that function, even if they would enhance the object's beauty if it were not considered as an object with that function. In other words, Kant distinguishes an attributive from a predicative use of the word 'beautiful' and maintains that an essential condition for something's being beautiful in the attributive sense is that it should well exemplify the function of the kind of object it is a beautiful specimen of; in so far as it possesses perceptual features inappropriate or unsuitable to that function, it lacks dependent beauty. Accordingly, it is a necessary condition of a building's being a beautiful church – of its being not just a beautiful building (when considered independently of its more specific function) but beautiful *as* a church – that it should satisfactorily discharge the specific function of a church of providing a communal place of worship sheltered from the elements; and only in so far as it does this does whatever beauty it may otherwise possess count towards its being a beautiful church. Kant insists that you must see a work of art' *as* a work of art and evaluate it from that point of view, and that, since a work of art is created to be a thing of a certain kind, a judgement of its beauty is not free to ignore its success in being such a thing but must take this into account. But this restriction in no way diminishes the significance of the free and harmonious play of imagination and understanding in the evaluation of art. For given the satisfaction of the requirement that the work is a successful realization of the artist's intention, its artistic value is determined by whether it is beautiful.[39]

Apart from the implausibilities and obscurities in Kant's theory of perception, in his idea of the free, harmonious play of understanding and imagination and in his explanation of why this activity is experienced with pleasure, and other difficulties, especially the uncertainty of his conception of a disinterested pleasure, Kant appears not to

demonstrate condition (iii) above, the condition that any object that engages one person's imagination and understanding in free harmonious activity is such that it will engage any other person's perceptual faculties in equal harmonious activity if the person perceives the object's form and engages with the object in the manner necessary to make a judgement of taste about it. His argument turns on a thesis about imagination and understanding, the two mental faculties of which perceptual judgement is held to be the product. This thesis assumes more than one form.[40] In its most developed form, Kant claims that a perceptual judgement can result from the operation of these two faculties only if there is a certain 'ratio' or 'relative proportion' between them, a particular way in which imagination and understanding are related to one another. This relative proportion is not an exact value but covers a set of possible values; and it must be the same for each person, since cognitive judgements necessarily admit of communication from person to person. Within the limits set by this relative proportion, different objects will induce different values of it. However, there must be one possible value of this relative proportion which, for both imagination and understanding, is best adapted for perceptual judgement; and it must be the same for each person. Imagination and understanding play freely and harmoniously together only when this optimal value is present. Hence, Kant concludes, the claim to the intersubjective validity of the pleasure expressed in a judgement of taste is justified.

But even within the terms of Kant's theory of perceptual experience, this is an unpersuasive argument. In fact, it is triply flawed. In the first place, Kant merely asserts that, in each person's case, there must be an optimal value for the relative proportion of imagination and understanding for perceptual judgement, rather than more than one such value or none at all. But this is a substantial claim, not a trivial truth, and without support it lacks plausibility. It follows that Kant's claim that this optimal value must be the same for each person is unfounded. Finally, even if there is a universal optimal value, and even if any object which is suited to induce it in one person when that person is concerned to make a perceptual judgement about the object is suited to induce it in any other

person when that person is similarly concerned, it does not follow that this optimal proportion between imagination and understanding will obtain when a person looks at an object, not to make a perceptual judgement about it, but to delight in its form.

Furthermore, even if Kant had established the intersubjective validity of a judgement of taste based on the pleasure experienced in the free harmonious play of imagination and understanding, he would not have rendered judgements of artistic value unproblematic. For his conception of such judgements is strikingly implausible.[41] It is clear that the proper foundation of a judgement of artistic value about a comedy, tragedy, sculpture or musical work, for example, includes more than a free harmonious play of imagination and understanding, if it includes that at all. But this is the only basis of judgements of taste for which Kant attempts to establish intersubjective validity.

This defect tends to be obscured by two factors. One encourages the thought that because Kant allows a more generous basis for the evaluation of a work of art than the free harmonious play of imagination and understanding, the intersubjective validity of judgements about artistic value will be secured by the additional element. The other provides sustenance for the view that Kant was dissatisfied with his deduction of judgements of taste based solely on considerations about the subjective conditions of perceptual judgement, which he therefore supplements with considerations of another kind.

The first factor is Kant's introduction of the ill-conceived and ill-motivated notion of an 'aesthetic idea' into his account of (fine) art, as the distinctive product of genius. He conceives of a beautiful work of art as the expression of aesthetic ideas, which are integral to an appreciation of the work's artistic value. An aesthetic idea is defined (apparently) as a representation of the imagination that induces much thought but to which no concept can be adequate, so that it is ineffable, that is, cannot be rendered fully intelligible in language (much as the force of a good metaphor eludes capture in language used literally).[42] Accordingly, an aesthetic idea cannot form the sensory core of a state of knowledge, which requires that a representation should be brought under a concept.

Kant maintains that if an aesthetic idea is associated with a concept, either one that cannot be exemplified in experience (eternity, for example) or one that can (love or death, say), then, in virtue of the wealth of thought it generates, the idea brings what the concept signifies so vividly to mind that, for the first alternative, it almost seems to do the impossible and exemplify the concept or, for the second possibility, it embodies the concept in an unusually full or complete manner – each of which is illustrated, above all, in the art of poetry. Genius consists in a certain relation between the faculties of imagination and understanding that enables the artist to generate an aesthetic idea for a given concept and to create a work that expresses the idea, so that the state of mind to which the idea gives rise is universally communicable. So the sense in which a beautiful work of art that displays genius can be said to be the expression of aesthetic ideas is that it has been endowed with a nature which is such that the appropriate imaginative experience of it encourages the understanding to flood the mind with a multitude of thoughts (or feelings or images).

This notion of an aesthetic idea plays a crucial role in Kant's understanding of art. For his insistence that a judgement of taste about a work of art is a judgement of *dependent* beauty turns on it. Only if an item is the expression of aesthetic ideas is it a work of (fine) art, and, accordingly, its being a good example of the expression of aesthetic ideas is a necessary condition of its being valuable as art. In so far as its success in expressing aesthetic ideas is achieved in such a way as to be beautiful – to be intrinsically pleasurable in virtue of the fact that its form encourages the imagination and understanding to engage in free, harmonious play – to that degree it is valuable as art. Hence the evaluation of a work of art *as* a work of art can focus either on its being an expression of certain aesthetic ideas or on its being beautiful (the way in which it is an expression of aesthetic ideas).[43]

It is clear that this murky account of art is at best a false generalization from the kinds of art works that appealed most to Kant. But, more important, it in no way advances the deduction of judgements of taste about works of art. It might seem to do so. For if artistic value is a

function, not merely of a work's beauty – its suitability to provide a disinterested pleasure in its form – but also of its being expressive of aesthetic ideas, perhaps this additional feature will facilitate the deduction of such judgements. But, in the first place, this line of thought requires there to be a contrast between the beauty of a work of art and its being an expression of aesthetic ideas; yet Kant explicitly identifies the two.[44] Moreover, even if this identification is untrue to Kant's best conception of artistic value, a superior deduction of judgements of taste about works of art would eventuate only if the beauty of a work of art that is expressive of aesthetic ideas must be communicable. Yet there is nothing in Kant's notion of aesthetic ideas to ensure that, if the class of items under consideration is restricted to works of art that are expressions of aesthetic ideas, any item whose form provides one person with disinterested delight must provide any other person with the same delight.[45] Secondly, Kant identifies the beauty, not only of works of art, but also of nature, with the expression of aesthetic ideas.[46] He can do so only by interpreting the activity of the mind induced by the aesthetic ideas expressed by a beautiful work of art as the inherently pleasurable, free and harmonious play of imagination and understanding. But reading this conception back into the idea of the free, harmonious play of imagination and understanding in no way advances the deduction of judgements of taste about natural beauty; and construing the state of mind induced by aesthetic ideas in terms of the free and harmonious interplay of imagination and understanding renders the deduction of judgements about the beauty of works of art vulnerable to the objections that undermine the former deduction.

The second factor that might obscure the defective nature of Kant's vindication of judgements of artistic value is his occasional failure to draw a sharp distinction between two issues about the pleasure that provides the foundation of a judgement of taste, a failure facilitated by an ambiguity in the idea that each person ought to be delighted by what is beautiful. The first issue, to which the deduction of judgements of taste gives a positive answer, is whether pleasure in the beautiful – a disinterested pleasure in an object's form – is communicable, that is to

say, is such that any object which is suited to induce it in one person is suited to induce it in any other person. The second issue is whether, given that the pleasure in the beautiful *is* communicable, it has a higher value than pleasure in the merely agreeable – a higher value (i) in virtue of its being communicable, or (ii) in virtue of the features that make it communicable, namely that it is disinterested and directed at an object's form. Pleasure in the beautiful could have a higher value either because its communicability (or the set of features that make it communicable) gives each person reason to take an interest in beautiful objects, or because a person who does take such an interest – an immediate interest that leads him to seek them out as delightful in themselves – thereby possesses a significant virtue, a desirable quality of character. If an interest in what is beautiful actually endows a person with a valuable character trait, or encourages the development of one she already possesses to some degree, then a good case can be made for the cultivation of an appreciation of or sensitivity to beauty and the importance of beauty in human life, although not an overwhelmingly strong case unless what a sensibility to beauty achieves can be gained in no other way, or not so easily. Given the satisfaction of this condition, it can be said that each person ought to cultivate an appreciation of beauty, that is, to take an interest in what is beautiful. Kant claims that only *natural* beauty can awaken an immediate interest, and that someone who takes an immediate, habitual interest in natural beauty – an interest in finding and taking delight in objects of natural beauty just because they are both natural and beautiful – thereby possesses the germ of a morally good disposition, because only an attraction to the morally good is sufficient to generate an immediate, steady interest in the beauty of the natural world; and he supports his claim by indicating a kinship between aesthetic and moral interest, founded on an analogy between the corresponding kinds of judgement.

This analogy between moral judgements and judgements of taste is further elaborated in the development of Kant's final thesis about beauty. This thesis is twofold and maintains, first, that beauty, *whether artistic or natural*, is the *symbol* of the morally good, and, second, that the

judgement of taste's claim to intersubjective validity is warranted only because this is so.[47] It is easy for Kant to reach the first part of this conclusion, given the points of resemblance he outlines, because for one thing to be a symbol (in Kant's sense) of another just is for a judgement that a perceptible object instantiates the concept of the first to be analogous to a judgement that something instantiates the concept of the second. In this sense, beauty is a symbol of morality: it is an 'indirect presentation' of the concept of morality. But the second part rests on nothing: Kant offers no argument to show that the claim to intersubjective validity is warranted, not (merely) in virtue of the nature of the pleasure on which a judgement of taste is based, but only because of an analogy between this judgement and moral judgement. The fact – if it is a fact – that this analogy obtains does not imply that those objects which have forms that one person can take a disinterested delight in must be the same as those that any other person can take a disinterested delight in. It is true that Kant concludes, from the supposed fact that an immediate interest in *natural* beauty is possible only for those who have a certain degree of moral sensibility, that it is right to demand of anyone that she should derive pleasure from objects of natural beauty, since each person must acknowledge moral value as the supreme value and aspire to possess it. But even if Kant is right in his claim that someone who takes an immediate interest in natural beauty 'can only do so in so far as he has previously set his interest deep in the foundations of the morally good',[48] nothing follows about the justifiability of the claim to intersubjective validity built into a judgement of taste, even one about natural beauty.[49] Furthermore, the introduction of Kant's additional claim, that a morally sensitive person cannot reflect on natural beauty without an interest in it being awakened, does not imply that this interest in natural beauty is an interest in it *as* a symbol of the morally good; and even if the implication held, it would not vindicate a judgement of taste's claim to intersubjective validity, for it does not guarantee that the natural forms in which different people take a disinterested delight must be the same. And, finally, this guarantee would not be secured by a strengthened form of this additional claim,

one that Kant favours, namely that the cultivation of an interest in natural beauty promotes or develops a person's moral sensibility, nor by the assertion that each person has a duty to regard beauty as the symbol of the morally good.[50] So Kant's idea that beauty is the symbol of what is morally valuable fails to make good the inadequacy of his deduction of judgements of taste from the essential subjective conditions of perceptual judgement. Hence the interpretation of his thought that represents his justification of the claim to intersubjective validity as being essentially based on a connection between beauty and morality, so that his deduction of judgements of taste is incomplete until he has articulated this connection, would not strengthen Kant's position, even if the interpretation were correct.[51] His deduction therefore fails to achieve its goal.

INTERSUBJECTIVITY, CRITICISM, UNDERSTANDING AND INCOMMENSURABILITY

What kind of property is artistic value? In the first place, although it is not a genuinely absolute value, it is not relative in any disturbing way. For instance, it does not have the kind or degree of relativity that attaches to sentimental value, which is relative both to persons and times. Objects do not in themselves possess sentimental values, but are valued by some, but not other, people on account of what they remind them of: there is no one-place predicate 'is of sentimental value', only the three-place predicate 'is of sentimental value to P at time t'. In contrast with this, a sentence ascribing artistic value to a work does not indicate, explicitly or implicitly, a relation between a certain person or persons and the work. But artistic value resembles sentimental value in being a sentiment-dependent property. A sentiment-dependent property is one the idea of which has to be explicated in terms of an affective response to the object in which the value is found. If the artistic value of a work is the intrinsic value of the experience it offers, the idea of artistic value must be unpacked in terms of a person's finding it intrinsically rewarding to undergo the experience the work offers. Hence, given that the notion of a sentiment covers all the ways in which

something can be found intrinsically rewarding, artistic value is a sentiment-dependent property.

But the fact that artistic value is a sentiment-dependent property does not imply that it is a 'merely' subjective property; for the instantiation of the property is independent of any individual's reaction to the work in which it is or is not instantiated. It is integral to our concept of artistic value that nobody is immune to error about a work's artistic value: it does not follow from the fact that someone judges a work to have a certain artistic value that it does so, and the fact that I judge a work to have a certain artistic value does not imply that I thereby rule out the possibility that I might be mistaken. Artistic value is not a mere projection of a person's reaction to an object — as in the case of the niceness of smells and tastes. On the contrary, the concept of justifiability intrinsic to the concept of artistic value introduces the ideas of appropriateness and inappropriateness into our understanding of a person's response to a work of art, and renders the value intersubjective by admitting the possibility of well-founded approval or criticism of a person's assessment of the artistic value of a work. Intersubjectivity is not confined to judgements about the world as seen from no point of view, or from a point of view uncontaminated by anything that is specific to a particular manner of responding to the world, but equally covers response-based judgements of value conceived of as being justified.[52]

Artistic value is also an anthropocentric property. For there is nothing built into the conception of artistic value that extends the relevant range of people — the people for whom a judgement of artistic value holds good — beyond human beings to all rational subjects who perceive the world. Judgements of artistic value are thought of as valid only, at most, for those who possess a distinctively human sensibility, with distinctively human powers of perception, comprehension, and emotional response, and who flourish and are vulnerable to harm in distinctively human ways. (Contrast Kant, who attempted to show that a correct judgement of taste is based on a pleasure that is valid for all rational creatures with the same *perceptual* capacities as human beings, no matter how they

might otherwise differ.) But the anthropocentricity of artistic value in no way detracts from its importance to us. Although the anthropocentricity of artistic value is a form of relativity, it is one that relativizes it to a kind of sensibility, not to an individual. In fact, artistic value can be thought of as anthropocentric in either of two ways. First, the experience a particular work of art offers might be one that only a subject with a distinctively human sensibility could undergo: it might call for responses which could be forthcoming only from such a sensibility.[53] Second, even if this is not so, there might be no good reason for a subject who lacks this human sensibility to value the experience as human beings do.

I have claimed that you attribute artistic value to a work in so far as and to the degree that you regard the experience it offers as being intrinsically valuable. For you to regard an experience as being intrinsically valuable is for you to consider it right or appropriate, merited or justified, to find it intrinsically rewarding. An experience merits such a response if there is good reason to find it intrinsically rewarding. My account of artistic value therefore has built into it a normative dimension, and this normative dimension houses reasons, not mere causes. The experience a work of art offers is intrinsically valuable if the work is such that it merits being found intrinsically rewarding to experience with understanding:[54] the response must be justifiable by reference to the nature of the work. Unless your response to a work is defensible by reference to features of the work that must be appreciated if the work is to be understood — features of the work that are open to others, that endow it with value, and that constitute good reasons for responding as you do — your response lacks any right to be thought of as indicative of the work's artistic value.

This is reflected in the distinctive practice, thoughts and feelings of those who evaluate works of art as art. For reflection on a work's artistic value has a twofold aim: to grasp the meaning of the work and so to appreciate it for what it is worth. This involves an attempt to characterize the work in such a manner as to warrant or mandate a certain kind of response. The primary concern of the art of criticism is the attempt to describe works of art in ways which justify our responses to them; it is

the rational appreciation of works of art. The art of criticism tries to enforce agreement about the description of a work – a description under which the work must be experienced if it is to be appreciated. Criticism seeks to establish the correct understanding of a work, to articulate its distinctive merits and defects, and so to assess its artistic value. This involves encouraging a certain way of experiencing the work: criticism's claim is that the work should be experienced in accordance with the offered interpretation, which discloses the work's true aesthetic qualities. Now a work's artistic value is dependent on its aesthetic qualities, which in turn are dependent on its non-aesthetic features.[55] Accordingly, criticism, in its attempt to establish a work's artistic value, will draw attention to the aesthetic and also the non-aesthetic characteristics upon which its value depends. Since convincing criticism changes or refines your interpretation of a work and what you are aware of in it, and since these are integral to the way you experience the work, a change of interpretation effects a change in your experience. Hence the similarity between aspect perception and the aesthetic experience of art and the appropriateness of the variety of resources available to criticism for the enhancement of appreciation.

Any work of art can be experienced in indefinitely many ways, but only an experience in which the work is understood is relevant to the work's artistic value. The possibility of lack of understanding carries with it the possibility of discounting a response to a work and the evaluation it implies. But it does not follow that there is only one possible evaluation of a work that is compatible with understanding it correctly and completely. In the first place, I have not claimed that there is only one understanding of a work that is both correct and complete.[56] If there is more than one such interpretation – my introductory definition of 'the experience a work of art offers' is formulated in such a way that it does not restrict admissible interpretations of a work to just one – then, since it is unlikely that evaluations based on different interpretations will coincide, there will be room for more than one evaluation that is not rendered null by lack of understanding. Secondly, even if there is only one correct and complete understanding of a work,

it does not follow from the fact that lack of understanding undermines the authority of an evaluation that understanding guarantees its unique validity. Three additional premises are needed to reach this conclusion. The first is that the evaluation of works of art admits the concept of correctness. The second is that there is only one evaluation of a work that is not incorrect. The third is that correctness of understanding ensures correctness of evaluation. While the first of these is certainly consonant with our practice of evaluating works of art, the second is contentious and the third implausible.[57]

It should not be expected that the art of criticism, perfectly carried out, will always result in a single, definitive evaluation of a work. This would only be so if, for each pair of incompatible qualities, one being an aesthetic merit and the other a demerit, the following were true: if a particular work can be experienced as possessing one member of the pair and can also be experienced as possessing the other member of the pair, then for at least one of these qualities it must be incorrect to experience the work as possessing that quality – that such a way of experiencing the work misunderstands it. But this is not always the case.[58] When it is not true, the work's nature and artistic value are indefinite, and the claim to universal assent or full intersubjective validity built into a judgement of the work's artistic value, based on experiencing the work as possessing one or the other of these incompatible qualities, cannot be vindicated: there is more than one evaluation of the work that is not incorrect. In such a case we must clip the wings of the aspiration to intersubjective validity of a judgement of artistic value and confine the demand for unanimous assent by relativizing the judgement to the work *as experienced as possessing one of the qualities*.

Indefiniteness also enters judgements of artistic value in another way. For an important feature of artistic value is its incommensurability. Although artistic value is a matter of degree, there is and can be no precise measure of the degree to which a work of art possesses it. Artistic value is not a measurable quantity. This implies that when one work is better than another, there is no precise amount by which it is better. It also implies that issues of comparative artistic value are

sometimes indeterminate: in some (but not all) cases, it is neither true that one of the works is better than the other, nor that they are precisely equal in value. It is wrong to think that indeterminacy obtains when and only when the works being assessed belong to different arts. For indeterminacy can obtain within a single art and it can fail to obtain across arts. One reason why artistic value is incommensurable is that there are different kinds of qualities that can endow a work with value and there is no common unit in terms of which their contributions to a work's artistic value can be measured.[59] This holds not only within particular art forms, but also within artistic genres; it also holds across different arts. Because incommensurability holds within each art, indeterminacy can obtain within a single art, and it is likely to do so: there will be some pairs of objects within that art for which the comparative ranking of their members is indeterminate. Indeterminacy also obtains across art forms, but not necessarily so: there are many pairs of objects taken from different arts for which the comparative ranking of their members is determinate. There is no problem about this, for the fact that artistic value is incommensurable, and that the substantive values of one art are not the same as those of another, does not imply that issues of comparative artistic value for works drawn from different arts must be indeterminate. Nor is there a problem about reconciling incommensurability with the existence of determinate comparative rankings within an art. In fact, incommensurability will be thought to threaten judgements of comparative artistic value only if incommensurability is thought, wrongly, to imply incomparability.

In sum: artistic value is intrinsic, sentiment-dependent, intersubjective, anthropocentric and incommensurable.

CODA

I have now sketched solutions to the problems of the individuation, status and epistemology of artistic value. It has not been my aim to indicate any of the different kinds of intrinsic value artists try to endow their works with. The elucidation of artistic value I have attempted has

been expressed in highly abstract terms. This is no accident: an account of the nature of artistic value must be abstract, for below an extremely high level of generality there is no unitary answer to the question, What is the value of art? The species of artistic value that are open to the different art forms in virtue of their distinctive natures are highly various and open-ended, and no exhaustive specification of these values is possible. Although we find the experience of very different kinds of art intrinsically rewarding, the nature of the rewards of literature are not the same as those of music or architecture; and within each art form works display different kinds of value.

In the rest of the book I examine three forms of art, pictorial art, poetry (in the widest sense) and music, and try to resolve, in a manner consonant with the conception of artistic value I have outlined, certain principal issues that arise in reflection upon the values of these arts. These problems are not of the same kind; they arise from a number of sources; and, like most compelling issues, they tend to be located at points of intersection of different lines of thought. One source is the uncertainty of the correct description of the nature of the experience demanded by particular arts or artistic genres. Another is the lack of clarity about which features of art works are aesthetically relevant. A third is the obscurity of the nature of certain features that undoubtedly are aesthetically relevant. Finally, for certain arts there is the elusiveness of a truly revealing characterization of the experiences works of those art forms can provide – a characterization that makes manifest the intrinsic value of those experiences.

II

The Art of Pictures

One is an artist at the cost of regarding that which all non-artists call
'form' as content, as 'the matter itself'.

Nietzsche, *The Will to Power*, §818

REPRESENTATION AND PICTORIAL VALUE

Three things are true of any representational picture: it is a pictorial
representation; it has a specific representational content; and it represents
its content in a certain manner determined by the non-representational
character of the picture surface. The issues I shall be dealing with in this
part of the book concern the significance of these properties of a picture
in the artistic appreciation of the picture. What kinds of significance do
they have? Is their significance always the same from picture to picture,
and, if it is not, in virtue of what does it vary? To what extent, or in
what ways, is the value of representational pictures *as art* dependent
upon their representational content? In what manner, if any, is the
appreciation of a picture's subject-matter relevant to the appreciation of
its value as art?

When you look at a picture and see what it depicts, your experience
of the picture surface will diverge more or less from the kind of
experience you would have if you were to see what is depicted face to
face. The more closely the appearance of the picture surface approaches
the appearance of what it depicts, the more closely will your visual
experience of the picture resemble your experience of what it depicts.
At the limit, although your field of view will encompass more than the
picture surface and you will remain aware that you are looking at a
picture, you will no longer see the picture as a picture and you will

undergo the illusion of seeing the reality depicted. In this kind of case, the picture is a means of providing you with the visual experience you would have if you were to see face to face what it depicts; and if that experience is intrinsically rewarding for you to undergo whether or not you believe that you are really seeing the world as the experience represents it to be, you thereby have reason to value the picture. You undergo in front of the picture a visual experience that is indistinguishable from the face-to-face experience of what it depicts and the picture is therefore a useful means for providing you with an experience you value. Moreover, the picture might be especially useful to you if the corresponding face-to-face experience is dangerous, difficult or impossible for you to obtain, or if you believe it is wrong really to look at what is depicted. But since you are not seeing the picture as a picture, you are not valuing it as a picture, and, a fortiori, its representational content, or the fact that you see it as depicting that state of affairs, makes no contribution to your admiration of it as a picture. There is therefore no question whether, and if so for what reasons, the experience of looking at the picture, seeing it as a picture and seeing what it depicts, might have for you a different intrinsic value from the corresponding face-to-face experience.

But this question does arise in all cases where you see a picture *as* a picture and see what it depicts. This will nearly always be so, since in most conditions, and especially the intended viewing conditions, the appearance of the picture surface will manifestly differ from that of the depicted subject and there will be no possibility, no matter how you look at the surface, of your undergoing the illusion of seeing what is depicted. It follows that there is in general no difficulty in principle in explaining why the experience of looking at a picture and appreciating it as a picture might have a different intrinsic value from an experience of looking at the corresponding reality. Since pictures (seen as pictures) look manifestly different from what they depict, the two experiences differ, sometimes in striking ways. But although this is so, there is still a problem throughout the range of pictures, which is most acute at each end of the naturalistic/non-naturalistic spectrum.

Consider, first, the class of naturalistic pictures. The more naturalistic a picture – the more successful the picture is in capturing the visual appearance of its subject – the more the visual experience of the picture is like the experience of the corresponding reality. Accordingly, there are fewer features that *can* be used to explain the difference, perhaps the considerable difference, in value between the experiences. Whatever set of features is responsible for the difference in value (if there is one), how does this set endow one of the experiences with a value that the other lacks? At the other end of the spectrum are non-naturalistic pictures, pictures that do not aim at an accurate rendering of the visual appearance of their subjects. The less a picture looks like what it depicts, the less will the visual experience it offers resemble its real-life counterpart, and, accordingly, there will be plenty of room for the existence of a difference in value between the two experiences. But if the value of the picture – the value of the picture *as a picture* to the spectator – is in some way dependent upon its representing what it does, how is the spectator's appreciation of its representational content relevant to his valuing it? Does he value it partly because his awareness of its subject is so *unlike* his awareness of its counterpart in reality, and, if so, how does this endow it with its distinctive value?

In what, then, does the value of pictorial representation reside?

A NATURAL PROPENSITY TO DELIGHT

There are two poles between which answers to this question lie. On the one hand, there is a view (found in different forms in Aristotle and Hume, for example) that lays emphasis on the fact of pictorial representation itself and maintains a natural propensity to react favourably to depiction. On the other hand, there is the Formalistic doctrine that restricts the artistic or aesthetic importance of the properties of a picture to features other than the representational content of a picture, thus effecting a radical separation of the appreciation of a picture from the recognition of its subject. The simplicity of these positions enables them to exert an immediate attraction denied to more complex solutions.

Towards the beginning of the *Poetics* Aristotle claims that it is natural for human beings to delight in works of imitation or representation, and in support of this claim he adduces the consideration that 'though the objects themselves may be painful to see, we delight to view the most realistic representations of them in art, the forms for example of the lowest animals and of dead bodies'. The explanation he offers of our capacity to derive pleasure from the accurate depiction of objects, even those we do not like to look at face to face, is both peculiar and implausible. Aristotle's explanation is that learning something is a considerable pleasure for all human beings and in recognizing what a picture depicts we are acquiring information, namely, the information that this is what the picture depicts.[1] That this is the correct explanation is confirmed, Aristotle believes, by the fact that when someone has not seen the thing depicted, his pleasure in the picture cannot be pleasure in it *as a depiction of that thing*, but must 'be due to the execution or colouring or some similar cause'. But none of this carries conviction. The acquisition of information is not always a pleasant process, and even if the information that a picture depicts such-and-such, acquired by looking at the picture and recognizing what it depicts, does on some occasions yield pleasure, the information is too trivial to explain our pleasure in depiction, and especially in depictions of objects that we look at face to face without pleasure or with displeasure. Our pleasure in a picture *as a depiction of its subject* must derive from something other than our visual awareness that this is just what the picture is, namely, a depiction of that subject. Given that we do not delight in looking at every picture whose subject we recognize, and in particular those whose subject is unpleasant for us to look at face to face, a more discriminating explanation than Aristotle's is required.

I have not argued that it is untrue that depiction 'as such' (to use Hume's expression) is delightful; and whether or not this claim is acceptable there is a way of understanding it that renders it compatible with the fact that we do not always delight in looking at a picture with a subject we recognize. For the claim might amount to no more than the proposition that anyone who sees a picture as a depiction of its subject

on that account or *in that respect* is inclined to derive pleasure from looking at it, which allows that, in virtue of the picture's subject or the way in which the subject is represented, the person's response to the picture might contain no trace of pleasure. But of course the most that could follow from acceptance of the claim, understood in this accommodating fashion, is that if the face-to-face experience of an object is not unpleasant, a picture that depicts that object in an undistorted, recognizable manner will be experienced with some measure of delight. There will be no explanation of the fact that it is sometimes more and sometimes less intrinsically rewarding to look at a picture than to look at what it depicts, nor of the supposedly ameliorating power of depiction. Accordingly, all the work would need to be done by supplements to the claim, by considerations about the manner of depiction and, perhaps, the nature of the subject represented. Hence it need not detain us.

FORMALISM

At the opposite pole to the view that one of the distinctive values of the experience of looking at pictures derives from a natural propensity to delight in the recognition of depiction is the set of doctrines that maintain that the recognition of what is depicted makes no, or at most a minor, contribution to the value of the experience of looking at a representational picture, if the picture is appreciated from the aesthetic point of view or from the point of view of its value *as art*.

The most extreme view claims that the representational content of a picture is always *irrelevant* to the picture's value as art, so that it is unnecessary for the spectator to be aware of what is depicted in order to appreciate the artistic value of the picture. So the only relevant factor is the picture's 'form', not its pictorial content: excellence of form is both necessary and sufficient for pictorial value. This is the view put forward by Clive Bell, although in an idiosyncratic form and with a notable absence of arguments. He maintained that there is a unique emotion (the aesthetic emotion) which is evoked by all valuable works of art and which is rarely evoked by anything else, natural beauty, for example.

The cause and object of this emotion is always the same, namely a characteristic shared by all valuable works, their 'significant form', a certain kind of way in which elements of pictures are combined and interrelated. The value of a picture is to be found in the emotion aroused in a spectator by, to use the words of Roger Fry, 'the pure contemplation of the spatial relations of plastic volumes', that is, the contemplation of the 'purely formal meaning' of the work.[2] Many admirable pictures interest us and excite our admiration but do not provoke the aesthetic emotion and, accordingly, do not move us *as works of art*. A representational (figurative) form may have as much aesthetic value as an abstract form; but if it has aesthetic value, it is *as form*, not as representation, that it has it. Hence, to appreciate a work of art we need bring with us nothing from life – nothing but a sense of form and colour and (in many cases) a knowledge of three-dimensional space.

This counter-intuitive Formalist doctrine not only lacks any plausible supporting arguments but appears defenceless against a number of objections. In fact, it is flawed both internally and externally. Perhaps the main consideration that underlies Formalism runs like this: since there are valuable works of art that lack an independently significant (or any) pictorial content, and poor or mediocre works that possess such a content, a valuable work of art cannot be valuable partly in virtue of its content; hence its content is irrelevant to its value as art. If this argument were valid, it would in fact lead to a much more radical position than Formalism, since it would make nearly all properties of works of art irrelevant to their value. But the argument is invalid. The main part of the argument is of the form: (i) there are good Xs that lack F, (ii) there are bad Xs that possess F, so (iii) a good X that possesses F cannot be good partly because it possesses F. Such an argument mistakenly concludes, from the fact that a certain property is neither necessary nor sufficient for something to be a good instance of a particular kind, that it can never contribute to the value of something of that kind. This overlooks the possibility that a property can contribute to a particular kind of value without being either necessary or sufficient for that value – as a good footballer with a powerful kick might be a good footballer

partly because he possesses that ability, despite the ability's being neither an essential nor a sufficient requirement for excellence at football.[3] The relevance of a property to a kind of value is not a matter of its being either a necessary or a sufficient condition of it. It is true that representational content does not determine artistic value, and that representational content – an independently significant content, or any content at all – is not necessary for artistic value. It follows that, given only these considerations, it is *possible* that even in those cases where a picture does have an independently significant representational content, this is always entirely irrelevant to its artistic value. For the second consideration implies that there is something other than independently significant representational content sufficient to endow a picture with value, and perhaps it is this alone that gives a picture which does have such a content its value. However, this is no defence of the Formalist position, which is open to powerful objections.

But first it is necessary to disambiguate the idea of representational content as it figures in the claim that the representational content of a picture is irrelevant to its artistic value. It would be absurd – and clearly contrary to the Formalistic view of pictorial value advanced by Bell and Fry[4] – to understand this claim as implying that the value of a picture is determined by the pattern on its surface, considered independently of its depicting anything, so that the beholder should confine his attention to the two-dimensional design of the picture surface, considered in itself, in abstraction from what is depicted. Formalism does not demand that pictures should be seen as if they were not pictures, as if they were non-representational structures. In fact, there are two interpretations of the Formalist position, one more and one less restrictive. The first, and more restrictive, version maintains that a picture should indeed be seen as the depiction of a three-dimensional scene, but the scene it depicts should be considered only from the point of view of its 'analogue content', that is to say, its being a spatial composition of the elements of colour (hue, brightness and saturation), shape, size and depth. A visible scene is composed of objects spatially related to one another; and whatever the natures of the constituent objects and however much they

are masked by the objects that lie in front of them, each presents to the viewer a visible colour, size and shape and they are seen as lying in various directions and at various distances. Each of these elements can vary continuously, and, given a picture of a scene, their values define the analogue content of the appearance of any point in the depicted scene.[5] The objects that compose the depicted scene will in general also be seen as falling under other concepts – as trees, houses, women, or whatever – but, according to the Formalist's claim, it is necessary to abstract from these concepts in aesthetic judgement and to consider the depicted scene only in its spatio-coloured aspect. In particular, no feelings about or attitudes towards the depicted objects must be allowed to enter the viewer's response if it is to be properly aesthetic, for the implications and associations of what is depicted are irrelevant to a picture's artistic value. A picture's value as art is entirely dependent on its being a depiction of a scene that, considered with respect to the disposition of coloured masses in space, constitutes a harmonious or impressive whole – possesses 'significant form'.

This understanding of the idea of significant form construes it as a property of the depicted scene (as seen from the point of view from which the scene has been depicted)[6] – a property of the depicted scene considered independently of the picture that depicts it. But it is unclear that this is what Formalism intends. For, as with other kinds of representation, there is a distinction between a depicted scene and a depiction of it, and properties of the depicted scene are not in general transferred to a depiction of it – as a picture of a beautiful woman is not thereby a beautiful picture of a woman, and a picture of a cruel scene is not thereby a cruel picture of a scene. In particular, if a depicted scene composes a harmonious array, its harmoniousness is not automatically transmitted to any depiction of it. In fact, unless we embrace an illusionistic theory of depiction, the experience a spectator has in seeing what is depicted is not the same as, and does not include, the experience of seeing such a scene face to face. Hence the experience of the picture does *not* provide the spectator with an experience of the spatial relations of 'plastic volumes', that is, of the spatial relations amongst objects in a

scene of the depicted kind. Furthermore, if significant form were a property of the depicted scene itself, there would be no distinctive artistic value possessed by a depiction of a scene – a value possessed by the depiction but not by a scene of the kind depicted. This would mean that there would be no reason why we should especially value a pictorial representation of spatial relations amongst coloured objects, in comparison with an actual arrangement of the same coloured objects spatially related to one another in the way the picture represents. It seems that what Formalism needs is a notion of significant form that is neither a property of the picture surface considered in abstraction from what is depicted, i.e. a property of the relations of items in a two-dimensional space, nor a property of the depicted scene considered independently of the picture that depicts it, i.e. a property of items in a three-dimensional space.

One possibility would be to recognize two aspects of a picture as capable of possessing significant form and so as relevant to its pictorial value: first, the non-pictorial character of its surface – the two-dimensional relations amongst the coloured marks that compose the surface – and, second, the analogue content of its depicted scene – the three-dimensional relations amongst the 'plastic volumes' that compose the depicted scene (or, perhaps, the three-dimensional relations visible from the point of view from which the scene has been depicted). Pictorial value could then be construed in a conjunctive fashion, as the sum of the aesthetic value of the two-dimensional non-representational character of a picture's surface and the aesthetic value of the depicted scene's analogue content – the significant form of the surface and the significant form of the depicted scene, a twofold impressiveness or harmoniousness. But there are three related reasons why this would be an unsatisfying position for Formalism to adopt. In the first place, it would merely yoke together two values each of which, so it would seem, could be appreciated independently of the other, leaving unexplained why these two distinct values should compose pictorial value. Secondly, the view would lack definition without an assignment of relative weights to the two kinds of harmony for which pictures can be appreciated aesthetically,

and it is unclear on what basis these relative weights could properly be assigned. Thirdly, it represents these two values as being entirely independent of one another, there being no flow from one aspect of a picture to the other, neither from the analogue content of the depicted scene to picture surface nor from surface to analogue content of depicted scene. And yet these two aspects of a picture could hardly be thought to be completely insulated from one another, merely lying side by side.

If significant form is not a property of the depicted scene, and it is not a disjunctive property of the picture (so that a picture would possess significant form if either the scene it depicts or its surface possesses its own distinctive 'significant form'), significant form must be a property the picture possesses in virtue of depicting the analogue content of the scene in the way it does, that is to say, in virtue of the *relation* between the two-dimensional nature of the picture surface and the analogue content of the scene it depicts – a relation that, perhaps, requires a twofold harmony, a harmonious two-dimensional design and a harmonious analogue scene depicted by that design, the one harmony creating, 'fitting' or enhancing the other, or the two interacting in a manner that somehow results in mutual enhancement. This understanding of significant form would certainly constitute a considerable improvement on its predecessors in one respect, namely its recognition of a genuine and crucial feature of pictorial value – the interplay between the character of the two-dimensional surface of the picture and the three-dimensional scene depicted in it. But without an account of the supposed merit-conferring relation between the analogue content of a depicted scene and the nature of the surface that depicts it – an account that has never been provided by Formalism – the proposed idea of significant form is lacking in definition.

Now Formalism consists of both a negative and a positive thesis about the appreciation of representational pictures. The positive thesis – that the appreciation of a picture consists entirely in the contemplation of its significant form – is, as I have indicated, ill-defined. But this lack of clear definition does not affect the negative thesis, which is therefore easy to assess. Its defects are apparent. In the first place, it deprives

(figurative) pictorial representation, intended as art, of a rationale. What would be the point of depicting familiar objects if artistic value is a function of purely formal relationships? It would be a remarkable coincidence if purely formal satisfactions could be best achieved by depicting objects which are to be considered in abstraction from their familiar meanings and sentiments. Even if this were so, it would be exceptionally difficult in the case of most pictures to eliminate from our attention the non-spatio-coloured aspect of what is depicted and to respond to the picture as if it were an abstract representation, that is, a picture that depicts only spatial and colour relations.[7] Secondly, there is no reason to restrict the appreciation of pictures as works of art to the appreciation of a picture as a depiction of three-dimensional form: there is nothing in the idea of art in general or pictorial art in particular that implies that art or artistry can be exemplified only in the depiction of abstract characteristics. It might be thought that Formalism could concede this point without materially weakening its stance, by admitting the artistic relevance of what a picture depicts whilst asserting the greatly superior value of the purely Formal character of the picture. But if this were not to be mere assertion, it would need to be founded in an account of the differences in the values of, on the one hand, the appreciation of the depiction of three-dimensional form and, on the other hand, the full appreciation of a depiction – an account that would need to show that the full appreciation adds little to the Formal appreciation. No such account is possible. Finally, although it is unclear what the property of significant form is supposed to be and what it attaches to, it is clear that the Formalist requirement that the aesthetic spectator should abstract from a picture's full pictorial content and confine his attention to the analogue content of the picture's depicted scene places undesirable restrictions on the factors that contribute to what is thought of as the formal organization of a picture. For if the spectator's response is to be shaped only by the picture's analogue content, he must ignore the direction of a person's gaze or pointing gesture, that a depicted form (a tree) is bent by the wind, or (a hunting dog) is in the act of springing, or (a flag) is fluttering, or (a bird) is

flying, or (a lifeless arm) is hanging, or (someone) is held back or is turning to the right or is supporting weight, and so on, endlessly. In other words, Formalism neglects depicted movement, depicted force and resistance, depicted energy and lassitude, and other features that are obviously relevant to a picture's unity, balance, harmoniousness, or impressive organization.

So the extreme Formalist view that the non-analogue content of what a picture depicts is irrelevant to its pictorial value is baseless, for our familiar conception of pictorial value does not impose such a restriction on the determinants of pictorial value.

A more plausible claim is that there is an important value that a picture can realize, which is confined to its depiction of analogue content, and that the aim of a valuable picture might be nothing more than the harmonious depiction of analogue content. There is no reason to deny this claim, although the class of pictures for which it holds is exceedingly small, if not null. Just as it is possible for a person to be primarily, or solely, concerned with the 'decorative' or harmonious arrangement of a set of objects, their nature being indifferent in every respect other than shape, size, volume, colour and texture – the aim is the composition of a pleasing visual pattern of lines, planes, volumes, colours, spaces, and so on – so the concern of an artist in the construction of his representational picture, and accordingly the interest of the picture to the spectator, might be purely 'formal': the objects depicted are material looked at abstractly to build a design (and so may be distorted or dismembered in the interest of the design, as may the light, perspective, etc.). But the restriction of the claim to a small class of pictures and the lack of an assignment of primacy to the value of the depiction of 'pure form' renders the claim uninteresting.

A related, but more interesting position is that of Roger Fry.[8] He acquiesced in the idea that there are two kinds of value that a picture can manifest, one associated with the analogue and the other with the non-analogue content of the depicted scene, and attempted to show that the achievement of these values is almost invariably at odds with one another,[9] so that a representational picture is a more or less unhappy

mixture of two distinct and separable arts, the art of 'illustration' and the art of 'plastic volumes'. There is, on the one hand, a picture's excellence as illustration – as a vivid realization, a moving or interesting presentation of an interesting or emotionally affecting person, event or scene; and, on the other hand, its excellence as 'plastic' expression – as a construction of (represented) volumetric relations; and these values do not sit easily together. Cooperation between the formal and non-formal aspects is most possible where neither is fully realized but each is to some extent only suggested or indicated; however fine the cooperation may be, it is not possible to attend equally and simultaneously to both aspects – rather, one must shift one's attention back and forth; and over time a picture's appeal as illustration tends to evaporate, leaving only its appeal as plastic expression. So there are no pictorial masterpieces of both illustration and plastic construction: no works of high art in which neither aspect predominates and the mutual accommodation of the aspects entails no sacrifice in either.[10]

Fry's argument is in some ways, but not entirely, successful, and it lacks the significance he credits it with. He argues convincingly that the value of Poussin's *Achilles Discovered by Ulysses among the Daughters of Lycomedon* derives minimally, or not at all, from its non-formal representational content: it is aesthetically appealing only as plastic construction, not as illustration. And it is true that some pictures that are impressive as illustration are not impressive if considered simply as plastic constructions. Hence plastic and illustrative value do not necessarily coincide: neither is sufficient for the other. But in so far as I am sensitive to the value Fry designated 'plastic construction', there appear to be many masterpieces of both illustration and plastic construction: Poussin's *The Martyrdom of St Erasmus, Bacchanal before a Term of Pan*, and *The Madonna of the Steps*, for example.[11]

The more fundamental weakness in Fry's position is, however, the bifurcation of pictorial value into value as illustration and value as plastic construction, as though these are the only, or the main, artistically valuable aspects or aims of a picture. What lies at the bottom of Fry's way of thinking is the idea of a picture's form as consisting of those

spatial relations amongst the elements of the picture that contribute to the picture's organization.[12] These spatial relations can be of three kinds: they can obtain between (i) elements of the depicted scene, (ii) elements of the picture surface, or (iii) an element of the depicted scene and an element of the picture surface.[13] It is clear that one aim of pictorial art has been to achieve an ordered composition by marking the pictorial surface in such a manner that the pattern on the surface and the arrangement of the objects in the depicted space are experienced by the beholder as endowing the picture with an impressive unity or ordering. If you were to conceive of pictorial form as solely a function of spatial relations, either between elements of the depicted scene or between elements of the picture surface; and if you were to think of the spatial relations amongst elements of the picture surface as contributing only to a picture's 'decorative' value, which is a minor affair; then you would be likely to identify the impressive ordering aspired to by pictorial art, when this is not a matter of effective illustration, along the lines of Fry's idea of plastic expression, and so assign plastic expression a high value. The result would be the identification of illustration and plastic expression as the two principal pictorial values, and the idea that the question of their relations to one another is the most basic issue in pictorial aesthetics. In fact, this is a fairly precise reconstruction of Fry's thought. This is borne out by his tacking on to his consideration of the relation between plastic expression and successful illustration in pictures some brief remarks about 'the relation of the decorative treatment of the picture surface to illustration', which he maintains is also a matter of the cooperation of two arts – decoration being a minor value for Fry. But it is mistaken to think of the artistic function of the picture surface in the way Fry does, as either decorative or representational (plastic expression or successful illustration); for this neglects the crucial characteristic of pictorial art, namely the *interrelationship* between the marks on the surface and what is depicted in them. It is integral to the appreciation of a picture that the beholder should see the subject-matter *as depicted in the medium*;[14] and the most important values of pictorial art are not confined to those of illustration and plastic expression.

I hope it will now be apparent that if the Formalist position is understood as restricting the aesthetic relevance of a picture's representational content to the analogue content of its depicted scene (or a product of this with the two-dimensional design on its surface) – and this is how it has so far been construed – it omits much of what gives any picture its artistic value. But there is, as I indicated earlier, another way of understanding the Formalist claim, which renders it less vulnerable. This version of Formalism allows in features of the depicted scene excluded by the more stringent version by expanding the set of aesthetically relevant features of the depicted scene so that it includes more than the depicted scene's analogue content, although still not the full depicted content. Its aim is to capture all the 'formal' features of a picture's depicted scene that might play a role in binding the picture together and be elements of its impressive form. In fact, this alternative interpretation of Formalism covers a range of positions, which are defined by the nature of the additional features of a picture's depicted scene that are allowed into a picture's form.

Whatever these features might be, the spectator must consider them in abstraction from the further non-analogue nature of the items in the depicted scene. A minimal addition would be purely spatial features not included in a depicted scene's analogue content (as I have defined the notion), namely depicted direction (of movement or of someone's gaze, for example) or non-depicted but indicated lines along which the spectator's eyes are intended to move (as indicated by a depicted figure's pointing gesture, for example). A further increment would be functions or characteristics of mass or weight, such as lightness or heaviness, force, resistance and momentum. It is clear that the impressive organization of Rubens's *Descent from the Cross* (Antwerp), for example, is achieved not merely by the depicted analogue content but by the directions in which the participants look, and it is a function not only of spatial relations in the depicted scene but of the weight of Jesus's body and the support it is given. Accordingly, the present version of Formalism is more plausible than the first. Nevertheless, it is only a last desperate attempt to preserve Formalism's exclusion of the significance of a

picture's subject-matter from the picture's artistic appeal. For it fails to do justice even to the significance of the features it introduces into a picture's 'formal' organization. For example, the role played by the fact that a depicted person is looking in a certain direction – its role in making the picture a satisfying composition – can rarely, if ever, be reduced to the mere indication of a direction or line. In fact, there are innumerable possible pictorial functions for depicted looks – as, for example, the mutual acknowledgement celebrated in Ghirlandaio's *Portrait of a Man with His Grandson*, as the gaze of trust meets the gaze of love.

The truth of the matter is that the form of a work of art is the way in which its elements are related to one another, that is to say, the structure of its elements. It follows that without an identification of the elements of a pictorial work of art the idea of its form lacks definition, and that different identifications will define different conceptions of form. If a work is analysed in one set of terms, it will have one kind of form; if it is analysed in another set of terms, it will have a different form. Hence the extra-analogue content of what is depicted is irrelevant *to the form of the work* only if it is not one of the elements of the work; for if it is an element of a work, the relations in which it stands to the other elements of the work define the work's form. It would be possible to consider a picture as being composed of the distribution of colour expanses visible in its surface, in which case even the analogue content of what is depicted would not be included in a picture's form. But this would be an absurd conception of a picture's elements. The question, therefore, is, What, from the aesthetic point of view, is the most fitting conception of the form of a picture? The answer follows from the fact that the form of a work of art is thought of as satisfactory only if the work is unified aesthetically, and its form is impressive to the extent that the spectator is rightly impressed by the relations amongst its elements. Therefore the most appropriate conception of artistic form is one that construes the elements of a picture as all those features of it that need to be integrated if it is not to be faulted aesthetically in virtue of the way in which one feature is related to another. This all-embracing

conception ushers in such features as colour, line, format, modelling, illumination, facture, pictorial space, depicted objects, analogue content, narrative content, subject, and others; and because pictorial unity is holistic – because the contribution of each element is affected not merely by its relation to another element, but by that element's relation to all others – this conception of artistic form allows for the possibility of innumerable ways in which pictorial elements, or selections of them, can be combined in an aesthetically impressive fashion. Given the inclusion of extra-analogue content in a picture's elements, it would be possible to acquiesce in Formalism's restriction of pictorial value to the quality of the work's form but to reject Formalism's denial of the aesthetic relevance of what the picture depicts.[15] Whatever the merits of such a position, it is ironic that the fundamental weakness of Formalism turns out to be its simplistic conception of pictorial form.

SUBJECT, DEPICTED SCENE AND PICTORIAL FIELD

Depiction is an essentially visual art, and its distinctive values are present in the act of looking at a picture. We are aware of these values in looking at a picture with understanding, and the experience of looking at a picture we value is itself intrinsically rewarding. The question is, What do we value in pictures when we value them as art? Or: what kinds of value can pictures realize in virtue of being pictorial works of art? Perhaps it will seem plausible to maintain that for any picture for which the perception not only of its analogue but also of its non-analogue content is relevant to its appreciation and an assessment of its artistic value, the picture's value is a product of what it depicts and the manner in which it depicts its subject. But not only is there a difficulty in deciding what kind of product this could be, and what exactly it would be a product of, the thesis does not answer the question.

Although it has often been maintained that the reasons for which we value pictures, when we value them as art, fall into a single narrow kind or set, the claim does not withstand scrutiny. In fact, there are indefinitely many properties that are capable of endowing a picture with

pictorial value, just as there are indefinitely many defects to which a picture is liable. It is in a sense true that the prime *determinant* of pictorial value is *how* the artist has depicted *what* he has pictured – how he has depicted his subject. The core of the aesthetic appreciation of pictorial art is the perception not only of the subject but also of the way in which the picture presents its subject, and it is from this that the picture derives whatever value it possesses. Pictorial value is basically a function of the *relation* between the depicted scene and the manner of depiction (although this formula, even when interpreted correctly, needs to be amended). But, so I shall argue, there is no single substantive value, or small set of values – harmoniousness, or the creation of a convincing illusion of reality, for example – that can be achieved by depicting a subject in a certain manner.

In fact, the usual terms of the debate, invoking a distinction between (or sometimes an (ideal) identification of) 'content' and 'form', 'what' a picture depicts and 'how' it depicts it, which have often been criticized, although not on the clearest of grounds, are certainly inadequate. For, in the first place, the idea of the manner in which a subject has been depicted is multiply ambiguous. I shall begin by drawing a distinction between a picture's *subject* and its *depicted scene*. In one sense, *how* the artist has depicted his subject is a matter of *what* he has or has not depicted: in this sense, manner of depiction embraces the subject *as depicted*. Two pictures of the same subject, the Annunciation, say, will present the subject in a different manner by depicting Mary and the Archangel in different ways, in different positions and postures in the depicted space, in which different enclosures are depicted as the backgrounds against which the drama takes place. So although the pictures depict the same subject, the scenes they depict are very different from one another. Or consider Matisse's shadowless *Red Studio*: Matisse has depicted the studio without depicting shadows, so that the studio as depicted is shadowless. The depicted scene of Matisse's picture is a shadowless studio. By a picture's *depicted scene* I mean the depicted arrangement of objects – the objects as depicted – as seen from the point of view from which they have been depicted, in the depicted prevailing

conditions of illumination, and so on. A depicted scene will be specified by a description of what is depicted, where, in relation to whatever else is depicted. It is important to recognize that a picture's depicted scene will always be, to a greater or lesser extent, indefinite in ways in which no real scene could be so. This is especially true with respect to spatial relations between objects in the depicted scene. Most pictures present a depicted scene. If the idea is interpreted with sufficient latitude, it can perhaps be stretched to cover all pictures, including those that present depicted items from different points of view, or even appear to allow depicted objects to occupy the same place through the use of overlapping ambiguous forms or superposition, or purport to depict impossible objects or worlds. To cover all pictures, it would certainly be necessary to recognize that a picture is sometimes composed of pictures whose depicted scenes do not compose a depicted scene, so that the claim would be that any picture either depicts a scene or is composed of pictures that depict scenes. But for my present purpose it will be sufficient to consider only straightforward cases. It is certainly character-istic of pictures created as art to present a depicted scene. The *subject* of a picture, in the sense I am here operating with, is given by a further specification of the picture's depicted scene, often a high-level descrip-tion, sometimes an identification of the persons or other items in the depicted scene: it is what the depicted scene is a rendering of – the Annunciation, Macbeth meeting the witches, the death of Marat, the Judgement of Paris, or whatever.

It is clear that the nature of a picture's subject is relevant to an assessment of its pictorial value. Perhaps nobody knows what the subject of Piero della Francesca's *Flagellation* is; if so, nobody understands it or can properly evaluate its success as a realization of that subject. It is obvious that the way in which a picture depicts its subject – the depicted scene the picture presents – is a crucial determinant of the picture's value, for pictures of the same subject can present that subject in indefinitely many different depicted scenes, and the nature of these scenes is a determinant of a picture's success or failure as a realization of that subject. For example, a picture can be a debasement or vulgarization

of its subject by realizing that subject in a depicted scene that is an unfit presentation of the subject. At the level of competent depiction, one of the most important ways in which manner of depiction affects pictorial value is by imposing affective qualities, of calmness, serenity, tranquillity or vivacity, for instance, on the subject depicted. It is also true, although less obviously so, that the manner in which a picture presents its depicted scene contributes to or detracts from its pictorial value. For if, and this is here my intention, we understand the idea of a picture's depicted scene in its most specific sense, so that it includes every depicted detail of the scene, no matter how minute, then it is still possible for visibly different pictures to depict the same scene, although this will rarely be so. This possibility is open, since there are different ways in which aspects of a scene – tone or shadow, for example – can be depicted that do not carry with them differences in what is depicted, and visible aspects of a picture's surface may lack pictorial significance, that is, may not depict anything. If we call the visible nature of a picture's surface its pictorial field, then the same depicted scene can be presented by different pictorial fields. Now if a picture has a subject, it has it in virtue of its depicted scene, and it has a depicted scene in virtue of its pictorial field: without a pictorial field, there is no depicted scene, and if there is no depicted scene, there is no depicted subject. Hence, at bottom, it is the nature of the depicted scene and the relationship in which the picture's pictorial field stands to its depicted scene that endows a picture of that scene, seen as a picture of that scene, with whatever value it has.[16] Just as poetic value is determined by how what is said relates to the means of saying it, the arrangement of words that compose the poem, so the artistic value of a picture is determined by how what is depicted relates to the marked surface in which it is represented. Accordingly, the appreciation of pictures, like the appreciation of poetry, requires a sensitivity to the relation between what is represented and the artist's use of the medium of representation.

But even if manner of depiction is understood in this most fundamental way, as restricted to the visible nature of the pictorial surface – the picture's pictorial field – pictures have meanings integral to their value

as art over and above what they depict – their depicted scenes and their subjects. Consider Chardin's *The House of Cards* or *The Spinning Top*. You fail to understand these pictures if you see them only as depictions of the scenes they present, for each has a complex meaning (a 'subject', but not this time a visible event) that you must grasp in order to appreciate the picture fully. *The House of Cards* is not just, what it might seem to be, a depiction, certainly a profoundly sympathetic depiction, of the innocent absorption of childhood, but a subtle image of the insubstantiality and uncertainty of human life and the coming loss of innocence upon entry into the adult world. And if you understand the picture you do not merely recognize this meaning intellectually as the picture's deeper 'subject', but you see the picture differently: your perception of the picture is transformed by the recognition, so that you experience the meaning *in* the picture. It is Chardin's ability to realize this meaning in a pictorial field that presents a depicted scene which both captures the spectator's attention and engenders a heightened and poignant awareness of the significance and fragility of human life that gives his painting its distinctive value. Or consider Caspar David Friedrich's *Moonrise over the Sea*, which depicts a man and two women contemplating the moon rising across the sea over which sailing ships are approaching. Whether or not the various details of the picture should be accorded a precise Christian interpretation, it is clear that you fail to understand the picture's meaning if you do not see the ships as symbols, as 'ships of life'; and in seeing them as such symbols, you see the picture differently from one who does not.

So the art of pictures is not the art of pictures *considered merely as depictions*. (Formalism attempts to impose a further restriction by representing the art of pictures as the art of pictures *considered merely as analogue depictions*.) But although this is so, it is certainly possible, as the Chardin example shows, to evaluate pictures from this restricted point of view. For someone might admire the Chardin as a picture *of its depicted scene*, and yet dislike its didacticism, its moralizing intent, and consider this to detract from its (full) pictorial value. In fact, a picture might without confusion, even rightly, be considered to be a fine picture

of its depicted scene under one description of that scene, but not under another description – and not, moreover with respect to some further meaning it carries. The perceived value of a picture does not always increase in accordance with the appreciation of additional meanings.[17]

RELATIONAL PICTURES

Chardin's *The House of Cards* is a picture of a boy building a house of cards; his *Self-portrait with an Eyeshade* is a picture of a man wearing an eyeshade. Each picture is a picture of something; it depicts its subject in the same sense, it seems; and what each picture depicts is, apparently, something of the same logical kind – a boy building a house of cards, a man wearing an eyeshade. But there is an important distinction concealed here, which is most easily revealed if I am allowed to make a certain assumption. Just as *The House of Cards* is, let me assume, not a picture of some particular pack of cards that Chardin had before him when he worked on the picture or that he had once seen and intended to represent in it, so, let me assume, it is not a picture of some particular boy, a friend's son, say. But the *Self-portrait with an Eyeshade* is a picture of a particular man, Chardin himself. The distinction we need to draw is one between two senses of the sentence 'P is a picture of . . .', where the gap is filled by an indefinite description, such as 'a man' or 'a boy'. For there is an ambiguity in the idea that a picture depicts something. When an item is said to be a picture of a man or a boy or anything else, there are two different ways in which the remark can be understood: it can be understood to license existential generalization or not to license it. If the remark is intended to license existential generalization, it follows from the fact that something is a picture of a man that there is or was a man of whom it is a picture; if the remark is understood otherwise, this conclusion does not follow (although it may in fact be true). I shall call the first concept of a picture the concept of a picture in the relational sense, and the second the concept of a picture in the non-relational sense. In the relational sense, a picture must stand in a certain relation to an actual thing, which it depicts; in the non-relational sense, this is

not required. To indicate that a picture is a picture of something in the relational sense I shall (following Antonia Phillips) write it as 'P is a picture *of* . . .', and to indicate that it is a picture in the non-relational sense I shall (following Nelson Goodman) write it as 'P is a . . .-representing-picture' or, for short, 'P is a . . .-picture'.[18] So *The House of Cards* is a boy-picture and *Self-portrait with an Eyeshade* is a picture *of* a man.

It is important to realize that whilst there are non-relational pictures which are not relational pictures, the converse does not hold: every relational picture is *at the same time* a non-relational picture. The reason for this is that a picture in the relational sense – a picture *of* something – cannot simply be a picture *of* its subject, but must depict it *as* something or other. What it depicts its subject as need not be something it is, but it cannot depict its subject without depicting it as a thing of a certain kind. A picture *of* something cannot blankly depict what it is *of*, as a word (a proper name, for example) can blankly refer to an individual thing. A picture *of* something must represent what it is *of* as having certain properties, as a description refers to what it is *of* by a property it attributes to its referent. Chardin could have depicted himself without depicting himself *as* a man wearing an eyeshade, as he did in his *Self-portrait with Spectacles*, but he could not have depicted himself without depicting himself as something of a certain kind, a man, say. But if Chardin depicts himself as a man, his picture is thereby a man-picture, and however he depicts himself, or whatever he depicts himself as, his picture is thereby a picture of that kind of thing. Accordingly, every relational picture must also be a non-relational picture. But a non-relational picture need not be a relational picture, as in the case (so I have assumed for the sake of illustration) of *The House of Cards*.

If I now replace the assumption that *The House of Cards* is not a relational picture with the supposition that it is a picture *of* a boy, a friend's son,[19] who has been painted from life, there will still be an important difference between *The House of Cards* and *Self-portrait with an Eyeshade*, if I am allowed to make a different assumption. For it is a further question whether, given that *The House of Cards* is a picture *of* a

boy, Chardin intended it to be seen as being *of* a boy, and in particular whether he intended it to be seen as being *of* the specific boy we are now assuming he depicted, that is, his friend's son. Let me assume that although Chardin used his friend's son as a model for the boy in the picture, another (similar-looking) boy would have served his purpose just as well because he did not intend the picture to be seen as a picture *of* his friend's son, or in fact *of* any boy. Given that assumption, *The House of Cards* and *Self-portrait with an Eyeshade* differ in an important way. For although both are pictures *of* particular people, only the second was intended to be seen as being *of* the person depicted. If we are concerned with the appreciation of a picture as a work of art, the relevant question is not whether the picture is *of* someone or something, but whether the artist intended it to be seen in that way.[20] For if that was the artist's intention, we do not understand his picture as he intended unless we see it so; and if it was not his intention, we import into the work of art a reference immaterial to the artist's intention if we see it as a depiction *of* a certain person. So whereas when we look at *Self-portrait with an Eyeshade* our thoughts must be about the person depicted (Chardin) if we are to see it as the artist intended, when we look at *The House of Cards* the person depicted (Chardin's friend's son) need not enter our thoughts.

Up till now I have been concerned with the issue of the relevance of what a picture depicts to its artistic value only (or primarily) when a picture is considered from the non-relational point of view. But with relational pictures a further question arises: what, if anything, is the aesthetic significance of the fact that the picture is a relational picture, and in fact a picture *of* X? Of course, even if a certain picture's being a relational picture is relevant to its artistic value, this does not prevent it from being evaluated not as a relational picture, and specifically a picture *of* X, but only as a picture in the non-relational sense; but such an evaluation must diverge more or less from the picture's true artistic value, if this is partly determined by the picture's relational nature. As I have already indicated, whether a picture is a relational picture, and, if so, what it is a picture *of*, may be irrelevant to its meaning, and so to its

artistic value – as when a picture is *of* a model whose identity is irrelevant to the artist's aim. Whistler's *Arrangement in Grey and Black* is in fact a picture, in one sense a portrait, *of* his mother. But as he remarked, 'To me it is interesting as a picture of my mother, but what can or ought the public to care about the identity of the portrait?' Hence the picture's title. Failure to see Whistler's picture as a picture *of* his mother is not a failure to appreciate the picture's artistic meaning; and seeing it as a picture *of* his mother, rather than *of* another woman (a look-alike, say), indeed, seeing it as a relational picture at all, does not endow the experience with an intrinsic value it would otherwise lack. In fact, what is true of Whistler's picture holds good for many other portraits – portraits that, unlike Whistler's, were intended by the artist to be seen as portraits *of* their subjects. For the decisive factor is not so much the artist's intention as to how his picture is to be seen, but whether it is integral to his *artistic* intention that it should be seen as a picture *of* X: a pictorial work of art has an artistic meaning; it is this artistic meaning the spectator needs to recognize if he is to understand the picture; and it is this artistic meaning that is being evaluated in judgements of a work's artistic value.

There are many other clear cases where what, if anything, a picture is *of* is irrelevant to its artistic value. To vary the kind of example: it is of no concern to the evaluation of a still life by Cézanne whether a certain part of his picture is *of* a particular fruit, or whether it is *of* a particular wax substitute (which was often the case), or whether it is *of* anything at all. So the question is whether the fact that a picture is a relational picture, and in fact a picture *of* X, is ever relevant to its artistic value. If it is relevant, does it matter whether X has been depicted accurately? Although it has sometimes been maintained that, from the aesthetic point of view, it is always a matter of indifference whether a picture is a relational picture, and, if it is, whether it depicts its object accurately or inaccurately, such a view is untenable.

There are three considerations about which we could ask whether they are or can be relevant to a picture's artistic value: (i) the mere fact that it is a relational picture; (ii) the mere fact that it is a particular

species of relational picture (one drawn or painted from life, for example, or a portrait, or a caricature); and (iii) the fact that it is a picture *of* X. Whereas the third of these considerations concerns the relevance or irrelevance of the *identity* of the depicted individual, the first two concern only the fact that there is such an individual. But there is a link between the second and third considerations. For a picture that depicts an individual drawn from life, or a picture that is a portrait, aims to capture the depicted individual's appearance and a caricature presents a distortion, but one that remains recognizable, of an individual's appearance. So what the second question asks is whether a picture's having the aim that is definitive of the particular species of relational picture it belongs to, whatever its success and whosoever the depicted individual might be, should inform the viewer's appreciation of the picture. And since a picture *of* X must depict X a certain way, one of the issues raised by the third question is whether the fact that a picture depicts X's appearance accurately or inaccurately can be relevant to its artistic value. But, as will be seen, this is not the only issue raised by the third question.

It seems fairly clear that the bare fact that a picture is a relational picture – the fact that it depicts an actual individual – could not be something that a spectator needs to be aware of to appreciate the picture, for it could not in itself be part of a picture's artistic meaning. That is to say, simplifying somewhat, given that an artist has created an F-picture, the fact that it is a relational picture *of* an F cannot endow it with an artistic meaning it does not otherwise possess. But this is not as obviously so for the fact that a picture is painted from life (or a portrait or caricature). Consider a picture that depicts a horrific scene drawn from life – a murder or torture scene, for example. Should the fact that it is not just a torture-picture but a picture *of* an actual torture scene (presented as such by the artist) be dismissed as irrelevant by the aesthetic spectator, or can it properly transform his appreciation of the picture?

Whatever the answer to this last question may be, the identity of an individual depicted in a relational picture often plays a significant role

in the appreciation of the picture. The reason why this is so is twofold. In the first place, many relational pictures cannot be understood or perceived correctly without some knowledge of the individual depicted – how much knowledge and what kind of knowledge varying from picture to picture.[21] To appreciate a subtle caricature *of* X you need to be able to see the distortion in the depicted individual's appearance, which you cannot do without knowledge of the undistorted appearance; to appreciate Paul Wunderlich's lithograph *George Sand* you need a fair amount of information about the woman depicted;[22] and to appreciate Manet's *Portrait of Zola* you must know at least that Zola wrote an enthusiastic defence of the artist in a pamphlet entitled *Manet* (shown in the picture).[23] Secondly, the identity of the depicted individual determines the acceptability of the attitude a picture may invite towards that individual. A picture *of* Stalin that aggrandizes him is defective in virtue of soliciting a misplaced attitude of admiration for him.[24]

An important artistic category of relational pictures is the self-portrait, and the identity of the person depicted in a self-portrait is often relevant to its appreciation as art. Self-portraits are often statements by the artists of their conceptions of themselves as artists and so invite evaluation of that stance. Poussin's 1650 *Self-Portrait* (Louvre) presents himself as a man of strong passion controlled by reason and will-power, utterly dedicated to the art of painting, and displays the dignity, intelligence, culture and concentration characteristic of his art. Or consider the three masterpieces in Western art of the pictorial representation of pictorial representation itself – Velázquez's *Las Meninas*, Vermeer's *The Art of Painting*, and Courbet's *The Painter's Studio* – each of which, if seen as a picture by the artist of the artist in the act of painting, possesses an artistic meaning it would otherwise lack.[25] But self-portraits need not primarily express an artist's conception of himself as, specifically, an artist. Certain of Rembrandt's late self-portraits are concerned to present not so much a conception of himself as artist, but a revelation of himself as an ageing man. They give the spectator a vivid sense of having been painted by a man who was capable of looking at himself without vanity or illusions and who was prepared to show himself as he was. In

presenting this unvarnished appearance they are free from the self-deception, wishful thinking, posturing, affectation or glamorizing intent that so readily enter the presentation of the self. And in virtue of being *self*-portraits, they possess a distinctive value they would otherwise lack. For they are paradigms not only of truthfulness, but of an especially difficult form of that virtue – truthfulness about oneself.

An interesting example of a relational picture, which in one sense is, but in another is not, a self-portrait, and where the fact that it is a relational picture assumes aesthetic significance, is *Double Portrait of the Two Artists* by Jean-Baptiste de Champaigne and Nicolas de Platte-Montagne. The picture depicts the two artists seated at a table, looking out of the picture, Nicolas introducing Jean-Baptiste to the imagined spectator. Since the picture was painted by the pair of them, it might be said to be a self-portrait of the pair. But neither painted his own portrait: as details of the picture declare, each was painted by the other. Now the picture is certainly a touching celebration of the two artists' friendship. But it is not just a celebration of their friendship: it is emblematic of friendship itself. For the picture not only depicts them as friends: it contains depictions by each of the other, acknowledged as such; the acknowledgement takes the form of each declaring that he was created by the other; and the sympathetic depictions compose a balanced scene, agreed by the two artists, in which the presence of each enhances the presence of the other.

The concept of a relational picture *of* a person requires that such a picture depicts an actual individual, rather than being merely a person-picture. But there are person-pictures which are not relational pictures and yet not merely person-pictures, because they are pictures of particular, but non-actual, persons. They are depictions of particular mythological or otherwise fictional characters, such as Echo and Narcissus or Saturn, who have an imaginary existence independent of their presence in a certain picture. The best way of treating such pictures is to think of them as being, not really, but make-believedly pictures *of* their subjects. It seems clear that the identity of the person or persons depicted in a picture of this kind is integral to the appreciation of the picture, and can

be relevant to its artistic value. Consider Poussin's *Echo and Narcissus*. Even if you did not know the identities of the characters depicted, or even that they have identities, you might be struck by the picture's beauty. But the realization that the picture is a depiction of the myth of Narcissus and Echo transforms your appreciation of the picture, not merely by enabling you to appreciate the haunting way in which Poussin has depicted Echo as in the process of becoming insubstantial, but by your seeing the meaning of the picture as Poussin understood it, as an emblem of the vicissitudes of narcissism. In coming to see this meaning in the picture, Poussin's artistic achievement assumes a higher value.

Now if it is true that the identity of a depicted fictional character enters into a picture's meaning, it might seem obvious that there are very many relational pictures, pictures *of* real individuals, which are such that the identity of the person depicted is part of the picture's artistic meaning and consequently relevant to its artistic value. Surely pictures of the Crucifixion derive their force from their being not merely crucifixion-pictures but pictures of the crucifixion of an actual man, Jesus, thought of by Christians as the son of God? But there is a plausible strategy for avoiding this conclusion, which is to admit the relevance of the identity of the person and event depicted but to insist that from the aesthetic point of view it is immaterial whether what the picture is *of* is real or imaginary. In other words, the real existence of the depicted individual is bracketed off by the aesthetic spectator, who responds to the picture as if it were only make-believedly *of* someone who lived the life attributed to Jesus. Although Poussin did not believe in the real existence of Echo and Narcissus, whereas Tintoretto did believe in the real existence of Jesus, the aesthetic spectator ignores this difference and regards Tintoretto's *The Crucifixion* as he regards his *Venus and Vulcan*, as depictions of subjects whose reality is irrelevant to the picture's artistic appeal and value.

There is little reason to adopt this strategy for a depicted individual in whose existence the spectator believes, if the strategy is confined to the actuality of the individual depicted. But if it is extended to cover not

only the actuality but the true nature of the individual's character and life, it begins to recommend itself in certain cases. For just as it is the myth of Narcissus, not his actual existence, that is relevant to the appreciation of Poussin's painting, so it is the nature and life attributed to Jesus by the Christian Church, not his mere existence, that is relevant to the appreciation of Tintoretto's picture. Accordingly, the aesthetic spectator ignores the Church's falsification of Jesus's status, representing him as being the son of God, and its acceptance of a picture of his life that touches reality in few places, and adopts before Tintoretto's *The Crucifixion* a similar attitude to the one appropriate to his *Venus and Vulcan.*

This bracketing move is designed to insulate Tintoretto's picture from questions about the accuracy of its representation of the individual it depicts – questions about the accurate representation not of the individual's appearance (about which nothing is known) but of his divine or merely human status, and of his actual beliefs, character, personality and life. But if the strategy is successful here, it does not follow that accuracy of representation is never an aesthetically relevant issue.

SUBJECT-MATTER AND PICTORIAL VALUE

In the case of any picture for which the nature of the depicted scene is integral to its pictorial value, there is a question about the nature of the depicted scene's contribution to pictorial value and so to the spectator's appreciation of that value. Does the depicted scene always make the same kind of contribution, and, if so, how?

John Updike has claimed that 'Representational painting asks a double response from the viewer: to the subject depicted and to the manner of depiction, of painting'.[26] This suggests that a spectator's response to a picture is a combination of two component responses – a response to the depicted scene and a response to the pictorial field; and the value of the picture to the spectator is the sum of the intrinsic values of these component responses. But such a view is inadequate. First, it is wrong to

think of the response to the depicted scene as being independent of and unshaped by an awareness of the pictorial field – perhaps a response of the kind that would be evoked by seeing such a scene face to face. It is true that some pictures owe their appeal to the fact that the spectator responds with delight to seeing face to face a scene of the kind depicted: Stubbs's pictures of horses appeal by virtue of the appealing look of thoroughbred horses; Paul Klee's etching *Two Men Meet, Each Presuming the Other to be of Higher Rank* amuses because the sight of such a grovelling pair is amusing; a pornographic picture might excite only because the sight of what it depicts would excite. So the represented world of a picture can engage our emotions or sustain our interest in a similar way to that in which a represented world in a literary work can: the scene we imagine is of such a nature that it would affect us emotionally in reality, and our response to the imagined scene is founded in the real-life response. In such cases, the visual interest or affective power of what is depicted is harnessed to the visual interest or affective power of the picture, although there is still a difference in our response, dictated by the realization – the visual awareness – that we are looking at a picture, not the reality itself. But it is an obvious feature of pictorial art that there is often a disparity between the spectator's response to the depicted scene – to the scene as depicted by the picture – and his response to the corresponding scene in reality;[27] and the reason for such a disparity is not simply the spectator's realization that he is looking at a picture, rather than the reality itself, but that his response to the depicted scene is shaped by the nature of and the relations between the specific lines, dots or coloured areas that compose the pictorial field, which he is aware of in seeing the depicted scene. Awareness of the depicted scene is penetrated, to a greater or lesser extent, by awareness of the pictorial field,[28] and the spectator's response to the depicted scene is a response to it *as* presented by the pictorial field. The aesthetic spectator no more responds to the depicted scene unaffected by the pictorial field in which it is visible than he responds to a picture's subject unaffected by the depicted scene in which it is realized. The fact that manner of depiction can affect pictorial value by

imposing affective qualities on the subject depicted is sufficient to undermine the idea that a component of the spectator's response to a picture must be the response that the picture's depicted scene would characteristically induce if seen face to face (or vividly imagined). For manner of depiction can present its subject in a manner that *counteracts* the response that would typically be wrung from a spectator of the actual depicted scene (as in the case of a serene picture of the Crucifixion, Raphael's exquisite *The Mond Crucifixion*, for example).

The second defect in the dual-component view is that there is usually no response to the specific nature of the pictorial field *as such*, considered independently of the depicted scene, any more than there is a response to the physical aspects of the words of a poem *as such*. Just as poetic appreciation does not contain a component which consists in a response to the words considered independently of the meanings they carry, that is, to the physical aspects of the words considered in isolation, so the appreciation of a picture does not contain a component which consists in a response to the pictorial surface considered independently of what it depicts. Furthermore, just as the physical aspects of the words in a poem have little, if any, aesthetic value considered in themselves (in relation to one another), rather than as embodiments of their meanings, so the disposition of marks or colours across a picture surface has minimal, if any, aesthetic value considered in itself, rather than as the field in which the depicted scene is visible. Both a picture's pictorial surface, considered independently of its representational content, and its representational content, considered independently of the way in which it is realized in the pictorial surface, lack aesthetic appeal. Hence, no more are there two separable responses in the appreciation of pictorial art than there are in the appreciation of poetry.

In fact, the idea that a component of the aesthetic beholder's response to a picture is a response of the kind that would be evoked by seeing face to face a scene of the kind depicted will appear plausible only if the significance of the various differences between the experience of looking at a picture and the experience of looking at the reality depicted is overlooked. The most salient differences for the present purpose are

these. In the first place, my perception of a picture *as* a picture is informed by my awareness that I am seeing, not the reality depicted, but a two-dimensional iconic representation of it (reflected in the fact that, as I move from side to side in front of a picture, there is a lack of the changing perspectival profiles of objects in the depicted scene that would be present in observing a real scene); and in seeing what is depicted I am simultaneously visually aware of the pictorial surface in which it is depicted. (The fact that I am aware that I am not seeing the reality depicted partly explains my willingness to look at pictures of scenes the observation of which in reality would constitute an invasion of privacy.) Secondly, whereas there is the possibility of my intervening in or responding to a scene I witness, I can be nothing other than a beholder of a depicted scene: I am powerless to interfere with the depicted world. If a depicted figure looks out of the picture, I am unseen and cannot respond to the imaginary look directed at me. Even if I enter imaginatively into the depicted space, I remain (and am aware of remaining) before the picture. Hence I am free from the necessity of appropriate responsive action that attaches to witnessing a real scene. (This partly explains my willingness to contemplate depictions of scenes I would not want to witness, and renders appropriate emotional responses that would be inadequate or out of place as reactions to a real scene.) Thirdly, throughout the time I look at a picture, the depicted scene remains, and must remain, the same: the scene depicted presents an unchanging appearance. If the scene is one of action, the picture depicts a time-slice through the action. The motion of an object can be depicted (as with the blurred spokes of the spinning wheel in Velázquez's *The Tapestry Weavers*), but (except for objects multiply-depicted and stroboscopic movement, as in Duchamp's *Nude Descending a Staircase No. 2*, where the same action is shown at successive stages) the appearance of the object is constant. A depicted scene endures unchanged. In that sense, a picture presents a scene frozen in time.[29] (Thus depicted scenes can be objects of contemplation in ways that many real scenes could not.) Fourthly, a picture's depicted scene is a purely visual object of appreciation, lacking any substance that might appeal to or distress the

other senses. So a picture remains silent no matter how long I contemplate it, even if it depicts a scene in which sounds are being made or heard: I cannot delight in the music of Titian's *Concert* nor close my ears against the scream that saturates Munch's *The Scream*, for these sounds occur only in the depicted, not the real world. Finally, in looking at a picture I am aware that I am looking at an artefact in which the artist has chosen to represent the scene as it is depicted; and this requires my visual attention to the picture to be informed by the artist's intention, style and exploitation of the resources of the art form and possibilities of the medium,[30] and the picture's location in the artist's *œuvre*. These and other differences should undermine the appeal of the idea that we respond to the depicted scene as we would if we were really to see such a scene.[31] Given that the experience of looking at a picture of a scene is so unlike that of looking at the scene itself, there is no reason to assume that the affective quality of the second experience must be transferred to that of the first, or that the affective quality of the first must derive from that of the second.

But I have not yet attempted to explain exactly what it is that determines the role that the subject-matter of a picture plays in the viewer's response, and how that response can diverge so markedly from the viewer's response to the reality depicted. A response to the sight of the reality corresponding to a depicted scene can be positive, negative or one of indifference, and such a response can be aesthetic or non-aesthetic. The reality might be intrinsically rewarding to look at, either for aesthetic or for non-aesthetic reasons, or intrinsically distressing to look at, again for either reason, or a matter of indifference, aesthetically or non-aesthetically. Yet a picture can evoke a response different, in kind or degree, from the response to the corresponding reality. We have already recognized one way in which this transformation might come about: a picture that depicts a horrifying scene (the Crucifixion, for example) might not depict it *as* horrifying (in contrast to Goya's *Saturn* or *This is Worse*, for example). But this is not the only possibility.

Consider the art of still life, which might in any case appear problematic. Some still lifes depict arrangements of objects that in reality would

not compel attention and would scarcely, if at all, reward continuous observation, and yet the pictures themselves are marvellous to behold. Such pictures do not exploit the nature of the viewer's response to the reality corresponding to the depicted scene. Even if a still life does depict an arrangement of objects that would be attractive to look at face to face, the experience it invites can be of quite a different order from that of the corresponding reality. Of course, the viewer's response to a still life might be solely a product of admiration for the artist's skill in capturing a likeness,[32] the extra-artistic significance of the depicted scene in no way shaping the response. But the most fundamental differentiating feature is that a still life belongs to an established artistic category within which the artist is working; the artist has chosen the objects to be depicted, their arrangement in the picture and the way they are illuminated, and he has depicted them in his personal style; and this imbues the picture with a meaning that the reality corresponding to the depicted scene would lack – a meaning about the world, the artist's attitude to the world or to his art. In fact, the dislocation of the beholder's response effected by a still life can arise in a number of ways, many of which direct the viewer's attention to the means of representation or the mode of depiction, rather than the nature of what is depicted. Two of the ways in which the extra-artistic significance of the depicted scene may be distanced from the beholder's response to a picture are of special interest. First, the viewer's response to the picture – to its depicted scene as realized in the pictorial field – might not include a response to the depicted scene as such, but rather to the artist's attitude to the nature of what is depicted, or to the nature of the artist-beholder's mode of visual attention to the depicted scene, as this is manifested in the picture.[33] Just as we look at a scene with a certain emotional attitude – with love, pride or regret – in a certain manner – casually, glancingly or with fierce concentration – and with our attention spread evenly across the scene or drawn to one or more points of special interest,[34] so a picture can depict a scene *as seen* with a particular quality of perception or emotion; and the viewer's response to such a picture is shaped by the way in which the implied artist-beholder sees the depicted scene. The

transfiguration of the commonplace effected by the still lifes of Juan Sánchez Cotán or Zurbarán, for example, is a function of the nature of the gaze directed at the depicted scene. Or the objects depicted in a picture might have a meaning for the artist – a meaning that the spectator must grasp in order to appreciate the picture. Van Gogh's *Still Life with Drawing-Board* puts together objects – food, drink, pipe and tobacco, a letter addressed to him (from his brother Theo, presumably), a book on health and hygiene, his drawing-board – upon which his stability depended at the time he painted the picture, and the painting is experienced as an expression of faith or hope. Second, the artist's primary concern, and so the focus of the aesthetic spectator's interest, might be not the nature of what is depicted but the power of art – the power of art to ennoble its subject-matter, as with Caravaggio's *A Basket of Fruit*, or to capture subtle effects of light and achieve a perfect harmony of colour, depicted texture, and the interrelationships of volumes and voids, as with many of Chardin's still lifes[35] – or the means of representation, as with Cézanne's purely aesthetic construct *Still Life with Apples*.[36] A picture that celebrates the primacy of the artist's use of the medium undercuts or disconnects the beholder's response to the nature of what is depicted.

If these points are put together with previous ones, and other possibilities are borne in mind,[37] there will be no difficulty in explaining any lack of fit between a beholder's response to what a picture depicts and the beholder's response to the corresponding reality, no matter how naturalistic the picture may be.[38]

PICTURE AND REALITY

We are now in a position to return to the issue of the possible disparity in value between the visual experience offered by a picture and the corresponding face-to-face experience. The intrinsic value of the experience of a picture can be the same as or more or less than that of the corresponding reality, whether the face-to-face experience is intrinsically rewarding, painful, or neither the one nor the other. Moreover, for each

face-to-face experience there are three possible kinds of picture with the same representational content as that experience: pictures that provide an experience with a greater intrinsic value, pictures whose experience matches the intrinsic value of the face-to-face experience, and pictures that yield a less rewarding experience. The scene depicted in a picture can be one that you would find intrinsically rewarding to look at in reality, or one you would have an entirely negative attitude towards, or one you would look at with indifference. If the visual experience of the scene is favourably transformed by a picture that depicts it – if the intrinsic value of the experience is changed from negative or zero to positive or if the positive value is enhanced – what makes the experience of the picture preferable to that of the reality?

It should now be apparent how artificial this question is. For we are invited to compare experiences which, on the one side, are likely to be more or less momentary, but, on the other side, endure for as long as the beholder wishes and, if the beholder is to appreciate the picture before him, require sensitivity to features of the depicted scene (and the pictorial field in which it is visible) unlikely to be noticed in the momentary experience of the corresponding reality.[39] So it will often be the case that you can *see*, but cannot *look at*, a real scene of the kind depicted, for many depicted scenes are ones in which action or move-ment is taking place and the picture presents only an instant of that action or movement. Accordingly, there will be no question whether the depicted or the corresponding real scene is more rewarding to look at. Again, the one kind of experience is the contemplation of a moment in a scene that is only make-believedly present to the beholder; the other is a momentary phase of an experience of a scene that, even if it is not unfolding before the beholder's eyes, may do so at any moment, and is in any case actually present. So the one is entirely free from the constraints of responsive action; the other is always of possible practical interest and may be pregnant with demands. The fact is that pictures as art provide the beholder with experiences that are comparable with those of the scenes they depict only in one respect – the two-dimensional aspect of the appearance of the scene as depicted.[40] The visual experience

of a picture – seeing what it depicts and appreciating it as art – is both lesser and greater than the corresponding face-to-face experience in ways that profoundly affect the beholder's interest in what he sees and his delight in the experience. It is lesser in that it lacks the third dimension. It is greater not only in its duration and all that this makes possible for the beholder, but also in possessing an additional aspect – the pictorial field, the nature of which penetrates the significance of the depicted scene – and in the variety of features that can accrue to it in virtue of the fact that it is an experience of a pictorial work of art, requiring awareness of its thematic, expressive, referential or other artistically significant characteristics. Moreover, as the brief discussion of still life illustrated, this is true not only for pictures of action and movement, but for pictures of objects that are at rest. Given the multifarious differences between the experience of a picture and the corresponding face-to-face experience, there is, if anything, too much to explain any disparity in their intrinsic values. But it should not be expected that for those pictures the experience of which is preferable to that of the corresponding reality, there is a single answer to the question, 'What makes the experience of the picture more valuable?' On the contrary, the multiplicity of factors involved implies that the issue can be dealt with only in a piecemeal fashion.

Truth, Sincerity and Tragedy in Poetry

The real thoughts of real poets all go about veiled, like the women in Egypt: only the deep *eyes* of the thought gaze out over the veil. – Poets' thoughts are on average not worth as much as they are accepted as being: for one is also paying for the veil and for one's own curiosity.

Nietzsche, *Human, All Too Human*, II, 1, §105

The first challenge when it comes to explaining the tragic myth is that of seeking the pleasure peculiar to it in the purely aesthetic sphere, without intruding upon the sphere of pity, fear or moral sublimity.

Nietzsche, *The Birth of Tragedy*, §24

THE UNIQUENESS OF POETIC VALUE

A poem presents thoughts in a certain manner by embodying these thoughts in an arrangement of words. The value of a poem as a poem does not consist in the significance of the thoughts it expresses; for if it did, the poem could be put aside once the thoughts it expresses are grasped. You grasp what matters in a philosophical argument, a treatise on economics, a school report, if you can express in other words the thoughts contained in these texts. You then have no need of the texts, of the words in which the thoughts were originally formulated. But what matters in poetry is the imaginative experience you undergo in reading the poem, not merely the thoughts expressed by the words of the poem; and it is constitutive of this imaginative experience that it consists in an awareness of the words as arranged in the poem. It is often the case that the function of a linguistic object or event is to achieve an end, fully specifiable independently of the linguistic vehicle, as when you are

concerned merely to convey information. In such a case, the same message will be conveyed no matter which of a number of linguistic vehicles is used, and changes in the language need not affect the realization of your intention. But it is never the sole object of poetry as poetry to convey a message; rather, the function of a poem as poetry is that it itself should be experienced, which is to say that its function is to provide an experience that cannot be fully characterized independently of the poem itself. Hence the value of poetry is singular or non-substitutable: poetry has an importance it could never lose by being replaced by something else that achieves the same end; for what we value is the experience of the poem itself, a specifically linguistic expression of a complex of thought, desire and sentiment.

It has sometimes been maintained that the reason why there can be no substitute for a valuable poem is that each such poem has a meaning that cannot be captured in any words other than those of the poem itself. This is the claim that underlies Cleanth Brooks's 'heresy of paraphrase', a tenet of the New Criticism:

... the poem is not only the linguistic vehicle which conveys the thing communicated most 'poetically', but ... it is also the sole linguistic vehicle which conveys the thing communicated accurately. In fact, if we are to speak exactly, the poem itself is the *only* medium that communicates the particular 'what' that is communicated ... the poem says what the poem says.[1]

Brooks's reason for believing that there cannot be an exact and complete paraphrase of any fine poem is fourfold.[2] First, he requires an adequate paraphrase of a poem to include a specification of the poet's attitude to her subject and implied audience as expressed in the poem, for 'the poet's attitude is a highly important element of *what* is communicated'.[3] Second, the attitude expressed in any fine poem will be of unusual subtlety. Third, the prime poetic function of figurative language, in particular metaphor, and such distinctive features of poetry as metre and rhyme, is to qualify and develop the poet's attitude. Finally, any subtle state of emotion, or nuance or shade of attitude or tone, can be captured in language only by the use of figurative language, metre, rhyme, and so

on – in fact, only by one particular arrangement of words that is exactly tailored to the precision of the emotion or attitude. So the idea that underpins the doctrine of the heresy of paraphrase is that each fine poem communicates a specific attitude which can be communicated only by the arrangement of words that constitutes the poem.

The weakness in Brooks's position is the last, crucial element, which is not only inadequately supported but implausible.[4] It is, however, unnecessary to claim that any fine poem communicates an attitude otherwise incommunicable in order to preserve the irreplaceability of poetic value. For, as I have indicated, there is an alternative and more secure strategy. Even if the attitude expressed in these lines from Marvell's *Definition of Love* can be fully and exactly characterized –

> As Lines so Loves *oblique* may well
> Themselves in every Angle greet:
> But ours so truly *Parallel*
> Though infinite can never meet

the combination of this characterization and Marvell's proposition 'in its logical paraphrase'[5] would provide a different experience from the lines themselves; and it is the experience the lines offer, not merely what they communicate (in Brooks's sense), that determines their poetic value. A poem is not rendered superfluous by the availability of a transcription into other words of what it 'says'; it does not need a meaning otherwise inexpressible; for it is a specific verbal embodiment of a meaning, and, as such, is unique.[6]

FICTION AND TRUTH

The common function of declarative sentences in poetry would be misunderstood if it were thought appropriate to object whenever such a sentence was not true. Someone for whom it was an invariable requirement that anything asserted in a poem should be true would be devoid of the idea of fiction. The fictional character of much poetic composition has indeed been considered by some theorists of poetry to

be problematic; and puzzlement about the generally fictional nature of poetry has been reflected in a preoccupation with the correct characterization of the state of mind of the reader of poetry. Coleridge produced some memorable formulations: 'that willing suspension of disbelief for the moment, which constitutes poetic faith', 'that negative faith ... without either denial or affirmation', 'a sort of temporary half-faith', 'this sort of negative belief'.[7] The fact of the matter is that we possess the capacity to entertain a thought without accepting it, the capacity to make believe, without believing, that some state of affairs obtains, and the capacity to imagine what we do not know to have happened. It is true that there are problems in giving an account of these capacities and in explaining the value of their exercise in the reading of poetry, but the possibly fictional nature of poetry in itself presents no obstacle to its appreciation.

Nevertheless, not all poetry is intended to be understood as fiction and, even for poems where that is the intention, there is a variety of ways in which poetry can present or give expression to beliefs; and these beliefs are either true or false. What significance should be attached to the acceptability, or the unacceptability, of any beliefs that a poem expresses?

SINCERITY AND BELIEF

The issue of the relevance of the truth-value of the beliefs that a poem expresses faces in two directions: towards the poet and towards the reader. As it pertains to the poet, the question is whether the beliefs of the poet and the beliefs expressed in the poem must coincide if the poem is not to be thereby deficient in poetic value. This question may be re-expressed (in the subjective mode) as the question whether a reader's judgement as to whether the poet accepted or believed what her poem expresses is properly relevant to the reader's appreciation of the poem and her opinion of the poem's value. In this sense, the question concerns the poet's sincerity. As the issue pertains specifically to the reader, the question is whether the beliefs expressed in the poem

and the beliefs of the reader must coincide if the reader is to enjoy, to appreciate and to value the poem fully. It is the second question that is usually discussed under the heading 'The Problem of Belief' – a problem that T. S. Eliot came to think is 'quite probably insoluble'.[8] This second question, concerning the match or mismatch between the beliefs expressed in the poem and those of the reader, is an instance of a more general issue: whether there must be a particular relationship, for example admiration or sympathy, between the reader and the various qualities of mind or character or the outlook or attitude or sentiment expressed in the poem, if the reader is not to regard the poem as flawed or defective.

PERSONA AND IMPLIED AUTHOR

Reference to the beliefs or the outlook that a poem expresses must be disambiguated; for it is necessary to distinguish between the imagined speaker of a poem and the poem's implied author, and reference might be to the beliefs or the outlook of the one or the other.[9] Characteristically, a poem has an implicit speaker: the ostensible utterer of the lines of which the poem consists.[10] A poem of this kind has an implied narrator, speaker or thinker who utters the lines. She can be called the poem's persona.[11] But in composing the poem the poet will also create an image of herself as its author. The poem will give the impression of having been written by a person of a certain kind: the reader receives from it a picture of the person who was responsible for the composition. She is the poem's implied author – the implicit or apparent poet. The impression a reader receives from a poem of the kind of person responsible for its composition – the reader's conception of the poem's implied author – is not determined solely by reading the poem itself. It is shaped by many other factors, most importantly by information, or misinformation, about the poem's actual author. In particular, it will in general be sensitive to knowledge of the actual author's intention or purpose in composing the poem. But if there is no apparent sign in the poem itself of its having been composed by a particular kind of person –

no marks that can properly be construed as indicators that the poet (as author of the poem) is of a certain character – then its implied author is not a person of that kind even though its actual author is such a person. In fact, this self-image that the poet creates may reveal much, little or nothing of herself: it may be an accurate, distorted or unfaithful picture of her.[12]

A poem characteristically invites concurrence with the view of life that its imagined speaker, its persona, expresses; it invites sympathy or admiration for, it solicits approval of, the attitude expressed by the persona of the poem. In such cases the philosophy of the persona and the philosophy of the implied author are one. But it is possible to write poetry in such a style that there is a divorce between the beliefs, values and attitudes of the implicit poet and those of the poem's persona, so that the poem does not invite acquiescence in the speaker's beliefs, values and attitudes. The implied author sometimes has an ironical attitude towards her persona: she does not regard her persona altogether uncritically and she does not expect the reader to respond without reservations to the persona's thoughts and feelings. The response that the poem invites does not involve in this sense an identification of the reader's sympathies with the poem's persona. Instead, the poem invites ironical contemplation of the persona. The implicit creator of a poem speaks from a particular standpoint or mouthpiece, but it may be clear from the nature of the poem that the poem is not in fact the product of someone located at that point of view or of such a person, and it may be apparent that the apparent author of the poem does not regard the imagined person whose words compose the lines of the poem with unqualified approval.[13] It may be clear that the poem's persona is the assumed form of a more intelligent person, for instance. For example, Coleridge wrote his early poem 'Pensive, at Eve, on the Hard World I Mused' to excite laughter at *doleful egotism* and at the recurrence of favourite phrases which are trite and also disregard accepted rules of syntax.[14] This intention is implicit or apparent in the poem itself, and it must be understood by the reader if she is properly to appreciate the poem. Of course, the poet's intention may not be realized in her poem

and she may produce a work that encourages readers to take it ironically when this was not her intention.[15] The implied author's attitude to her persona *is* the apparent attitude of the poet to the persona; but although this is often the same as, it can be different from, the poet's actual attitude to the persona. One way in which this can come about is through the poet's failure to express in her poem her own attitude to the persona she has imagined, although this was her intention. A poet's intention is poetically significant only as it is manifestly realized in her poem. (But remember that what is manifest to the reader will depend upon more than her reading the text whilst lacking all information about it.)

The possibility of this kind of irony affects the form that the consideration of the different problems of belief should take. It matters little whether it is pursued in terms of the outlook of the implied author or of the persona when ironical distancing is not present in a poem. But when there is ironical distancing, the consideration must be directed towards the outlook of the implied author of the poem rather than that of its persona. A full identification between the reader and the philosophy of the poem may not be precluded by a disparity between the beliefs and attitudes that are held or expressed by the poem's persona and those of the reader if the beliefs and attitudes of the poem's implied author coincide with the reader's. Likewise, a poet's sincerity is not put in question by a clash between her own outlook and that of the persona of one of her poems, but only by a lack of harmony between her own outlook and that of the implicit poet.

INSINCERITY AND THE POET'S BELIEFS

A poet's insincerity can take many forms. But if her insincerity is not manifest in the poems she writes, it does not affect the value of her poems as poems. T. S. Eliot advanced the view that the suggestion that Lucretius did not believe the cosmology expounded in *On the Nature of Things*, or that Dante did not believe the Aristotelian philosophy that is the material of some cantos of the *Purgatorio*, would necessitate the

condemnation of the poems they wrote. A poet must believe a philosophy or philosophical idea that she embodies in her verse on pain of insincerity; and insincerity would annihilate all poetic values except those of technical accomplishment.[16] But an argument can be valid even though the person who advances it believes that it is not; and a system of beliefs is not rendered false by the fact that it is put forward for our acceptance by someone who rejects it. When Eliot asserts that a poet's insincerity would annihilate all poetic values except those of technical accomplishment, that is at most true for the poet's view of her own work. If she is not concerned that her poem should express an acceptable system of beliefs, and yet she wishes to compose a philosophical poem, her interest will be taken up entirely by the mode of expression into which her poem is to render a given philosophy. It is unclear why it should be thought that a poet's insincerity must affect the response of readers in the same way, and prevent us from attaching different values to poems of equal technical accomplishment. It would be open to us to assess a philosophical poem not solely by its manner of expression but also by the acceptability of the view of the world it expresses. The fact that the poet did not hold the philosophy that her poem expresses does not imply that the philosophy is false, and it does not prevent the poem from being a good poem. It may be true that if we were to believe that a poet did not herself have the deep convictions that her poetry apparently evinces, our reaction would be undermined and we should feel ill at ease. But a poet's insincerity need not result in an unsatisfactory poem, and there is no compelling reason why we should not attempt to insulate our response to the poem from our knowledge of the poet's real beliefs.

It might be objected that if a poem is the creation of a poet who does not believe what the poem expresses, it should be criticized on the ground that it carries itself as though it were the expression of the poet's beliefs when it is not. For if the poet attempts to pass off the poem as the expression of her own beliefs, then she is behaving in a similar fashion to a poet who attempts to pass off a poem she has written as the creation of another (possibly fictitious) poet, who supposedly wrote the

poem at an earlier period and expressed in it the beliefs she then held. And the misrepresentation of the poem's origins misleads readers about the poem's nature and so about the proper approach to the poem. If, on the other hand, the poet is not concerned to pass off the poem as the expression of her own beliefs – about which there may be no secrecy – even so she will be writing against a background where the normal expectation is that a philosophical poem expresses the poet's philosophy. But this objection lacks force. For it counts in no way against the possibility that a non-believer might construct in poetic form a finer expression of a system of beliefs than a believer, and that readers can react to the poem as an expression of those beliefs without being concerned about the lack of fit between the beliefs of the poem and the beliefs of its author.

A poet can also be insincere in a poem that does not express a system of beliefs about the nature of the world. The poem may, for example, deliberately misrepresent her thoughts and feelings about a particular person. But if the poet's insincerity is not detectable in the poem itself, a reader may properly discount it and consider the poem only as the product of an implied author who is sincere in what she professes.[17]

POETIC INSINCERITY

One form of insincerity a poet can practise is the deliberate attempt to produce effects in the reader that do not happen for her: she attempts to kid others. She is not moved by the sentiments that her poem expresses in the manner that she desires her readers to be. This kind of insincerity is closely connected with that involved in the issue Eliot raised about the relation between the philosophical beliefs expressed in a poem and those held by the poem's author. Hence a judgement about a poem's sincerity might be only a certain kind of relational judgement – a judgement about the poet's relation to her product: whether she accepts the system of beliefs her poem expounds, or held the high opinion of a particular person her poem expresses, or is herself moved by the sentiments her poem is calculated to arouse in the reader, and so on.

Such a judgement is about the poet's sincerity only and can be discounted critically. But a more important kind of insincerity, from a literary point of view, is the inability of the poet to be true to her own genuine feelings.[18] She may be unable to distinguish them from those she merely would like to have, so that in her own thoughts she misrepresents her feelings, perhaps out of a desire to avoid acknowledging them, or in an effort to match up to an ideal; or she may be unable to distinguish her real feelings from those she hopes will make a good, or original, or striking poem: she kids herself. This form of insincerity may be apparent in the poetry she writes, with the result that the poem's persona and the poem's implied author are insincere. If the poet identifies herself with the imagined speaker of the poem then the insincerity of the speaker will feed back to the poet. Indeed, a poet's insincerity may be precisely what leads her to write an unironical poem with an insincere persona. But it is the lack of sincerity of the persona that is directly our concern, for a poem with an insincere persona and insincere implied author may emerge – perhaps as an exercise – from a poet who does not identify herself with either. And here it is clear that the poetic merit of much poetry is bound up with the sincerity of the imagined speaker of the poem. It is often a poet's intention to compose a poem which has a persona whose thoughts and feelings are sincere; and if the persona's thoughts and feelings are insincere, the poem is a failure. As T. S. Eliot remarked, most religious verse is bad verse because of a pious insincerity.[19] It is the expression of ideals not truly felt.

The persona's sincerity is especially important in that form of poetry that consists in the representation from the standpoint of the first person of someone's outward verbal expression of her mental condition or the internal counterpart to it; that is to say, in poetry that is the representation of a person expressing her thoughts and feelings in speech or that is the representation of her process of thought and feeling itself: in lyric poetry (in one sense of the term). In fact, there is a well-known problem about the evaluation of lyric poems by reference to their sincerity or lack of sincerity. For the following dilemma can be posed. Either the reference is to the poet's sincerity – to whether she agrees with the

sentiment that the poem expresses – which is a fact that is external to the poem, and so irrelevant to the evaluation of the poem as a poem; or the notion of sincerity can have no application at all, for there is no reality that the lyric 'I' can either be misrepresenting or be representing aright. That is, the imagined person's thought or utterance cannot represent her emotion rightly or wrongly, cannot correspond or fail to correspond to her emotion, for the poem consists only of the representation of her thought or utterance, and this is the only reality that the imagined person, and so her supposed emotion, has: the sincerity of the thought or utterance cannot be ascertained by reference to its correctly representing the subject's emotion because, since the emotion is not otherwise represented, there is no sense to the idea of what the emotion really is, whether it matches or mismatches the thought or utterance. In short: a reference to sincerity in the evaluation of poetry is, from the literary point of view, either irrelevant or inapplicable.

The escape from this dilemma is not hard to find. It lies in a twofold realization: lack of sincerity need not involve a mismatch between a person's thought or utterance and her feeling, and defects in sincerity, or forms of insincerity, can properly be attributed on the basis of the manner in which a person expresses her feeling or the style of her self-communion. In the first place, the dilemma operates with an over-simple concept of sincerity.[20] The expression 'lack of sincerity' actually ranges over a series of cases. At one end are various forms of insincerity – not only the deliberate misrepresentation to others of one's real feelings in order to deceive but also self-deception; and the series moves through the attempt to feel differently from others for the sake of originality, the absence of self-examination to discover what are one's real feelings, the failure or inability to see lucidly and soberly into oneself and self-ignorance that derives from emotional and intellectual immaturity. Lack of (complete) sincerity, or insincerity, is not merely something that can be present in one's profession of feeling; it can infect the feeling itself.[21] Furthermore, the manner in which a person thinks, speaks or writes can be indicative of a lack of sincerity on her part. When we come across certain kinds of thinking, speech or writing in

poetry we therefore properly regard the poem as if it were the work of someone who is insincere in its production. It is part of the imaginative project involved in reading and understanding a lyric poem to form a conception of the poem's persona and implied author, and there are various features the presence of which in the poem may be explained for us by the recognition of what they are signs of: lack of sincerity. The failure by a poem's implied author to achieve complete imaginative integrity can be revealed by such features as the use of inflated language, vague emotive clichés, lack of precision and the manner of the poem's indebtedness to other poetry. The implied author may be posing or striking an attitude; her feeling may be forced, or artificial, or merely superficial, and in these different ways lacking in sincerity. In consequence, the poem is defective. Hence reference to sincerity in the evaluation of poetry can be both relevant and applicable.

A justly celebrated and instructive attempt to rehabilitate the term 'sincerity' for criticism is F. R. Leavis's 'Reality and Sincerity'.[22] A cursory reading might leave the impression that when Leavis claims that in postulating the situation of *Barbara* Alexander Smith is seeking a licence for an emotional debauch, and when he claims that in *Cold in the Earth* Emily Brontë conceives a situation in order to have the satisfaction of a disciplined imaginative exercise – the satisfaction of dramatizing herself in a tragic role, maintaining an attitude, nobly impressive, of sternly controlled passionate desolation – his judgements are essentially, and unacceptably from the poetic or critical point of view, about the poet. But Leavis was vividly aware of the need to provide reasons for his judgements that are internal to the poems, and his judgements are supported by descriptions of the poems, not the poets. *Barbara* is characterized as offering 'a luxurious enjoyment that, to be enjoyed, must be taken for the suffering of an unbearable sorrow', and it may therefore be said to be insincere. Someone who luxuriates in the poem – and this is true also of its imagined speaker in his thoughts – is deceiving herself, for she must be taking herself to be imagining an unbearably painful experience, whereas the experience is really an indulgence in the sweets of sorrow, an emotional or sentimental wallow-

ing, the alleged situation only spuriously an excuse for the indulgence, which in fact is sought for its own sake. And in *Cold in the Earth* the imaginative self-projection is characterized as being insufficiently informed by experience of the imagined situation, as is evident from the paradoxically noble declamation and the accompanying generality, the imagery being in places essentially rhetorical, unable to sustain the claim to strength that it makes.

It is therefore not essential to the validity of this kind of account that, for example, in fact Emily Brontë did not have the experience of the type of situation her poem expresses. She could have experienced in reality the kind of situation she imagines in the poem and yet still have written the same poem. All that is necessary for her poem to be judged to be lacking in sincerity is for the represented thoughts, which purport to be those of someone who has undergone a particular experience, to be judged not to be the thoughts of a deeply sincere person who has suffered that experience and is now being true to it in her thoughts. Hence judgements about the relation of the poem's persona and implied author to the experience that is presented or expressed may properly be made by features internal to the poem, and corresponding judgements about the poet as author of the poem derived from the empathic and uncritical identification of the poet with the implicit speaker of the poem. It is unsurprising that Leavis, having attempted to show that Hardy's *After a Journey* represents a profounder and more complete sincerity than *Cold in the Earth*, that it manifests a rare and subtle form of integrity, with no nobly imaginative self-deception or idealization, explicitly makes the point that it could have been written only by a man who had the experience of a life to remember back through, and that we can be sure from the poem what personal qualities we should have found to admire in Hardy if we could have known him. But even if this last inference should be suspected, it is possible to agree with Leavis's account of the poem.

SENTIMENTALITY

A poem can be judged to be sentimental in a fashion similar to that in

which it can be judged to be insincere. Sentimentality can be understood in a variety of ways, but certain important conceptions of it tie it closely to a form of insincerity. One sense in which a person's emotional response can be said to be sentimental is this: not only is it rewarding for the person to feel the emotion but the existence or continuation of the emotion is motivated by the satisfaction experienced in feeling the emotion, so that in consequence the person is unready to act from the emotion in an appropriate manner.[23] Another variety of sentimentality linked to insincerity involves the wilful neglect of various aspects of the target of the emotion that would necessitate a more complex and less rewarding response; a false intensity of experience is gained by ignoring any features that militate against the simple, one-sided response, which typically idealizes, glamorizes or romanticizes the target, making it tug at the heartstrings.[24] This mismatch between the thought at the core of the emotion and the nature of the emotion's object is often motivated by a desire for a gratifying self-image – a self-image founded on a manufactured emotion.[25] A related sense was identified by D. H. Lawrence:

Sentimentalism is the working off on yourself of feelings you haven't really got. We all *want* to have certain feelings: feelings of love, of passionate sex, of kindliness and so forth. Very few people really feel love, or sex passion, or kindliness, or anything else that goes at all deep. So the mass just fake these feelings inside themselves. Faked feelings! The world is all gummy with them. They are better than real feelings, because you can spit them out when you brush your teeth; and then you can fake them afresh again.[26]

Whether sentimentality is construed in this kind of fashion or whether it is taken to imply merely an excess of sentiment that is not occasioned by unmotivated error, a poem is sentimental if its persona and implied author are sentimental. I. A. Richards maintained that when a poem is said to be sentimental either in a 'qualitative' sense ('crude') or in a 'quantitative' sense ('too great for the occasion'), there are two possible locations for the sentimentality. When we call a poem sentimental in the quantitative sense we mean, Richards claims, either (i) that the poem

was produced by someone who was too easily stirred to emotion – the author was sentimental – or (ii) that we would be too easily moved if we responded highly emotionally to the poem – we would be sentimental.[27] But if, when we say that a poem is sentimental, we mean to assert the first alternative, we are making an inference from the nature of the poem to the character of the poet herself, and this inference may not only be ill-founded but turns us from a consideration of the poem to a concern for the poem's author. We may instead mean that the poem's persona and its *implied* author are sentimental. Our concern remains bound up with the nature of the poem itself, and it continues to be critical rather than biographical.

A poem is open to all the criticisms that an attitude or emotion is open to, and it can possess the same virtues. A defect or virtue in an attitude or emotion expressed by a poem is a defect or virtue in the poem and adversely or beneficially affects the value of the experience the poem offers. Insincerity and sentimentality are just two of many defects that consciousness is liable to, but they provide a model for the ascription to poetry of other such defects and for the aesthetic relevance of their presence in a poem. Unless a poem's implied author is distanced from the poem's persona, any inadequacy or corruption of the persona's consciousness is a defect in the poem. For the poem endorses a response from the reader – a sympathetic response to the persona's sentiments and thoughts – that it does not merit.

THE PROBLEM OF BELIEF

What is the relevance of the adequacy or inadequacy of a poem's beliefs – beliefs it invites the reader to accept – to its value as a poem, and so to its appreciation by a reader who accepts or rejects these beliefs? At one extreme, there is the view that any mistaken beliefs in a poem are faults in the poem: in so far as the poem's beliefs are defective, so too is the poem. At the other extreme, there is the view that the acceptability or unacceptability of the beliefs advanced in a poem is irrelevant to its merit as a poem: what matters from the critical point of view is not what a poem's beliefs are, but how they are expressed. In the middle, there is

the view that not all unacceptable beliefs, but only those of a certain kind, affect the value of poems that put them forward.

In his essay on Dante, T. S. Eliot tentatively embraced the second position (or a near relative of it): to understand and appreciate the poetry of *The Divine Comedy* it is not necessary to believe what Dante, as poet, believed;[28] and in general it is not necessary for the reader to share the beliefs of the poet in order to enjoy the poetry fully.[29] Rather, the reader should suspend both belief and disbelief in the philosophical and theological views a poem expresses.[30] Eliot is clearly right about Dante: it is no more necessary to believe in the reality of Dante's journey in order to appreciate his poem than it is necessary to believe in the body of doctrine his poem presents, and is designed to render attractive, in order to understand and enjoy the poem. It is possible to enter imaginatively into the world of thirteenth-century Catholicism even if we reject, and find unsympathetic, its interpretation of the world and humanity's place in it.

When he returned to the issue, in an essay on Shelley and Keats, Eliot came to favour the third position.[31] Where the poets are such as Dante and Lucretius, he remained faithful to his previous view that it is not necessary to accept the philosophy of the poet in order to enjoy the poetry: one can share the essential beliefs of Dante and yet enjoy Lucretius to the full. But his dislike of some of Shelley's views hampers his enjoyment of the poems in which they occur; and others seem to him so puerile that he cannot in any way enjoy the poems that give expression to them. Eliot suggests that it is not the presentation of beliefs he does not hold or those that excite his abhorrence that creates the difficulty for him. Instead, he makes the following claim:

When the doctrine, theory, belief, or 'view of life' presented in a poem is one which the mind of the reader can accept as coherent, mature, and founded on the facts of experience, it interposes no obstacle to the reader's enjoyment, whether it be one that he accept or deny, approve or deprecate. When it is one which the reader rejects as childish or feeble, it may, for a reader of well-developed mind, set up an almost complete check.

He is inclined to think that the reason why he was intoxicated by Shelley's poetry at the age of fifteen, and now finds it almost unreadable, is not so much that at that age he accepted Shelley's ideas, and has since come to reject them, as that at that age 'the question of belief or disbelief', in I. A. Richards's phrase, did not arise in reading the poetry. The young Eliot was in a much better position to read Shelley with enjoyment not because he was then under an illusion which experience has dissipated, but because the question of belief or disbelief did not present itself to him. Eliot quotes this passage from Richards with approval:

Coleridge, when he remarked that 'a willing suspension of disbelief' accompanied much poetry, was noting an important fact, but not in the quite happiest terms, for we are neither aware of a disbelief nor voluntarily suspending it in these cases. It is better to say that the question of belief and disbelief, in the intellectual sense, never arises when we are reading well. If unfortunately it does arise ... we have for the moment ceased to be reading and have become astronomers, or theologians, or moralists, persons engaged in quite a different type of activity.

In sum: Eliot represents himself as no longer being capable of reading Shelley well and deriving enjoyment from his poetry, for the question of belief and disbelief does now arise ineluctably. And, he maintains, the reason for his disability is that he regards the doctrines or view of life presented in much of Shelley's poetry as childish or feeble, rather than coherent, mature and founded on the facts of experience.

Eliot's position is unsatisfactory, however,[32] because (if for no other reason) there is a crucial lack of clarity in the idea of a view of life being founded on the facts of experience. Are the poems of Lucretius and Dante supposed nowhere to be founded on anything that is not a fact of experience and not to be inconsistent with any facts of experience – in which case they could not present opposed philosophies; or are they supposed to be founded upon certain specially important facts, their inconsistency with other facts being of no poetic importance? Since Eliot fails to answer this question, his position is either incoherent or incomplete.[33]

But in fact the question to which Eliot addresses himself – whether it is possible to enjoy fully a poem that expresses a philosophy one does not accept – does not identify the real or most important issue from the critical point of view. It is necessary, first of all, to put aside the matter of the intensity of a person's enjoyment of a poem. Intensity of enjoyment is not denied necessarily to someone who rejects, or is unconvinced of, the philosophy a poem expresses. In principle, a reader can derive as much enjoyment from a poem that advances a philosophy she denies or about which she is agnostic as can a reader who accepts the philosophy, whether or not the believer's enjoyment is in part founded upon the poem's expressing a philosophy she considers to be true. But there is a kind of enjoyment open to the believer from which the unbeliever is debarred. A person who embraces the philosophy the poem presents can enjoy the poem not only on account of the fineness of its expression, but also on account of the poem's expressing what she takes to be the truth about the world. It is therefore the nature rather than the intensity of the enjoyment available to the believer that is different from that available to the unbeliever. So if we wish to consider the problem of belief, as Eliot understands it, we should discount that aspect of the enjoyment founded upon agreement between the beliefs of the poem and those of the reader, and consider only that aspect of a believer's enjoyment not founded in possession of a common philosophy.

Secondly, the question whether a person can fully enjoy a poem that expresses opinions not in accordance with her own is a psychological question and it can receive only a personal or statistical answer. The ability to disconnect one's response to a poem from one's attitude to the beliefs it expresses varies from person to person and belief to belief. Different people have unequal capacities to derive pleasure from the imaginative experience of a philosophy they do not embrace, and the ease with which any particular person can manage this will be dependent on the nature of the specific philosophy in question. The problem of belief, as Eliot construes it, is therefore not of immediate relevance to the question what should be the appropriate attitude of a reader to a poem that expresses a philosophy she does not consider to be true, that

perhaps she rejects. The question whether a reader's rejection of the philosophy a poem presents should affect adversely her estimate of the poem's value – or whether the falsity of the philosophy a poem expresses is a defect in the poem – must not be run together with a question about a reader's ability to enjoy poems that present a philosophy to which she does not adhere. The first question falls within the theory of poetry, the other is proper to psychology. It is clear that the rejection of the philosophy embodied in a poem is not always and to everyone an insuperable barrier to experiencing the poem with enjoyment. It can in a particular case prevent or distract from enjoyment. But even if no diminution of enjoyment is experienced by an unbeliever when she reads a poem, the question remains whether her estimate of the value of the experience may properly be qualified by virtue of her rejection of the philosophy the poem embodies. Eliot, in his concern with enjoyment, does not engage with the question of the value of the enjoyment derived from Shelley's poetry by the not as yet well-developed mind of the fifteen-year-old Eliot, which enjoyment is unavailable to him as an adult. He therefore leaves untouched the question of the value of Shelley's poetry. But what is supposed to be the value of the enjoyment of the imaginative experience of the expression of a childish or feeble view of life, in which experience the question of belief or disbelief does not arise? Eliot gives the impression that it is a valuable experience, but one from which unfortunately he is debarred when grown up since the question of belief or disbelief will arise irresistibly for someone of mature mind. But this is not made out. In like fashion, even if it is possible for a mature person to enjoy a poem that expresses a view of life she deprecates as long as the view is not childish or feeble, it is a separate matter whether a mature reader may or properly should fault the poem and qualify the value she assigns to her experience of it in virtue of the poem's expressing a view which is unacceptable to her.[34]

LUCRETIUS

The truth of the matter is that Lucretius's *On the Nature of Things* is

significantly different from most poems, and the particular nature of the poem invites special considerations. It is a doctrinal or didactic poem in the specific sense that it is explicitly concerned to expound, enforce and render attractive a philosophical, cosmological and physical system of beliefs: the Epicurean account of the nature of the universe, the origin of the world and the various forms of life that inhabit it, the physical laws that govern matter, and the nature of the gods and their relevance to human life. The poem is in fact essentially a series of assertions and arguments: it consists in the main of a set of theses with supporting reasons. Furthermore, the ultimate object of the poem is to encourage the eradication of unnecessary fears – especially of the gods and death – through understanding the true nature of reality. In consequence, the poem, despite its imaginative grandeur, is defective or unsatisfactory wherever the arguments it presents are fallacious or inconclusive. Lucretius's Epicurean arguments for the finite divisibility of matter (for the existence of indivisible and indestructible atoms), for the finite extent of space, for the precise physical nature and bodily location of the mind, and for the irrationality of being concerned about the fact that we will die, are merely a few of the arguments that the discerning reader will properly fault and regard as blemishes on the poem.

It is perhaps possible to read *On the Nature of Things* without considering whether any of its arguments are compelling or whether the propositions it advances are true; that is to say, without the thought ever crossing one's mind whether any argument is valid or invalid or a certain thesis is tenable or untenable. But the value of reading the poem in such a manner is questionable, and the view that it is the only proper way to read the poem as a work of literature has no adequate foundation.

Perhaps it is also possible to read *On the Nature of Things* by making believe that one is a convinced or incipient Epicurean, and so making believe that the arguments it contains are always valid and the propositions it advances are true. Such an activity would be less pointless, for it would enable us imaginatively to appropriate the experience of an adherent to the Epicurean philosophy. But it does not follow from this

possibility that inadequacies in the account of the universe the poem presents are irrelevant to the poem's value as a poem.

It is true that our response to *On the Nature of Things* is affected by the fact that it would not have been unreasonable for an intelligent and cultured person of Lucretius's time and circumstances to accept the philosophy that the poem presents. Furthermore, the qualities of mind that the poem displays are of the highest order. Our rejection of the philosophy is compatible with unqualified admiration for the poem's author, and the greatness of Lucretius's accomplishment is secure. But our admiration for the poet is consistent with the opinion that the value of his creation, the poem, is lessened by the inadequacy of the system of beliefs it expounds, to the extent that it is inadequate.[35]

TWO CONSIDERATIONS

Underlying the view that agreement with the philosophy expressed by a poem is properly irrelevant to a judgement of its worth as a poem, and so to the poetic enjoyment of it – since the adequacy of the philosophy is irrelevant to the poem's value as a poem – are two related considerations. The first claims that only what is distinctive of poetry, and not what is in common with (unpoetic) prose, can determine the poetic worth of a poem. The second claims that two poems might make equally meritorious use of any distinctive or prominent features of poetry – such characteristics as versification and figurative uses of language – and if so would be equally fine poems, because *as poetry* they are equally distinguished.

The first consideration, if it is understood as the claim that any features that can be possessed by both poetry and prose should be discounted in assessing the poetic value of a poem, undoubtedly secures the desired consequence that the nature, and so the truth, of a thought poetically expressed is irrelevant to the poetic worth of the poem. For prose and poetry share the capacity to express thoughts. But construed in this fashion the first consideration has the undesired and unacceptable consequence that not even the fact that the words of a poem are

concatenated in such a manner as to form meaningful sequences is relevant to poetic merit. Indeed, there would appear to be nothing of substance in which poetic merit could reside.

If, alternatively, the first consideration is understood as the claim that any features that can be common to prose and poetry are insufficient to make something a fine poem, then it fails to secure the desired consequence, for it leaves open the possibility that the falsity of a thesis advanced by a poem is a defect in the poem.

The second consideration is based on the assumption that the meritorious use of distinctive or prominent features of poetry is the sole determinant of poetic merit, and so the sole proper object of poetic enjoyment. This assumption is encouraged by the thought that a composition that is better poetry, or better as poetry, than another poem is thereby a better poem. But this is false encouragement. One person might express her thoughts on a certain subject in better prose than does another person and yet the second person might write the better essay. If the thoughts of the first are untenable, the merits of their presentation are not enough fully to redeem the work. A work that is composed in better prose is not thereby the better composition (in prose) – the better essay, the better story. There is a sense of 'better poetry' in which it refers to a judgement about only certain features of a poem. Just as one prose composition can be written in a clumsy style, lack economy and elegance and be in those respects inferior to another composition – which is therefore said to be written in better prose – so one poem can use language in a less felicitous manner than another poem and the superiority of the second work marked by calling it better poetry. But in each case our judgement overall may be that the less well-written work is the better work of literature – the better story, the better poem.

It is certainly true that a poet with a philosophy of life that we reject may present this view for our acceptance by making better use of any other features that are relevant to poetic merit than does another poet whose philosophy we find sympathetic. We may choose to put this by saying that the first poet writes better poetry than the second, just as she might express her objectionable view in better prose, and just as

Schopenhauer better expresses an unacceptable philosophy than many capable of correctly criticizing it. And this poetry might have such advantages as to outweigh the true but uninspired poem. But there remains the question whether the mistaken philosophy is a defect in the poem, as a silly thesis would flaw a song no matter how beautiful the melody is to which the words are set. It is, in itself, a matter of indifference how this defect is characterized. If the view of life is not said to detract from the poetic merit of the poem, or from the value of the poem *as a poem*, there will still be the question whether it renders it a less valuable work of literature, and whether the unacceptability of the philosophy is properly held against the poem, as a deserved lack of interest in what a poem says is held against it. T. S. Eliot wrote of Akenside that he 'never says anything worth saying, but what is not worth saying he says well'.[36] A poet who has nothing worth saying may in one sense write better poetry than another who does have something interesting to say, but what she writes may be a poem of less value. If poetic merit is tied only to what are sometimes called 'purely literary values', then our interest should undergo a change of focus. There is no reason for our interest, in our experience of poetry, to be concentrated solely upon 'purely literary values', good writing for its own sake; for that has minimal value unless in conjunction with something worth saying.

DOCTRINAL AND NON-DOCTRINAL POEMS

The doctrinal nature of Lucretius's *On the Nature of Things* is shared by few poems. Many poems do not advance any arguments or theses that the reader is invited to accept. But the weakness created in a poem that presents a world-view by inadequate arguments in support of that view arises equally in all poems that contain arguments the function of which is to establish a thesis the poem invites us to accept. Furthermore, it is not merely that unsatisfactory arguments make a poem that proposes a thesis to that extent unsatisfactory. If a poem maintains a thesis that is unacceptable, the poem is flawed even if it does not present inadequate arguments in support of the thesis.

It might be thought that the fact that arguments occur *in* a work means that their validity matters to the success of the work; but since truth is correspondence with something outside the work, the truth or falsity of the beliefs expressed in a poem is irrelevant. But this reasoning is doubly flawed (leaving the idea of truth as correspondence aside). In the first place, the beliefs are in the work in the same sense as the arguments are: the question is whether a certain property of the items – the truth-value of the beliefs, the validity of the arguments – is relevant to the work's poetic value. Secondly, the train of thought presupposes that nothing 'outside' a work – no relation in which it stands to anything else – can be relevant to the artistic value of the work; and, as I have argued in the case of pictures, this is mistaken.

The problem of belief, as considered so far, is only a minor issue in the theory of poetry. For there are many kinds of poetry, and openly didactic poems form a relatively small class. The scope of the issue has indeed been widened to include not only doctrinal poems of the order of Lucretius's *On the Nature of Things* but also such a poem as Johnson's *The Vanity of Human Wishes*, written in the mode of general statement and illustration. Most poems, however, fall outside the circle of those that in this sense lay a claim upon the reader's belief. Nevertheless, many poems have personae or implied authors whose philosophies of life may in various ways be unacceptable to a particular reader; and even if the intention of a poem is not to advance a thesis that the reader is asked to accept, but instead to give expression to some aspect of life as seen or experienced from a certain point of view, or to render dramatically the experience of a person of a given persuasion in a specific circumstance, there arises a question as to the relevance of the reader's closeness to or distance from this point of view to her evaluation of the poem. This question cannot be answered as it stands, or in the abstract, for how much that is distinctive of the point of view actually is expressed in the poem, its significance within the poem, and the extent to which the reader shares beliefs or values with the persona or with what is expressed of the alien philosophy will vary from poem to poem. The problem presented to the non-Christian by Nashe's 'Adieu, Farewell

Earth's Bliss', Ralegh's *The Passionate Man's Pilgrimage*, Donne's 'At the Round Earth's Imagin'd Corners' and Hopkins's *The Blessed Virgin Compared to the Air We Breathe* is in each case different. But whilst it is indisputable that a non-Christian can assume the Christian standpoint imaginatively and that Christian belief is inessential to the full and perfect imaginative realization of any one of these poems, this does not settle the question whether the non-Christian's interest in Hopkins's poem, for example, and her estimate of the value of the experience it offers may properly be qualified precisely by her non-Christian point of view. If this is a non-Christian's attitude to Hopkins's poem, must she be failing to consider it solely as a poem, or from the point of view of literature, and applying to it inappropriate, because non-artistic, standards? Is she concerned with its value not as a work of art but as something else?

There is no reason to accept this conclusion. The objection that the non-Christian who values poetry less highly when it gives expression to Christian attitudes or beliefs she does not share cannot be concerned with a poem's value as a work of art (or as a poem) lapses unless there is a concept of valuing something as a work of art that is sufficiently precise to deliver a verdict on the issue whether the non-Christian's valuation, grounded as it is, can properly be said to evaluate a poem as a work of art. The objection fails unless there is a necessary condition of a person's valuing something as a work of art that the non-Christian cannot satisfy. Now it is clear that the non-Christian who allows her verdict on a poem's value to be adversely affected by the falsity of the Christian point of view expressed in it need not be considering poems from some point of view other than their value as poems. For she may instead be concerned with the intrinsic value of the experience of a poem, and her view may be that the intrinsic value of an imaginative experience can be adversely affected by the unreality or the unacceptability of the outlook it expresses. The reason she has to regret that much distinguished poetry – despite its manifest sincerity – is the expression of religious views of life that do not by her lights correspond to the true nature of reality may derive from her estimate of the poems' value as poems.

But there is a further question. Given that the non-Christian's evaluation

can properly be said to evaluate a poem as a poem, is the evaluation right or wrong? It is easy to conceive of other positions about the relevance of the unreality of the view of the world that a poem expresses to its value as a poem. For example, it might be thought that if the sentiments expressed in a poem are fine *given* the world-view it embraces, then if the world-view was faultlessly believed by the poet, the falsity of that world-view does not import a fault into the poem *considered as art*. But there do not appear to be compelling arguments for this or any alternative position. According to the account of artistic value I have outlined, the question turns on the notion of the intrinsic value of experiences. If there are no constraints on the proper assessment of the intrinsic value of experiences, then of course the non-Christian's position cannot be mistaken. But if there are such constraints, the non-Christian does not seem to flout them. Consequently, I do not believe that the critical non-Christian can properly be said to be mistaken – even though her attitude must lead her to fault *The Divine Comedy*. On the other hand, there do not appear to be constraints that make it mandatory to assess the intrinsic value of the imaginative experience that a poem offers by reference to the unreality or unacceptability of the view of the world to which it gives expression. And if this is so, the non-Christian's manner of evaluation, although faultless, cannot be deemed correct.

MORALITY

I have focused the problem of belief on the relevance of beliefs about the nature of the world that are put forward in a poem for the reader to accept. Understood like this, the problem is greatly restricted, for in many poems no false beliefs about the nature of the world are advanced. But the issue is often understood (as it was by Eliot) to include the relevance of any moral beliefs or more personal values or attitudes to life expressed and endorsed in a poem, and this gives it a vastly wider scope, since nearly any poem expresses an attitude, feeling, emotion or value judgement. A poem's moral outlook or attitude to life is not so much true or false, but profound or superficial, balanced or one-sided, good, bad or evil. It is important to acknowledge that we can respect

and even approve of a view of life without being disposed to act in accordance with it: we can admire a view of life we do not embrace; there are differences of temperament and feeling that we tolerate, regard without disapproval, and even welcome. The question, therefore, is whether the reader's valuation (not her acceptance) of a poem's view of life is an integral part of the valuation of the poem as a whole; and, in particular, whether the reader's negative attitude to the moral outlook implicit in a poem should influence adversely her judgement of the poem's value.

The extravagant denial by adherents of the slogan 'art for art's sake' of the relevance of a work's morality merits no more than Henry James's magisterial dismissal:

To deny ... the importance of the moral quality of a work of art strikes us as, in two words, very childish ... to count out the moral element in one's appreciation of an artistic total is exactly as sane as it would be (if the total were a poem) to eliminate all the words in three syllables, or to consider only such portions of it as had been written by candlelight.[37]

But there is a less extreme position. Putting doctrinal poems aside, it might be claimed that a poem presents some aspect of reality as viewed and valued by a human being and should be considered as a *dramatization* of a particular situation. It might then be thought that since we can be moved by the fate of characters in a play who do not necessarily command our moral approval, as long as they are credible human beings, what matters about a poem is not that its moral outlook should correspond to an acceptable moral code, but that the point of view the poem expresses should be coherent with human nature. This is how Cleanth Brooks attempts to escape the problem of (moral) belief.[38] But what this overlooks is the distinction between a poem's persona and the implied author. The outlook of a poem's persona is in a comparable position to that of a character in a play; but the outlook of the poem must be compared with that of the play itself. A poem solicits the reader's approval of or respect for the outlook expressed by the implied author, and in so far as this is not forthcoming the reader has good reason to withhold admiration from, or qualify admiration for, the work.[39]

TRAGEDY AND CATHARSIS

The classic problem about a spectator's response to a play concerns the value of the experience of tragic art. This problem has been conceived in different ways. One conception of it derives from a feature of Aristotle's characterization of tragedy, and represents the nature of the response as being paradoxical. Aristotle identified two specific emotions, each defined as being essentially painful, as the distinctively tragic ones – pity (at the sorrow of others) and, inseparable from it, fear (for someone like ourselves) – and he claimed that the tragic pleasure derives from pity and fear by means of mimesis ('imitation'),[40] believing that by arousing pity and fear tragedy achieves an alleviation, purification or clarification (*katharsis*) of pitiful and fearful emotional responses.[41] But if the distinctively tragic emotions are essentially *painful*, how can they constitute or form the basis of the distinctive *pleasure* of tragedy?

Was Aristotle right to identify the proper function or specific effect of tragedy as that of producing a *katharsis* of the emotions (of pity and fear) and what is supposed to be the connection between this idea and the idea that the distinctive pleasure of tragedy comes from the tragic emotions?

The pathological theory of the effect of tragedy[42] construes *katharsis* as purgation and represents tragedy as affording a pleasurable relief of its distinctive emotions by means of a previous excitation of them: the spectator experiences a pleasurable calm after undergoing a powerful experience of the tragic emotions of pity and fear; the emotions are tranquillized after and because of a painful excitement of them. But this interpretation of Aristotle's thought certainly diminishes it, depriving the experience of tragedy of a rationale for anyone who does not have a morbid tendency to experience these emotions to excess: if you do not suffer from a liability to experience pity and fear too frequently and to an excessive degree, you do not need to be cured by having these emotions purged homoeopathically.[43] By locating the benefit of *katharsis* in its after-effects, this interpretation is defective in two closely related ways. In the first place, it assigns only an instrumental, not an intrinsic,

value to the experience of tragedy. Secondly, it fails to locate a distinctive pleasure *in* the experience of the tragic emotions: the pleasure it identifies is pleasure in the freedom *from* the (overcharged) emotions of pity and fear.

A different interpretation of Aristotle's thought understands *katharsis* to be the refinement or purification of the tragic emotions: the experience of tragedy involves the removal of the painful element in these emotions as they are experienced when they are responses to actual, not represented events. This removal is effected by the disengagement of the emotions from that concern for the self in which they are founded. For Aristotle, both pity and fear are forms of pain, and a susceptibility to pity presupposes a susceptibility to fear – to fear for ourselves. The fear aroused by tragedy is directed at the fate of a fictional character[44] – an imperfect and vulnerable character, like ourselves, but one who falls from a great height and suffers more than she deserves – with whom the spectator sympathetically identifies; and in virtue of being fear for another, who is only fictionally threatened with disaster, the emotion loses its painful aspect, as does tragic pity. Furthermore, the fact that the spectator's identification is with the fate of an *exceptional* human being means that the spectator experiences a sympathetic ecstasy in feeling at one with the tragic hero or heroine, and so experiences not merely a pain-free state but the pleasure distinctive of tragedy.[45]

But this interpretation, although perhaps marginally more plausible than the pathological theory of the tragic effect, suffers from three principal weaknesses. The first is its implausible construal of the removal of pain from the tragic emotions as a purification of them: even if *katharsis* should be understood as purification, the fact that pity for real suffering and fear for actual danger are painful conditions (according to Aristotle) does not constitute an impurity in them. Pity and fear are not impregnated with an impure element that ideally should be filtered out. The second is its attempt to explain the removal of pain from the experience of pity and fear when these emotions are responses to the fates of characters in tragedies. This explanation makes use of two features of the spectator's experience of tragedy: the fact that the emotion felt is pity or fear for another and the fact

that the spectator is witnessing not real but only represented suffering and danger. But neither feature can explain the pain-free condition of the spectator. Fear and pity can be experienced for another in real life and are then forms of pain; and if the spectator's realization that she is not witnessing real catastrophe does not prevent her responding with pity and fear, why should it nullify their normal hedonic charge? The third weakness is the idea that through imaginative identification with the fate of an exceptional but unlucky individual (as represented in the drama) the spectator's experience of pity and fear is transformed into pleasure. But this transformation has not been rendered perspicuous. Why should the exceptional nature of the tragic protagonist make sympathetic identification with her a pleasurable rather than an especially painful experience?

HUME'S TRAGIC EMOTIONS

The principal attempt to explain the supposedly pleasurable nature of the experience of normally painful emotions in the appreciation of tragic drama is David Hume's essay 'Of Tragedy', which opens with these remarks:

It seems an unaccountable pleasure, which the spectators of a well-written tragedy receive from sorrow, terror, anxiety, and other passions, that are in themselves disagreeable and uneasy. The more they are touched and affected, the more are they delighted with the spectacle ... The whole art of the poet is employed, in rouzing and supporting the compassion and indignation, the anxiety and resentment of his audience. They are pleased in proportion as they are afflicted, and never are so happy as when they employ tears, sobs, and cries, to give vent to their sorrow, and relieve their heart, swoln with the tenderest sympathy and compassion.[46]

Hume attempts to explain this apparently problematic pleasure[47] – an intense pleasure, unqualified by pain, but one that retains all the features and outward symptoms of distress and sorrow – by appeal to a principle that, he claims, governs the interaction of concurrent emotions. This principle maintains that if someone experiences two emotions at

the same time, one of them being positive (intrinsically pleasurable) and the other negative (intrinsically unpleasant), then if one emotion is stronger than the other not only will it efface the hedonic sign of the weaker emotion but it will capture that emotion's strength and thus magnify its own. The result of such an interaction is an unusually powerful emotional state with a uniform hedonic tone. According to Hume, there are two emotions involved in the aesthetic experience of a well-written tragedy: the emotion caused by the *manner* of representation and the emotion caused by *what* is represented. These emotions are opposites: the one is pleasurable, the other unpleasurable. The satisfaction derived from the manner of representation – the beauty of language, the selection and arrangement of incidents, and the fact and manner of imitation of human life – is much stronger than the disagreeableness and uneasiness the spectator feels when she experiences grief, sorrow, pity, terror, indignation, or other negative emotions at the events represented in the play. So the emotion aroused by the manner of representation is the *predominant* emotion; by its greater strength it appropriates the passion of the *subordinate* emotions aroused by the tragic incidents of the play and converts it into pleasure; and so the delight experienced by the spectator is magnified – it is given greater force by harnessing to itself the strength of the subordinate emotions it has transformed. So a pleasurable tragic imitation 'softens' a negative emotion '*by an infusion of a new feeling*' (of pleasure), 'not merely by weakening or diminishing' the negative emotion.[48]

But Hume's solution to the problem he addresses lacks plausibility.[49] In the first place, the principle Hume appeals to is an ill-founded speculation,[50] and it has the unfortunate implication that it is not possible to experience concurrently a positive and a negative emotion of unequal strength, where the stronger emotion does not efface, overpower and convert the weaker emotion. Secondly, it is mistaken to represent the spectator of a well-written tragedy as deriving pleasure in the manner of representation of the tragic incidents of a play, independently of the power of the tragedy to arouse negative emotions. Thirdly, even if there were such an independent pleasure, there is no reason to believe

that it would standardly be of greater intensity than the negative emotions experienced by the spectator, which in fact vary in intensity from spectator to spectator, occasion to occasion and work to work. (Is the strength of the horror and outrage you experience when you witness Gloucester's blinding, or the strength of the sympathy and compassion you experience when Lear enters with Cordelia's dead body, less than the strength of the aesthetic delight occasioned by the manner in which the play represents its unfortunate subject-matter?) Hence there is no reason to acquiesce in Hume's idea that there is a process of transformation at work in the experience of a well-written tragedy, whereby the allegedly predominant emotion of delight swallows up any negative emotions, yielding an especially powerful pleasure. His doctrine of the conversion of the 'movements' of one emotion into those of another is only a piece of vague a priori speculation, introduced to underpin his account of the tragic spectator's problematic experience of negative emotions, which is claimed to be both painless and highly pleasurable.

But it would be mistaken to attempt to replace Hume's solution to the problem he tries to resolve by a more adequate account, for his conception of the problem presented by the tragic spectator's emotional response is wrong-headed. Hume attempts to explain the intense and unqualifiedly pleasurable experience of a spectator of a well-written tragedy who responds to the tragic nature of the incidents represented in the play with negative emotions. But this conception suffers from two related defects. First, it limits the problem to the experience of spectators who are not pained by the represented suffering and misfortune of the tragedy's sympathetic characters. Second, it applies only to spectators who undergo negative emotions without in any way suffering, which seems impossible if unpleasantness is intrinsic to the experience of these emotions and these emotions are experienced in a full-blooded form in response to what is represented. For Hume, what I have called a negative emotion is one that is such that if it is the *only* emotion experienced by someone on a certain occasion, then necessarily it is experienced as unpleasant. This is what Hume means by saying that such an emotion is *in itself* 'disagreeable and uneasy'. Now it is possible

to question whether every emotion cited by Hume as being in itself unpleasant and aroused in the breast of a delighted spectator of a well-written tragedy is really a negative emotion. Is it intrinsic to the isolated experience of grief, sorrow, terror, anxiety, resentment, compassion and indignation that it is, in Hume's language, 'uneasy'? But I shall not pursue this tack. For in so far as any emotion is not a negative emotion (in the sense that unpleasantness is intrinsic to it) there is no apparent difficulty in the idea that it should be experienced with pleasure when aroused by the tragic incidents in a play. In any case, it is plausible that some, if not all, of the emotions Hume mentions *are* in themselves disagreeable, and all that Hume needs for his problem is that at least one of these emotions is a negative emotion and is sometimes experienced by spectators of a well-written tragedy. But the concession that negative emotions *are* aroused in the tragic spectator's breast serves only to highlight the difficulty for Hume's conception of the problem. For if it is intrinsic to the experience of an emotion when suffered in isolation that it is disagreeable, a natural explanation of this fact is that it is intrinsic to the *concept* of that kind of emotion that it is undergone with some degree of pain or unease. But that would make it *impossible* for Hume's tragic spectator to undergo such an emotion without in any way suffering, unless the emotion were to be experienced in some suitably watered-down form, involving only the bodily sensations characteristic of the emotion, for example. And if the spectator is not to be credited with only a diminished form of the emotion, lacking its constitutive hedonic quality – if the spectator is allowed to undergo the emotion in its full-blooded form – it is necessary to reformulate the problem of tragedy and to reject Hume's conception of the problem. In particular, the problem should not be restricted to the experience of spectators who are not pained by the represented suffering and misfortune of the play's tragic characters, but should cover the experience of spectators who find scenes in the tragedy distressing or the entire play disquieting or harrowing.

There are two obvious ways in which the problem might be reformulated. Both of these reformulations deviate from Hume's understanding

of the issue, one more radically than the other. First, it might be suggested that the problem is to account for the fact that a spectator of a tragedy can respond with a negative emotion (which is experienced as 'disagreeable and uneasy') and *at the same time* derive pleasure from the arousal of the emotion. Second, it might be suggested that the problem is that of explaining why it is that spectators find it intrinsically valuable to undergo an experience which involves the arousal of negative emotions, that is to say, what they find rewarding in the experience. Now each reformulation of the problem deprives the phenomenon to be explained of the apparently paradoxical quality assigned to it by Hume. For whereas there seems to be an inherent difficulty in the idea that someone should experience a negative emotion as pleasurable and in no respect disagreeable, there is no inherent difficulty in the idea that someone should derive pleasure from her experience of a negative emotion or should find intrinsically valuable an experience that involves her undergoing a negative emotion. All that is required is, in the first case, an indication of the nature of the pleasure supplied by the experience of a negative emotion and, in the second case, an indication of the reason for which the person finds the experience intrinsically valuable; and it does not even appear to be problematic to suppose that explanations of the required kinds are available.

PAIN, PLEASURE AND VALUE

Both the purification interpretation of *katharsis* and Hume's conversion doctrine claim to identify the philosophers' stone that transmutes painful into pleasurable emotions in the experience of tragedy. They are versions of what can be called the No Pain solution to the problem of the nature and value of tragic experience. Theories of the purification or conversion kind accept that the emotions aroused by tragic drama must be painful when they are responses to the witnessing of real tragedy, rather than an artistic representation of tragedy, but represent the experience of tragic art as being entirely free from pain – indeed, as being highly pleasurable. The denial of the assumption common to

these theories – that the experience of 'negative' emotions in witnessing real events is essentially painful – would allow a different No Pain solution, according to which there is not even an apparent paradox in the idea that spectators can experience pity and fear with painless delight.[51] But although this would dissipate the so-called paradox of tragedy, for there would be no question of explaining how it is possible for normally distressing emotions to be experienced painlessly (and not just painlessly but with great pleasure), it would leave two issues untouched – issues that correspond to the two suggested reformulations of Hume's problem.[52] The first is what (respectable) source of pleasure there might be in the experience of negative emotions directed at fictional characters if, as seems often to be the case, these emotions are welcomed even when or if they are painful. The second is the high value assigned to tragic art and the reasons for which we value the experience it offers.[53] There are two other kinds of solution to the problem of the nature and value of tragic experience, the Pain–Pleasure and the No Pleasure solutions, each of which accuses the purificatory and Humean theories of distorting the experience of tragedy by representing it as lacking a painful aspect, the former being primarily addressed to the first issue, the latter to the second.

A theory of the Pain–Pleasure kind maintains that the spectator who responds with a sympathetic emotion (such as pity or fear) to the plight of the tragic protagonist undergoes a painful experience, but one that has compensating pleasures concurrent with the painful emotions. Accordingly, it construes the experience of tragic emotions as complex, consisting of a negative affect directed at the represented calamity and a positive affect that redeems the experience. The tragic emotion, in Santayana's words, 'must . . . be complex; it must contain an element of pain overbalanced by an element of pleasure . . .'.[54] There are two kinds of candidate for this second component: the redeeming pleasure could be one that is merely concurrent with the negative emotions, or it could be one that is essentially related to them – indeed, a pleasure *in* experiencing them. Delight in the medium of presentation of the calamity would be a pleasure of the first kind:

The agreeableness of the presentation is thus mixed with the horror of the thing; and the result is that while we are saddened by the truth [e.g., that death is a fact of life] we are delighted by the vehicle that conveys it to us. The mixture of these emotions constitutes the peculiar flavour and poignancy of pathos.[55]

One example of a pleasure of the second kind would be what Nietzsche identified as being responsible for 'the painful voluptuousness of tragedy', 'what seems agreeable in so-called tragic pity', namely, 'the spiritualization of cruelty', that is, the enjoyment in making oneself suffer.[56] Another example would be a second-order response to the first-order response that forms the first component of the complete experience. This first component is a painful response to the tragic aspect of the work; and it is right that the spectator should be unpleasantly affected by the imaginative realization of what would affect her unpleasantly in reality. But because this is the right response, indicating that the spectator's moral sensibility is sound, the spectator might derive satisfaction from being painfully moved. The existence within her of a capacity to respond sympathetically to the plight of others lays her open to a painful response to the work's tragic content; but she wants to be someone with this capacity, and so can derive satisfaction from the confirmation of her sensitivity provided by the arousal of this painful response.[57]

A No Pleasure theory maintains that there is no need for the spectator to experience the tragic emotions with pleasure (in either of the senses illustrated); for even if this takes place, there are other and better reasons for the spectator to value the experience of tragedy, and so to submit herself to an experience that can possess a phase that is unqualifiedly painful (even if, as is overwhelmingly likely, the realization that she is witnessing an artistic representation, not an actual tragedy, diminishes the painfulness of the response).[58] If the experience of the tragic emotions is an integral stage of a total experience that is intrinsically valuable to undergo, it is misguided to concentrate on the moment or moments at which the spectator reacts to the represented scene with negative emotions, believing that it is necessary to discover there some

pleasurable aspect of the experience. And this is precisely the claim of a No Pleasure theory.[59]

What might give the experience of a tragedy, phases of which are both painful and essential to the experience's value, an intrinsic value commensurate with the esteem in which great tragedies have traditionally been held?[60] This question presupposes an understanding of what is to be included in the sphere of the tragic. It is clear that the class of dramas that are now called tragedies consists of works of heterogeneous kinds; in other words, the dramatic art of tragedy lacks a precise essence. Tragic drama has been subject to many different interpretations, none of which recommends itself as a true account of most, or even just the greatest, instances of the form, so that attempts to enforce a conception of tragedies genuinely so-called lack persuasion. It would be possible to draw the boundaries of the tragic so tightly that only those ancient Greek mythic tragedies which formed the basis of Aristotle's account of tragedy would fall within them.[61] But it is better to give the question a wider scope by means of a more relaxed understanding of tragedy as a dramatic form, an understanding that allows in any serious play in which the central theme is the fate of characters, suited to arouse sympathetic emotions in the audience, who come to grief through human agency, and especially at least partly through their own thoughts, feelings and behaviour.[62] In particular, it is advisable not to build in any reference to a distinctive response, the so-called 'tragic effect', or to the *katharsis* of pity and fear, or even to these specific emotions.[63]

Given this understanding of tragedy, there is no reason to expect that there must be a unitary answer to the question: the reasons for which tragedies are to a high degree intrinsically valuable to experience (if they are) need not be the same but might well vary from case to case. The celebrated theories of tragedy put forward by Hegel and Nietzsche, for example, are best seen, not as universal diagnoses, but as offering insight into the nature of some of the reasons for valuing the experience of certain, but by no means all, valuable tragedies. Furthermore, it would be wrong to insist that any answer to the question must refer only to what is specific to tragic drama. On the contrary, it must advert

to considerations that apply more generally, to comedy, for example, as well as to what is distinctive of tragedy.

One crucial consideration concerns the distance between the spectator and the events represented in a play. Even when, as is often the case, a play is about real people and actual incidents in which they participated, the spectator is aware that she is not witnessing these events themselves. The events are not really present to her: she is witnessing only a theatrical representation of them. The consequences of this realization are far-reaching. I have already referred to the likely mitigation of the spectator's painful emotional response to the tragedy that engulfs the play's characters. But two related features are more directly relevant to the intrinsic value of the experience of tragedy. In the first place, the spectator is free from the normal requirements imposed on a witness; and this freedom encourages her to concentrate on *understanding* the spectacle (into which she cannot enter), which requires an understanding of the situations in which the protagonists find themselves, how they have got there, how they see their situations, their characters and motivations, the ways in which they are imprisoned by their pasts, the possibilities open to them and those that are closed. Since a spectator's apprehension of the nature of the characters in a tragedy, and the unfolding of the catastrophic events that overwhelm them, is independent of a concern for any practical effects these might have on her or those she cares for, a rare fullness and purity of appreciation is open to her. The 'aesthetic' attitude towards the dramatic events, dictated by the work's being a representation, not the reality itself, transforms the spectator's experience, which, unlike the experience of a witness of real events, is informed by an exceptionally vivid sense of circumstance and unusually complete grasp of action and passion, thought, perception and motivation. Secondly, the tendency to shrink from the unpleasant is inhibited in the experience of a dramatic representation of what is unpleasant – as it generally is in representational art; so are the forces that encourage prejudice and self-deception, which distort insight; and each of these is conducive to whatever understanding a tragedy might offer to the spectator.

Furthermore, a vital resource of dramatic art, identified by Nietzsche, allows us to enter more fully and easily into the minds of characters subjected to intolerable suffering or unenviable fates than would be possible if we were to witness the distress of their 'counterparts' in real life:

Even of passion on the stage [the Greeks] demanded that it should speak well, and they endured the unnaturalness of dramatic verse with rapture. In nature, passion is so poor in words, so embarrassed and all but mute; or when it finds words, so confused and irrational and ashamed of itself. Thanks to the Greeks, all of us have now become accustomed to this unnatural stage convention . . .

We have developed a need that we cannot satisfy in reality: to hear people in the most difficult situations speak well and at length; we are delighted when the tragic hero still finds words, reasons, eloquent gestures, and altogether intellectual brightness, where life approaches abysses and men in reality usually lose their heads and certainly linguistic felicity.[64]

Tragic drama typically administers to our desire for insight into the ways in which people can suffer and face adversity by endowing its characters, even at the most crucial or appalling moments of their lives, with an extraordinary ability to articulate thoughts and feelings appropriate to the kinds of people they are, the lives they have led and the conditions in which they find themselves. These perspicuous representations allow us to experience, in imagination, from the first-person point of view, what it would be like to be a certain kind of person in extremity; yet at the same time we see the person's situation from the external point of view provided by the entire framework of the play – a framework that includes by and large only what is relevant to the unfolding of the catastrophe that engulfs the tragic hero or heroine (or, more generally, the tragic figures). This duality of points of view from which we experience the action of the play, and the clarity of vision they afford, gives us a twofold understanding, both of how a person experiences his or her world when disaster is imminent or has struck and of the nature of the world in which that disaster has come about.

Given that it is natural for us to react emotionally to dramatic characters who command our imagination, and in particular to respond with sympathetic emotions to the misfortune of characters with whom we can identify to a greater or lesser extent, what we value is available only on condition that we are prepared to undergo an imaginative experience in which the fates of those we care for cause us to suffer.[65] The reason we value this experience of a heightened understanding of misfortune arises from our attachment to truth. In the experience of tragedy our emotions are engaged by a world in which evil, misjudgement, suffering, luck and irresolvable conflicts of values play crucial roles in the lives of the protagonists; and it is our implicit acknowledgement of the fact that these are factors intrinsic to human life that renders the experience of a tragedy valuable for the insight it provides (an insight contained within the experience itself),[66] if the tragedy manifests a superior understanding of how a person's life might be shaped by and ultimately come to grief because of such factors.

But (and this is the other side of Nietzsche's thought) this is not the only reason for which we value the remarkable ability of the greatest dramatic characters, even when their lives are ruined, to express thoughts and feelings that are adequate to the people they are, how they have lived and the situation in which they find themselves. For this is an ability that we admire in itself, and someone who possesses this ability is a different kind of person, and in this respect a more impressive person than someone who does not. Tragedies about individuals with this ability are not just works of art that make clear what it is like to be people, in some ways sympathetic, who, for various reasons and in various ways, come to grief; and if we value such works, it is not just because of the understanding of suffering and disaster that they embody. Part of the value of works of this kind lies in the qualities of character and consciousness, imagined by the poet, that are made manifest in the tragic hero or heroine. It is characteristic of our reaction to tragic figures of this stature, especially when they endure suffering or face catastrophe with uncommon courage or equanimity, that admiration for the individual's 'greatness of soul' mingles with regret for his or her fate. This

applies even when, as is usually true of the central figures of a tragedy, the character is in other ways flawed or unadmirable – as with Macbeth, for example. Admiration for certain of a person's impressive *qualities of mind*, and regret at their destruction, is compatible with recognition of undesirable characteristics that weaken or even totally undermine our attachment to the *individual*.

Admiration figures in the experience of tragedy in a further, significant manner. Henry James claimed that: 'There is one point at which the moral sense and the artistic sense lie very near together; that is in the light of the very obvious truth that the deepest quality of a work of art will always be the quality of the mind of the producer.'[67] In addition to the qualities of intellect, understanding, imagination and artistry that are needed by dramatists of whatever kind, the specific requirement for the tragic artist is the ability to recognize and contemplate the most painful facts of human life without giving way to despair or pessimism. As Nietzsche emphasized, this is what the tragic artist communicates and celebrates in her work;[68] and the intrinsic value of the experience of great tragedy is a product of this ability, an awareness of which informs the spectator's experience.

IV

Music as an Abstract Art

Compared with music all communication by words is shameless; words
dilute and brutalize; words depersonalize; words make the uncommon
common.

Nietzsche, *The Will to Power*, §810

MUSIC AS AN INDEPENDENT ART

The reason we no longer struggle to accommodate the art of 'pure' or
'absolute' music in the canon of great art forms is not because we have
solved the philosophical problem that theorists of the late eighteenth
century faced in their attempts to justify the emancipation of instrumen-
tal music.[1] The remarkable flowering of artistic genius that went hand in
hand with the dissolution of the chain that bound music to language was
itself sufficient to undermine scepticism about music's capacity to consti-
tute a self-sufficient art of high value. The vindication of pure music's
eminence as art was achieved not by theory but by art. This was no
accident. For, as both Hume and Kant emphasized, there are no a priori
principles of taste, so that a description of music as an independent art –
a description not based on its actual achievements – could not carry
conviction. Furthermore, the principal theoretical obstacle to the recogni-
tion of music divorced from words as an art on a par with the other
acknowledged great art forms fell with the abandonment of the assump-
tion that the true or highest aim of art is the seductive presentation of
the most significant moral or religious truths. Nevertheless, the mani-
festly high artistic value of many instrumental works and the jettisoning
of the religio-moral prejudice does not itself introduce an alternative
conception of the distinctive artistic value of absolute music, and it is to

the construction of such a conception that theorists of the nineteenth and twentieth centuries have directed their efforts (although with questionable success).[2] The problem has therefore been transformed but not solved. There is no longer any question of seeking to establish music's credentials as an independent art which is potentially just as valuable as the arts of literature, painting and sculpture. Instead, the problem is that of explaining the undeniably high artistic value attainable by pure music – explaining it by elucidating the distinctive virtues of music as an art – and, hence, its power to affect us as deeply as the other arts.

This problem often tends to be run together with a different one by sliding from one understanding of the idea of the value of music as an art to another understanding – a slide eased by assigning to art a moral or religious goal. When a question is raised about the value of music as an art vis-à-vis the values of the other main art forms, what kind of value is in question? Is it music's actual or potential cognitive, cultural, educational, moral or religious value – the value of the knowledge, if any, that music makes available or music's effects on the lives of those who appreciate it? Or is it music's artistic value – the intrinsic value of music's products? Unless this intrinsic value is determined solely by cognitive or moral criteria, there is no simple route from an account of music's value as art to its value as a cognitive or moral instrument; and this holds for the other kinds of instrumental value that music might be credited with. But whatever determines the intrinsic value of musical works, the fundamental philosophical problem concerns music's artistic value, not any other kinds of value it may have.

THE ENIGMA OF MUSIC'S VALUE

But why should the value of music as an art be thought of as enigmatic? The source of the puzzlement is undoubtedly music's abstract nature. Of course, not all music is abstract; but it is the evidently merited claim to high artistic status of abstract music, or music in so far as it is abstract, that poses the problem. The difficulty is to provide an account of the nature of music which both recognizes the abstractness integral to it and

does justice to its artistic achievements by rendering intelligible music's capacity to generate products of exceptional intrinsic value. What appears puzzling is that human beings find it profoundly rewarding to absorb themselves in abstract processes that seem to be about as far removed from everything they value in their extramusical lives as anything could be. Music seems to be a paradise essentially unrelated to the world we live our ordinary lives in, deriving its import and sustenance from itself alone; and its effects on us appear unaccountable or out of all proportion to their cause and object. That, at least, is how music has commonly been seen by those who find its value theoretically problematic and its capacity to enrapture us mysterious.

ABSTRACTNESS IN MUSIC

But is this really so? In fact, this simple line of thought should not carry conviction, because it is by no means obvious that abstraction renders the power of an art which has an abstract nature deeply problematic. For, in the first place, there is the possibility of explaining the value of artistic experience in general (as Schopenhauer did),[3] or of abstract art in particular (as Worringer did),[4] by reference to the tranquillity that results from its freeing us from undesirable or painful features of our normal experience of the world. Second, and more important, abstraction would render the power of an art which has an abstract nature questionable only if there were reason to believe one or the other of these claims: either that we never value aesthetically the perception of abstract forms in our extra-artistic lives and that we can make sense of our valuing a feature inside art only if we value it outside and prior to art; or that although we do value aesthetically the perception of abstract forms outside art, we can make sense of our valuing a feature inside art *to a certain degree* only if we value it outside and prior to art to that same degree.[5] But the first claim breaks down, if only because we do value aesthetically the perception of abstract forms outside art; and the second claim overlooks the twofold possibility that the perception of abstract forms within an art might, on the one hand, lack characteristics possessed

by their perception outside art and which tend to diminish their intrinsic aesthetic appeal, and, on the other hand, possess characteristics that enhance their aesthetic appeal and that are lacking outside art, especially in the sense modality addressed by the art form in question. Since both aspects of this dual possibility are, I believe, realized, the train of thought is fatally flawed.

But I have not yet attempted to demonstrate this conclusion, which, as will become clear, needs to be supplemented by an investigation of the nature, scope and value of what has often been taken to be music's principal claim to artistic excellence and the source of its power, namely the musical expression of emotion.

First of all, it is necessary to attend to the notion of an abstract work of art, for the idea of abstraction in art can be understood in a stricter or looser fashion. In its most exclusive sense, a work of art is abstract to the extent that it 'represents' nothing, or makes no reference to anything, outside itself: it introduces nothing from the world external to it as its subject; it is 'about' nothing other than itself or what it contains; in consequence, its appreciation does not require that its experience should be informed by concepts whose primary application is to the outside world in the way that the experience of literature, drama, sculpture and representational painting is so informed.

In fact, music is *at heart* abstract in this strong sense. For the core of musical understanding – of hearing music with understanding – is the experience of what I shall call the intramusical meaning of a musical work, that is, the work's audible musical structure, the musically significant relations (melodic, harmonic, rhythmic and so on) that obtain amongst the sounds and silences that compose the work. To hear music with understanding it is necessary to hear the music as having that structure, which is the music's skeleton (at least). Music is fundamentally abstract in the sense that, whatever other kinds of 'meaning' it may have – semantic, representational, expressive – it has them only in virtue of its intramusical meaning; and only if this meaning is understood – only if this audible musical structure is heard – is any other meaning heard in understanding the music.[6] This purely musical meaning is a meaning

that the work has *in abstraction from* any meaning that accrues to it in virtue of a relation in which it stands to anything else (any other music or any other phenomena).[7]

But in whatever way this most exclusive conception of abstract art might be made more precise, it is likely to be too restrictive to be ultimately useful in considering the problem of music's value as an abstract art. For, apart from any other considerations, abstraction in art is not usually understood in such a way that abstract art must display nothing of the outside world that the audience needs to appreciate; in particular, it is usually understood to rule out not 'expression' of the 'inner world' of psychological states – the 'inner world', as such, is not perceivable, and hence not picturable – but 'representation' of the 'external world' of physical objects and events. It is in something like this looser fashion that I intend to understand the notion of abstraction in art, for it is precisely by reference to music's supposed capacity to express emotions, moods and feelings – their essence, their 'morphology', their otherwise inexpressible particularity, or whatever – that theorists have usually proposed to reconcile music's abstract nature with its high artistic possibilities and so unlock the secret of music's appeal. Furthermore, the inclusion of the expression of emotion within the scope of abstract music does not compromise music's abstractness, for the musical expression of emotion is, in a sense I shall make clear, the expression of *abstract* emotion.

The required notion of abstraction must do justice to the striking disanalogy between music, on the one hand, and literature, sculpture and representational painting, for example, on the other. Literary works of art are distinguished by the requirement that their appreciation involves a grasp of the contents of the sentences that compose them. Representational paintings require of the beholder an awareness of the visual states of affairs depicted by the coloured marks that compose their surfaces. Sculptures demand a recognition of the perceptible objects, often people, they represent. Accordingly, I propose to regard music as 'abstract' in so far as its appreciation requires neither the grasp of any thought-content of its constituent sounds (as with verbal music)

nor an awareness of any extramusical audible (or otherwise perceptible) state of affairs or object that its constituent sounds stand to in a similar relation to that in which a picture stands to the visible state of affairs it depicts or a sculpture to what it is a sculpture of (as with representational music). This conception is admittedly loose[8] but captures reasonably well that respect in which music diverges from the 'representational' arts which appears to render its artistic powers problematic. When we listen to music we do not understand it as a language (in the strict sense); and the experience of music we are interested in is one in which we do not hear it as a representation of the perceptible world outside music.

MUSICAL REPRESENTATION

What in fact is meant by musical representation, and in what manner do we experience music if we hear it as a representation of its subject?

The most straightforward sense in which music can be said to be representational is this: the music is successfully intended to sound like the sound of something extramusical, which it is designed to call to mind, as when the music 'depicts' the calls of birds, the humming of bees, the braying of an ass, croaking frogs, alpine horns, church bells, raindrops, the boom of cannons, the noise of thunder or the chugging of a train. In this sense music can represent only sounds or things that make sounds, and when it does represent things that make sounds it represents them by imitating, more or less closely, in one or more respects, the sounds they make. If the listener experiences the music as being a representation, if he hears the music as representing the sound of a cuckoo, for example, he hears the music as sounding like a cuckoo's call.[9]

But sounds are not the only extramusical perceptible phenomena that music can be successfully intended to resemble, and that the listener is intended to experience the music as resembling. Although music consists of sounds and silences, the properties of its sounds and their manners of combination and succession are such that experienced resemblances can

obtain between music and non-audible perceptible objects (or non-audible aspects of audible objects), the sun, fire or water, for example, as when musical rhythms or qualities of melody are used to represent moving things or modes of movement (Debussy's *Voiles*), or as when fine gradations of tone are used to represent minute differences in the phenomena (light or height, for example) of a sense modality other than hearing, or as when the character of a chord or the musical texture is used to represent something with an analogous character (Debussy's *Reflets dans l'eau*). In these cases also, a listener who experiences the music as representational undergoes an experience of resemblance, likeness or affinity.[10]

It has sometimes been asserted that music is an abstract art with no power to represent the extramusical world.[11] This thesis usually rests on the claim that awareness of what is represented is essential to the understanding and appreciation of a truly representational work of art, but representational music can be fully understood and appreciated without such an awareness. Hence music, understood as an art, is abstract, not representational. The foundation of this position might seem open to refutation by counter-example, for there appear to be many cases in which musical understanding requires awareness of the music's representational content.[12] But the matter is not as simple as this, since even if the relevant concept of musical understanding is agreed to be understanding the music's audible structure (its intramusical meaning),[13] this idea needs to be disambiguated. The two concepts of understanding a work's musical structure that need to be distinguished here are, first, perceiving the structure of the music as you listen to it, and second, understanding why it has that structure. In other words, the idea of understanding as it figures in the notion of experiencing music with understanding might refer to understanding *what the work's structure is* or to understanding *why the work has that structure*. The first of these notions, which I have identified as the core of musical understanding, is basic, since it does not presuppose the second but is presupposed by it.

The fact of the matter is that whereas it is necessary to see what is depicted in a picture to perceive pictorial structure, it is not necessary

to hear what is represented in a musical work to perceive musical structure – to hear what that structure is.[14] So in the first sense of understanding, awareness of what is represented always *is* unnecessary for full musical understanding. However, when the musical structure of a work is partly determined by its representational content in such a way that the structure is puzzling or unsatisfactory by 'purely musical' criteria, failure to grasp that content will make the structure appear aesthetically unsatisfactory and prevent the listener from understanding why the music has that structure (the structure the listener can hear); whereas grasp of that content, by enabling the listener to understand why the structure of the music is as it is, enables the listener to appreciate the aesthetic appropriateness of the structure. Since one aspect of our aesthetic response to representational music is an appreciation of the quality of the representation – how successful the music is in capturing aspects of its subject and the way in which it does so – the second sense of musical understanding *is* relevant to the aesthetic appreciation of such musical works. Hence music, understood as an art, is not necessarily lacking in representational elements integral to its appreciation. The truth is that representation in the art of music is distinguished from representation in the art of pictures not by its absence but by its relative poverty and imprecision.[15] Accordingly, musical representation in Western instrumental music has nothing like the aesthetic significance of pictorial representation: it is neither as common nor, usually, as aesthetically significant where it does occur – you do not lose as much if you fail to perceive the representational content.[16]

THE SCOPE OF ABSTRACT MUSIC

To consider music from the abstract point of view I have outlined is not in fact to restrict the field of music, for the entire field of music is open to it. The limitation it imposes concerns not the field of musical works, but aspects of them. To be interested in music solely as an abstract art is not to discount any musical works; it is to be deaf to certain aspects a

musical work might possess. So verbal and programme music are not ruled out of consideration, but their semantic or programmatic aspects are ignored because they fall outside the bounds of the abstract. Although the chosen point of view undoubtedly restricts music's power and cannot do full justice even to many non-illustrative purely instrumental works, this is no objection to adopting it. For the aim is to demonstrate that music's value as an art can be rendered unproblematic even under the imposition of a restrictive and artificial point of view that excludes much that can contribute to music's value. Once this aim has been achieved, the self-denying ordinance can be revoked, thereby allowing music's full significance as an independent art to reveal itself.

Note that what has sometimes been thought of as being constitutive of the expression of 'inner states' in music is placed outside its limits by this conception of music as an abstract art. If instrumental music is thought of as being expressive of emotion in virtue of the fact that it is designed to sound like a human voice expressing that emotion, and if it is intended that it should be heard *as resembling* such a voice, or *as if it were* such a voice;[17] or if expressive music is intended to be heard as a *sui generis* bodily means of direct sound production;[18] then in that respect, even though the idea of emotion is imported into the experience of the music, the music is not to be heard as abstract.[19] For the idea of emotion is introduced only through the conception of an audible event in the 'external world', namely a human voice or 'voice', that the music 'represents'. But the musical representation of the emotionally expressive human voice is on a par with the depiction or sculpture of the human body in an emotional state – paradigms of non-abstract art – perhaps diverging from the appearance of its model to a greater extent, but still a representation of it; and just as the musical representation of non-human sounds of the natural or man-made world falls outside the boundaries of music as an abstract art, so does the musical representation of the emotionally expressive human voice. If the musical representation of the human voice makes a significant contribution to music's power as an art, it does not do so to music's power as an abstract art.

An interest in the power of music as a self-sufficient art requires a

narrowing of the abstract point of view I have specified. Much music is designed to accompany or to guide other activities, and its success is determined by how well it performs the extramusical function for which it is intended, rather than solely by its intrinsic artistic merits. But the theoretical problem about music's value as an art concerns not music's suitability to play any kind of supporting or supplementary role, but its ability to stand alone. So we must consider music not only in so far as it is *abstract*, but music *as such*, music itself, independently of any extramusical function it is intended to serve. Again, this imposes no restrictions on the range of music that falls within the adopted point of view; the point of view restricts, not the range of music available to it, but the considerations relevant to the assessment of music's artistic potential. Nevertheless, nothing essential is lost if the investigation of music's power as an abstract art is thought of as focused upon purely instrumental, non-representational works that are not intended to serve any non-musical function.

MUSIC AND THE EXPRESSION OF EMOTION

It has often been thought that the sole and sufficient explanation, or at least a considerable part of the explanation, of music's eminence as an abstract art is its ability to express emotion, mood and feeling (emotion, for short) – an ability unrivalled by the other arts. For this to be in itself a sufficient explanation, three propositions must be true. First, all valuable abstract music must be expressive of emotion. Second, abstract musical works must be valuable in proportion to their merit in expressing emotion, that is to say, in proportion to the extent that, or the degree to which or the manner in which, they do so, or to the nature of the emotions they express. Third, abstract music must be able to express emotions or characteristics of them that are inexpressible by the other art forms, or to express features of our emotional life in an especially valuable manner denied to other art forms.

It might appear plausible to concede at once the existence of musical works in which emotion is expressed but to maintain that there are

significant forms of music or many important musical works in which emotion is not expressed at all or only fleetingly so. The minuet of Haydn's String Quartet Op. 20, No. 3 is characterized by fierce desolation, the Andantino of Mozart's Piano Concerto in E flat (K. 271) is an expression of grief and despair, the Prelude to Wagner's *Tristan and Isolde* is permeated with yearning, the trio of Elgar's Funeral March Op. 42 is expressive of 'heroic melancholy' (Yeats's description), and the Allegretto theme of his *Introduction and Allegro for Strings* is suffused with wistful regret; but, so it might seem, neither Bach's masterpiece *The Art of the Fugue* nor the famous last movement of Mozart's 'Jupiter' Symphony nor Beethoven's Eighth Symphony nor Brahms's *Variations on a Theme of Joseph Haydn* is everywhere, or everywhere it is impressive, or even very often, expressive of one or another kind of emotion. If this is so, music's eminence as an abstract art cannot essentially or in large part derive from its being expressive of emotion.

But there are two strategies open to an adherent of the view that all impressive music is expressive of emotion for dealing with any impressive music that is brought forward as an apparent counter-example to his all-inclusive claim. The first is to allow that there is indeed an important difference between the alleged counter-example and agreed paradigms of emotionally expressive music, but to maintain that this difference is not a matter of the putative counter-example's failing to express emotion, but of its expressing a *different kind of emotion* – perhaps one for which we lack a name – from that expressed by any of the paradigms. The second follows suit in conceding a striking difference between the supposed counter-example and the paradigms, but this time explains the difference in terms of the *different styles of expression* of emotion in the two kinds of music. Although neither strategy is self-evidently correct, it cannot be denied that there are various kinds of emotion and also different manners of expression of emotions of the same kind. Hence an adherent of the all-inclusive view can always preserve his stance by the adoption of one or the other of the two strategies or by a combination of them.

To break this deadlock and to assess the claim that music's expressive

capacity is sufficient to explain its high artistic potential we need an analysis or elucidation of the concept of the musical expression of emotion – an elucidation consonant with music's retention of its status as abstract art. For without such an account we will be unable to determine the extent of the expression of emotion in abstract music or the nature of its contribution to the value of music that possesses it.

In thinking about the expression of emotion in music, it is helpful to bear in mind two interconnected distinctions. The first is the distinction between a type or kind of emotion and a particular instance or occurrence of the type – sadness and my present sadness, for example. The second is the distinction between two senses in which something can be an expression of emotion: the distinction between an expression of emotion that is a manifestation of an occurrence of the emotion and one that is not – my sad expression when I am overcome with sadness and the sad face of a clown, say.[20] An expression of emotion in the second sense is a mere expression; in the first sense it is a product or constituent of an instance of the emotion. The bearing of each of these distinctions on the problem of the musical expression of emotion is the same. Unless the emotion expressed by a musical work is an occurrence of a certain kind of emotion and not merely that general kind of emotion, it makes no sense to attribute the emotion expressed to anyone, in particular to the composer, for it is only a type of emotion, not an occurrence of that type. Again, unless music that is expressive of grief, say, should properly be thought of as, or as if it were, an expression of grief in the first rather than merely the second sense, there is no question of assigning the emotion expressed in the music to anyone.

I shall maintain that there is no single concept of the musical expression of emotion, but a number of such concepts, which fall on different sides of the distinctions I have drawn.

THE BASIC AND MINIMAL CONCEPT

I believe that the prime concept is one according to which qualities of emotion are audible features of music: the most basic way in which we

experience music when we hear it as being expressive of an emotion is that we hear the emotion the music is expressive of as characterizing the music itself, as when we hear the music as being sombre, melancholy, cheerful or blissful: we hear the emotion *in* the music. In what sense is this possible?

The key to the analysis of music's capacity to 'contain' or 'embody' emotion can be found in Schopenhauer's celebrated account of the essential nature and significance of music. Schopenhauer's theory interprets music as being a direct representation or copy of the innermost essence of the world, 'the will', which is realized in human life especially vividly in the experience of the various emotions; and it represents this iconic correspondence between music and emotional experience as explaining music's deep appeal as an art. The insight in Schopenhauer's theory that I want to highlight is, as a first approximation, this: music can mirror what we feel when we experience an emotion. But this formulation needs to be qualified because of the limitations in music's expressive capacity that Schopenhauer recognizes:

... music does not express this or that particular and definite pleasure, this or that affliction, pain, sorrow, horror, gaiety, merriment, or peace of mind, but joy, pain, sorrow, horror, gaiety, merriment, peace of mind *themselves*, to a certain extent in the abstract, their essential nature, without any accessories, and so also without the motives for them.[21]

What the insight amounts to, then, is that what music reflects is the infinitely various forms in which the non-representational and non-conceptual content of the emotions – their 'extracted quintessence' of satisfaction and dissatisfaction – can be experienced in time.

I propose to appropriate Schopenhauer's insight in the following way. The basic and minimal concept of the musical expression of emotion comes to this: when you hear music as being expressive of emotion E – when you hear E in the music – you hear the music as sounding like the way E feels;[22] the music *is* expressive of E if it is correct to hear it in this fashion or a full appreciation of the music requires the listener to hear it in this way. So the sense in which you hear the emotion *in* the music –

the sense in which it is an audible property of the music – is that you perceive a likeness between the music and the experience of the emotion. Note that, since the perception of a likeness is a matter of degree, this account accommodates the fact that music can be heard to be expressive of emotion to a greater or lesser degree. The account also accommodates the often-remarked feature of musical experience that music can be heard to be expressive of different emotions at the same time: this is possible because concurrent perceived likenesses to different, even opposed, feelings are possible. It also gives a sensible content to the apparently paradoxical thought that in the experience of music we perceive directly what ordinarily we can perceive only indirectly (as manifested in the appearance of the body), namely the 'inner life' of emotion. Or, in Schopenhauer's formulation, that music is a representation of what can never be directly represented.

Although the perception of a likeness between one thing and another does not require that the perceiver should be aware of what the likeness consists in, the (non-creative)[23] perception of a likeness does require that the two items should be alike in a respect that is responsible for the perception. So emotion can properly be heard in music in the cross-categorial likeness sense only to the extent that music and emotion are alike. Furthermore, to be able to justify the perception of a likeness between one thing and another by identifying a common property through reflection on the appearances of the two items, the point of resemblance must not lie below the level of consciousness, so that it cannot be noticed and pointed out. Hence this kind of reflective justification of the perception of likenesses between music and the emotions requires that music and emotion should be alike in noticeable ways. But the respect in which two items are alike that is responsible for the impression of likeness might lie below the level of consciousness, in which case its detection would be a matter for scientific investigation, rather than reflection on the appearances of the items.

MUSIC AS THE MIRROR OF FEELING

In what ways can music sound like how an emotion or mood feels? That is to say, what audible features of music can be perceived as resembling features of the way an emotion feels? This question is important for more than one reason. First, the correct answer to it determines the *range* of emotions mirrored by music. There are two sides to this determination. On the one hand, if an emotion lacks a distinctive feeling, that emotion cannot be specifically mirrored by music, that is to say, music cannot present an image of it which differs from the musical image of any other emotion; on the other hand, if the distinctive feeling of an emotion is such that music lacks any analogue of it, then music cannot mirror that emotion. Second, the correct answer determines the *extent* of emotionally expressive music, that is, how much music is expressive of emotion, in so far as emotionally expressive music mirrors the feeling of the emotion it is expressive of. Music that does not sound like how any emotion feels is not emotionally expressive: you do not hear music as being emotionally expressive *at all* if it does not sound to you like the feeling of emotion; you do not hear it as being expressive *of emotion E* if it does not sound to you like how E feels.

The question 'In what ways can music sound like how an emotion feels?' turns on the underlying question 'How do the emotions feel?' (or 'What do the emotions feel like?'), and to answer this pivotal question it is necessary to answer the double-barrelled question, 'What is an emotion, and what general category or categories of feeling are involved in the experience of the emotions?' However, the commonly recognized emotions do not form a sharply defined and unified class, and the feelings the emotions involve inherit the disparity in the membership of the class. So I will need to simplify.

The answer to the first part of the double-barrelled question is, in brief, that the emotions, considered as kinds of experience, are positive or negative reactions or attitudes to how the world is represented – in perception, experiential memory, imagination or thought – and they are distinguished from one another either by the different representations,

or by the different responses, intrinsic to them, or in both of these ways. An emotion in its experiential form is a causal structure composed of a representation and a felt evaluative reaction to the representation's content: for an emotion to be experienced, the positive or negative attitude integral to the emotion must be felt; it must be caused by the representation intrinsic to the emotion; and it must be directed at what the representation is about.[24]

But what is felt when an emotion is experienced? When someone undergoes an emotion, what kinds of reaction or attitude are constituents of the experience? What types of feeling are involved in the experience of the emotions?

There are two senses in which a feeling can be 'involved' in the experience of a certain emotion. First, it can be the feeling *of* that emotion – the feeling of remorse, jealousy, pride or fear, say. The feeling of an emotion is often understood as what is fully constitutive of the experience of the emotion. But as I intend the notion, the feeling of an emotion is whatever any person must feel (as opposed to think) if the person is to feel that emotion. In other words, it is partly definitive or constitutive of the experience of the emotion. Second, a feeling that is not essential to the experience of a certain emotion might sometimes, often, or always be induced in people – people of a specific bodily constitution – in virtue of the fact that they are in that emotional state.

The feeling of an emotion has often been identified with the experience of bodily sensations or feelings – feelings of occurrences in, or states of, the body. But it is a mistake to represent the feeling of an emotion, admiration, disgust, gratitude, shyness or nostalgia, for example, as being composed of bodily sensations. Such an identification will seem plausible only if attention is directed exclusively to a few special cases that are deemed to be paradigmatic – fear of imminent danger, for instance. In these cases there are notable bodily manifestations that the subject of the emotion experiences: the rush of adrenalin, the pounding of the heart, the erection of bodily hair, the tingle along the spine. But for the great majority of emotions, there are few, if any, characteristic

bodily feelings; and for all emotions, including fear, even if an emotion were always to be experienced with characteristic bodily feelings, these would not be what the feeling of the emotion is. It is the subject's felt evaluative attitude to how the world is represented, not what bodily sensations are undergone, that makes his reaction an emotional reaction and serves to define the emotion the subject feels. The truth is that bodily sensations are involved in the experience of an emotion only in the second of the two senses I have distinguished.

The feelings intrinsic to the experience of the emotions are, by and large, types of felt desire and aversion (as with envy and disgust or shame), distress (as with fear or grief), pleasure (as with joy, amusement or pride) and displeasure, especially displeasure at the frustration of a desire (as with anger). The feeling of an emotion is often complex, consisting of more than one of these elements. Apart from bodily sensations, the feelings involved in, but not necessarily intrinsic to, the experience of emotions include feelings of energy or lethargy (as with joy and sadness), of movement or tendencies to movement (as with the bodily trembling of anxiety), of inclinations or impulses to action (as with rage), or of tension or relaxation (as with excitement and emotional relief).[25]

But it is mistaken to focus exclusively upon the feelings involved in the experience of the commonly recognized emotions. For, on the one hand, there is no hard-and-fast line between what are and what are not emotions, and, on the other, I have been using the term 'emotion' as short for the more cumbersome 'emotion, mood or feeling', and it is music's ability to express emotion in this wide sense that is under investigation.[26] The account I have given of the perception of emotion in music applies equally to the perception of the musical embodiment of feelings that perhaps or definitely fall outside the field of the emotions. You can feel buoyant, dejected, expectant, restless, reconciled or irresolute, for example, and to hear music as expressive of buoyancy, dejection, expectancy, restlessness, reconciliation or irresolution is to hear it as sounding like how these states feel. So an account of the feelings involved in the experience of the emotions is of interest only in

determining how much or how little of the emotions can be reflected in music, not in determining how much it can express of what we feel when we are emotionally affected or in a mood. This larger issue is the more important one.[27]

The belief or thought, if any, that forms an emotion's core (how the world is represented as being); the content of any component desire (how the world is represented as desired) or of any affect (what is found distressing, dispiriting or reason for joy); the nature and location of that in which a movement or some other bodily change is felt; these are all features that music cannot mirror. If they are subtracted from the experience of an emotion or feeling, the respects in which episodes of emotion or feeling can differ from one another are greatly reduced, and so, accordingly, is music's ability to mirror one kind of episode rather than another. The fact that this is in accordance with the normally recognized severe limitations of music's capacity to express our highly variegated inner lives is one confirmation of the accuracy of the account of the musical expression of emotion, mood and feeling as founded on a form of likeness perception.[28] As Schopenhauer insisted, abstract music can reflect only the non-representational and non-conceptual character of experiences of emotion, and this character is not as variegated as the complete, thought-impregnated character.

It is not hard to begin to identify the resources in virtue of which music is able to mirror those aspects of feeling available to it — the mere fact of desire and the ease or difficulty with which it is satisfied, tension and relaxation, pleasure, pain, satisfaction and distress in their various degrees, differences in upwards or downwards direction, magnitude, speed and rhythm of felt movement, levels of felt energy, and so on. (Note that some of these resources have correspondences with more than one mirrorable aspect of feeling.) Schopenhauer emphasized a correspondence between the melodic aspect of music and the springing up of desires and their satisfaction. A melody of the kind Schopenhauer had in mind is a process in which there is a progression from one point of relative repose to another such point: the interlocking phrases that

compose the melody form shorter processes whose final notes are their goals; but these goals are merely temporary and the melody comes to an end only when it returns to the keynote with finality. This is analogous to the way in which in order to attain a desired end we may strive for an intermediate goal, which perhaps we achieve and are for the moment satisfied by, only for a new desire to spring up and to demand satisfaction in turn, until the final goal is reached. More simply, there is a natural correspondence between the transition, integral to tonal music, from those musical sounds that do to those that do not stand in need of resolution and the transition from states of desire to states of satisfaction or from states of tension to states of release. There is a correspondence between the dimension of pitch and the vertical dimension of space, and, accordingly, between successions of notes of different pitch (duration and emphasis) and (rhythmic) upwards and downwards movements of greater or lesser magnitude and speed, thus allowing music to reflect felt movements integral to a certain kind of emotion (as with the bodily trembling intrinsic to the feeling of acute anxiety or agitation).[29] Levels of felt energy find natural analogues in variations of the strength of the musical pulse, the degree of movement and the musical mass, for example. The feeling of floating or being excited can be mirrored in music by lightening the musical texture, perhaps to a single highly pitched melodic strand, or by increases in pitch, loudness and tempo.

There is therefore no difficulty in principle in justifying our perceptions of likeness between music and emotion, mood and feeling by indicating the respects in which the two are alike. But, as I have previously said, the point of resemblance may lie below the level of consciousness (as, perhaps, with the melancholy sound of a minor triad as contrasted with a major triad), so that no matter how well we reflect on how music sounds and how an emotion feels we might be unable to identify a common property that is responsible for the perception of likeness – in which case we must rest content with a community of response.

THE SPECIFICITY OF MUSICAL EXPRESSION

We are now in a position to evaluate the common claim that music is superior to language as a means of capturing the precise nature of emotional states, or, rather, the precise nature of the feeling that forms the flesh of the representational and conceptual core of the state. It is often supposed that if this claim were true, the value of music as an art would be vindicated. How does the claim arise? It often appears to be reached by a train of thought that leads, first, to the conclusion that no two musical works could ever express exactly the same emotional state, second, to the conclusion that the precise nature of the emotional state expressed by any musical work must always elude the grasp of language, and, third, to the conclusion that the nature of any emotional state can be revealed by the literal and non-poetic use of words only in a vague, indefinite fashion, whereas music can present this nature with a precision denied to language.

The line of thought runs as follows. It is true that there is a sense in which more than one musical work can express the same emotional state or feeling. For it is possible that the emotion expressed by one work can fall under a description that applies to the emotion expressed by another work. But this description must be pitched at a certain level of generality and it will not be the most specific description of either state of mind. Accordingly, more than one musical work can express a sense of loss; but 'a sense of loss' is an inadequate specification of the particular sense of loss expressed by Mozart's *Masonic Funeral Music* (K. 477) and it is also an inadequate specification of the particular sense of loss expressed by Elgar's *Sospiri*. But if there is a more specific description that applies equally to the particular senses of loss expressed by these two works, it will again not be the most specific description of either state of mind. It follows that it is not possible that, as a description is made ever more specific, it should continue to fit each of the states expressed by different works. Hence the precise state of mind expressed by one work is expressed by that work and by no other: it is specific to that work. Now for any independently specifiable emotion expressible

in music – any emotion the intrinsic nature of which is fully specifiable independently of the nature of the musical work that expresses it – it is possible that more than one work should express that emotion. But each emotionally expressive musical work expresses an emotion whose nature is more specific than that of any independently specifiable emotion it expresses. Hence language is an inadequate instrument for capturing the precise nature of the emotions expressed by music. Mendelssohn's memorable words have often been taken to encapsulate this position: 'The thoughts which are expressed to me by a piece of music which I love are not too indefinite to be put into words, but on the contrary too definite.'[30] Deryck Cooke, perhaps the most impressive representative of this point of view, referring to the Allegretto of Beethoven's Seventh Symphony, wrote: 'Of course, no words could ever describe precisely the emotion of this movement, or any other. The emotion is, in Mendelssohn's words, "too definite" to be transcribed into the ambiguous medium of words.'[31]

But such a view is unconvincing, although it is easy to understand how one might come to embrace it. If one were to think that it is just what is expressed by a piece of emotionally expressive music that determines its aesthetic appeal, the only way of preserving the distinctive appeal of different such pieces would be to convince oneself that each piece of music expresses what can only be expressed by that piece of music, and it is a short step from this position to the conclusion that what each piece of music expresses cannot be formulated in language. But it is the complete nature of a piece of music, not merely what emotion it expresses, that determines its value, and it is a mistake to attempt to force the individuality of each piece of music into the nature of what, if anything, it expresses.

In fact the doctrine of the essential specificity of the emotion expressed by a musical work – the specificity of the emotion to that work – is unwarranted. It is necessary to distinguish the determinate nature of (i) a particular musical passage, (ii) the kind of emotion expressed by the passage, and (iii) the way in which the emotion changes (in strength, say) as the passage progresses. The doctrine that each emotionally

expressive musical work expresses a particular emotion expressed by no other work could be applied either to (ii) or to (iii) (or to both). But it is clear that the fact that a work has a determinate nature, distinguishing it from all other works, implies neither that the kind of emotion expressed by the work nor that the way in which this emotion changes as the work unfolds is specific to the work, unless the relations between the nature of a musical work (specified in non-emotional terms) and, firstly, the kind of emotion expressed and, secondly, the way in which it fluctuates are not many–one. But given my account of the basic concept of emotionally expressive music, there is no reason to believe that either of these conditions obtains.[32] For if the musical expression of emotion is founded on the experience of hearing music as sounding like how an emotion feels, it is not necessary that each feature of a musical passage should affect the nature of the emotion expressed – the emotion the music should be heard as resembling – or the way in which it alters. Heard resemblances can be and usually are indifferent to various changes in the vehicle of resemblance. The nature of the emotion a piece of music is heard as resembling can be unaffected by certain aspects of the music: the nature of the emotion expressed is not automatically as determinate as the nature of the music that expresses it. So the identity of the emotion a musical passage expresses is not tied to the identity of the music.

Furthermore, it is one thing to allow that music might be able to express emotions for which there are at best highly general words in our language; it is another to assert that music can express emotions or aspects of emotion for which there could be no fully adequate linguistic formulation. The claim that the precise nature of the emotion expressed by a musical work *cannot* be put into words refers, not to a remediable defect of actual languages, but to an impossibility in principle. Rejection of this claim is compatible with the view that we are in fact unable fully to capture the emotion in the words we possess. It is plausible to concede that the expressive capacities of music exceed in certain ways those of the English language; but it is mere confusion to imagine that music can express features of emotion which could not be captured in

any conceivable language because of some supposed lack of fit between the definite nature of emotion and the indefinite nature of language.

EMOTIONAL QUALITIES AND AESTHETIC VALUE

It is easy to defuse a common objection to the aesthetic significance of the emotionally expressive properties of musical works. The fact that musical works of different value can express the same kind of emotion fails to undermine the importance of the emotional quality of a piece of music, for all it shows is that the emotion expressed by a piece of music is not the sole determinant of its value. The claim that an awareness of the emotional qualities of a musical work is an integral part of a full appreciation of the music is no more vulnerable to the fact that different works, works with unequal values, can express the same emotion than the claim that an awareness of what is depicted is an integral part of a full appreciation of a representational picture is vulnerable to the fact that different pictures, pictures of unequal value, can depict the same thing. So the irrelevance of the emotionally expressive aspect of music to the truly musical listener does not follow from the existence of musical works of unequal value that express the same emotion.[33]

My account of the basic conception of the musical expression of emotion also undermines two positions that threaten the relevance of the emotional qualities of a piece of music to its value as music. The first is a claim about the status of the emotional qualities of music to the effect that they have only a subjective existence, residing solely in the ear of the listener. The second concedes the objectivity of music's emotional qualities but advances a sceptical thesis about any listener's knowledge of them: no listener is ever in a position to know whether the emotion he hears a piece of music as being expressive of is really expressed by the music. Although each position seeks support from the striking lack of agreement about the precise emotional qualities of some music, this support is fragile. For although heard resemblances do reside in the ear of the listener, the resemblances are there to be heard, open to anyone with cultivated ears; and the heard resemblances that constitute

the musical expression of emotion are not fortuitous but are due to the composer's understanding and manipulation of his musical resources.[34] Furthermore, as I have indicated, the basis of these resemblances is often accessible to consciousness, so that our judgements about the emotional qualities of music, which lay claim to intersubjective validity, are not free-floating but can be given a solid ground.

FURTHER CONCEPTIONS OF MUSICAL EXPRESSION

I have advanced the above account of the expressive perception of music, according to which it is a form of cross-categorial likeness perception – one that consists in the experience of a likeness between, on the one hand, the objects of a sense modality and, on the other hand, 'internal' psychological states – as part of the analysis of what I called the 'basic and minimal' concept of the musical expression of emotion. For there certainly are other conceptions of expressive perception and the musical expression of emotion and I do not wish to deny their applicability to music. In particular, there are conceptions that exploit the accretions that the mere perception of a likeness between music and feeling is liable to attract – exploit them by building them into their conception of expressive perception and its correlate, musical expression.

One possible accretion to the basic perception of a likeness with feeling is the bare feeling itself: the music's sounding to you like how a certain emotion feels can induce the feeling in you, and is likely to do so if you 'set' yourself to resonate emotionally with the music. In such a case, the music no longer merely sounds to you as the emotion feels, but you experience the music with the feeling it sounds like – you experience what it feels like to feel sombre, melancholy, cheerful or blissful. A more stringent conception of musical expressiveness would demand not only the perception of a likeness with the feeling expressed, but the arousal of the feeling itself: only if this extra condition is satisfied is the music heard as being *expressive* of the feeling.

A different accretion to the perception of a likeness with a feeling,

which would yield a different account of musical expressiveness, would be the imagining of the feeling 'from the inside'. The fact that the music sounds to you like the feeling might induce you to imagine undergoing the feeling: as you listen to the music, guided by the likenesses you hear, you imagine what it is like to feel sombre, melancholy, cheerful or blissful. This is a different accretion from the first, since just as seeing differs from visualizing, so feeling differs from imagining what feeling is like. Now in this case your imagining does not float free from the music in which the emotion is expressed, for the imagined experience of emotion is sensitive to the nature of the music, which guides and shapes the experience; but it is tied no more closely to the music than by its going hand in hand with the nature of the feelings the music sounds to you to be like. But the activity of imagining a feeling might be bound up with the music in a more intimate way: in virtue of how the music sounds, you might imagine *of* your auditory experience of the music that it is an experience of feeling what the music expresses. Such a case is one not merely of cross-categorial likeness perception, but of cross-categorial imaginative identification. This yields a further conception of expressive musical perception as your imagining of your experience of hearing the music that it is an experience of the feeling you hear the music as sounding like.

Finally, a different imaginative project, founded in the perception of a likeness between music and feeling, could attach itself to the music in an especially intimate manner. Instead of imagining of your experience of hearing the music that it is an experience of undergoing the feeling, you might just imagine the music to be an instance of the feeling. An important difference between the first and second kinds of imaginative engagement with music is that whereas the first requires you to figure in what you imagine, the second does not. The second imaginative project requires you to do the imagining; but the imagining you are required to do in no way introduces you into what you imagine, and, in particular, it does not demand that you conceive of the imagined instance of feeling as your own. If you imagine the music to be an instance of the feeling, you thereby imagine someone's undergoing the feeling. The

subject of the feeling does not, however, need to be conceived of as anyone in particular – the composer, or yourself, for example, to take the two most likely candidates – but is allowed to assume no more definite form than that of the music's imagined 'persona'.

If you experience music in accordance with this last account, your experience of the music will be informed by the idea of emotion being experienced, and you will be imagining the music to be an occurrence of the emotion. Now imagining an occurrence of an emotion need not stir you to emotion: it might leave you emotionally unaffected. But it might encourage you to an emotional response. If you react with emotion to the emotionally expressive aspect of the music, let us assume that your response is of a simple, non-reflexive kind. Then it can take one of two forms: either you are infected with the emotion you imagine, or you are affected by that emotion in a sympathetic or antipathetic fashion.

If you experience a sympathetic response to the emotion expressed, you will be aware that the emotion to which you are responding is not real, but make-believe: you are only imagining an experience of the emotion, and it is this imagined emotion you are moved by. Your sympathetic emotional reaction will therefore be unlike a real-life case, in which your reaction is founded upon a belief about the actual occurrence of the emotion in a particular person; and it will be unlike it in more than one way. For in the case of the musical expression of emotion, the emotion you are moved by is not only imagined (rather than real), but both abstract and, as it were, disembodied: the emotion is not about any definite state of affairs and it is not experienced by someone of definite characteristics (age, race, sex, and so on). If the emotion is triumph, it will be triumph whose object is not specified, and it will be the triumphant feeling, not of a particular individual, but only of an indeterminate persona, defined only by the nature of the emotion that is make-believedly his or hers.[35] The emotion lacks both a definite object and a definite subject. Hence your sympathetic response to the imagined experience of emotion will consist only of an emotion directed to this disembodied and abstract emotion: you will experience sympathy for

melancholy or loneliness, or pleasure in another's imagined triumph or gaiety.

If your response to the emotionally expressive aspect of music mirrors the emotion expressed, it will still be the case that the emotion expressed by the music is experienced as both abstract and, in the sense I have given to the word, disembodied. But it will not now be true that you merely imagine an occurrence of the emotion: you will experience the emotion and you will experience it in the form in which the music expresses it. So you will experience what it feels like to experience melancholy or loneliness or triumph, without founding the feeling upon a definite thought that specifies the object of the feeling. Furthermore, you will be aware that this feeling is induced in you only through your imagination of the make-believe persona's emotion, so that your feeling of melancholy, loneliness or triumph will be experienced not merely in an indefinite or objectless form (as it might be in a real-life case), but in such a way that it will not thereby be true to characterize you as melancholic, lonely or triumphant.[36] The fact that you experience what melancholy, loneliness or triumph feels like will not imply that you feel melancholy, lonely or triumphant, in the sense that you will be in a melancholy, lonely or triumphant condition.

One advantage of this make-believe account of the expressive perception of music is that it readily accommodates any indefiniteness or nebulousness in the musical expression of emotion. Corresponding to your hearing music as being expressive of emotion, but not of any highly specific kind of emotion, there will be an indefiniteness in what is make-believedly true for you: if you experience music as being expressive of a state of enraptured and passionate contemplation (the sublime Molto Adagio sections of the third movement of Beethoven's String Quartet in A minor (Op. 132), for example), it will be make-believedly true that someone is in such an indefinitely characterized state; if you hear music only as being impassioned, the make-believe truth will be that someone is in that less specific state.

I have now identified a number of ways in which music might be experienced as abstract and yet as expressive of emotion, each based

upon the perception of a likeness between music and emotion, and each giving rise to a distinctive conception of the expressive perception of music (and so of musical expression itself). First, there is the bare likeness conception of expressive perception: the music sounds to you the way the emotion feels. In this case, you hear the music as expressing, not an *occurrence* of emotion, but a *quality* of emotion, not a real or imagined instance of sadness, say, but the property of sadness. Second, there is the likeness conception enhanced by an occurrence of the emotion itself: the music's sounding to you the way the emotion feels induces the feeling in you. Note that the feeling you experience lacks any object provided by the music (and must lack any definite object if it is an ingredient in the perception of music's expressiveness, rather than an artistically irrelevant response triggered by the music). Third, there is the likeness conception supplemented by the activity of imagining an occurrence of the feeling: the music's sounding to you the way the emotion feels induces you to imagine the feeling being undergone. In this case, you hear the music as expressing, not merely that *quality* of feeling, but an *occurrence* or instance of the feeling. There are two ways in which the imagination of an emotion might be tied especially closely to the music. In the first you imagine of your experience of hearing the music that it is an instance of feeling the emotion. In the second you imagine the music to be an instance of feeling the emotion. These define two more conceptions of the expressive perception of music: the music's sounding to you the way the emotion feels induces you to imagine of your experience of hearing the music that it is an instance of feeling the emotion; and the music's sounding to you the way the emotion feels induces you to imagine the music to be an occurrence of the emotion. Moreover, your imagining the music to be an occurrence of an emotion might induce a matching or contrasting feeling in yourself directed at the imagined occurrence of emotion, and a more stringent conception of expressive perception will require not merely the imaginative activity but such an emotional response.

But this does not bring to an end the ways in which music might be experienced as abstract and yet as expressive of emotion. Each of the

ways listed above is based upon the perception of a likeness between music and emotion. If we now liberalize the basis of the two imaginative projects that tightly link the imagination of the emotion to the music, we obtain further conceptions of the expressive perception of music. These result by dropping the demand that the imagining must be done in virtue of a perceived similarity between the music and the feeling imagined and allowing that the imagining can legitimately be controlled by the music in other ways; and unless these explicitly introduce representational or other non-abstract aspects of music to guide the imagination, they too will be consonant with music's abstract nature.

One advantage of a less stringent requirement is that it enables the imaginatively based conceptions of expressive perception to be generalized to other psychological states or characteristics which music can be expressive of in just the same sense as that in which it can be expressive of emotion. And this supports the claim that if when you imagine music to be an occurrence of emotion you respond emotionally to the imagined occurrence, the emotional response might either match the emotion expressed or react to it. For if you hear music as being expressive of heroism, say, it is plain that two possibilities are open to you: you can enact what you hear and experience what it feels like to be unflinching in the face of danger or you can be moved by the heroism you hear, as you might be moved to tears by an act of heroism or generosity that you witness.

THE MUSICAL REALIZATION OF EMOTIONAL QUALITIES

In whatever way the expressive aspect of music is experienced and whatever contribution it makes to the music's value, our experience of the expressive aspect is not separable from our experience of the music and we value the expressive aspect not in itself but *as realized in the music*. Because emotionally expressive music can be heard and valued without hearing it as being expressive of emotion, there is a temptation to think that when its emotional character *is* heard and the music valued on that account, the value of the music to the listener *in virtue of its*

expressive aspect is an increment to its 'purely musical' value. A related temptation is to think that a particular emotionally expressive aspect must make the same contribution to the value of any music that bears that aspect. But neither temptation should be yielded to.

A comparison with the expression of emotion in the human face helps to present the musical expression of emotion in the right light. In the first place, although it is possible to see a person's face and miss the emotion it is expressive of, the experience of the person's face as being expressive of that emotion is a new experience, which does not consist of the former experience and an additional component. Likewise, when we experience music as being expressive of a certain emotion, our experience does not consist of two components, one being an experience of the bare music – the music considered independently of its expressive aspect – and the other an experience of the emotion expressed. So the value of the music to us is not some kind of compound of the values of the two supposed component experiences. There is not, on the one hand, the music's 'purely musical' value and, on the other hand, its emotionally expressive value.

Secondly, two faces can express the same emotion, joy, say, and yet one of the joyful faces be more pleasing to look at. Furthermore, this face may not be very pleasing to look at generally, but only or especially when it is expressive of joy and it is seen to be so. Hence a face can wear an expression of joy and be visually pleasing only in virtue of doing so, and yet the same expression – the expression of the same emotion – be less pleasing on another face. So the fact that the character of a certain face is attractive to look at only or principally because it is expressive of joy does not imply that any face which expresses joy is for that reason equally attractive nor that the face in question is 'independently beautiful' – attractive to look at even when its expressive aspect is not seen. It will be the realization of joy *in the particular form which this face assumes* when it expresses joy that makes it so attractive to us, and the special appeal it then has does not need to derive from some further fact about the face (its 'beauty'). In this respect emotionally expressive music is similar: what appeals to us is the

instantiation of an emotional quality *by a particular arrangement of notes*. The 'beauty' of music and the emotional quality, if any, it expresses are not always independent features: music can be beautiful *as* an expression of a certain emotion.[37]

VALUES OF EXPRESSIVE PERCEPTION

But which of the conceptions I have outlined is the *correct* account of the expressive perception of music? The question is based on a mistake. These different conceptions should not be seen as competitors, amongst which we must choose the one that has the sole or best right to the title. Although some conceptions undoubtedly have a much wider application than others, nothing is gained by selecting one as the true claimant to a title that has been so widely conferred and whose possession entails no rights.[38] What is important is to realize how varied are the ways in which, when we experience music, we can hear it as being related to emotion; and for what reasons, and to what degree, we might value hearing music in one or the other of these ways and so value a composition for which it is correct to perceive it thus. It is clear that these various modes of experiencing music will not make equal contributions to music's appeal. On the one hand, the mere perception of a likeness between the music and an emotion constitutes at most a minimal enhancement of the experience of hearing the music, perhaps none at all. The basic and minimal sense of the musical expression of emotion does not in itself constitute an aesthetic value: it does not automatically endow music that accords with it an aesthetic value; the aesthetically sensitive listener can perceive an emotion in music (in the cross-categorial likeness sense) and yet be aesthetically unaffected by the perception.[39] On the other hand, the musically based imagination of emotion sometimes enables the listener to experience imaginatively (or really) the inner nature of emotional states in a peculiarly vivid, satisfying and poignant form. For music's resources can be used to enrich the comparative poverty of the unaided imagination and to shape and control the development of the imagined emotion, bestowing upon it whatever strength, complexity,

delicacy and inevitability the music possesses. Moreover, a musical work can be constructed in such a manner as to lead the imaginative listener through a succession of emotional states the vicissitudes of which form an intelligible drama that is resolved in a deeply satisfying way, concluding, perhaps, with a sense of the achievement of harmony, peace, stability, acceptance and understanding. Furthermore, in this kind of experience of emotionally expressive music the listener surrenders the autonomy of the imagination and delivers himself into the hands of the composer. If the listener's faith is not misplaced, his realization that the experience of emotion he imagines or undergoes is not his alone, but is open to others and has been made available by the creative imagination of the composer, encourages a sense of community that his private imaginings must lack.

MUSICAL EXPRESSION AND MUSIC'S ENIGMA

But whatever values these different modes of experiencing music may have, these various conceptions of the expressive perception of music transparently fail to underpin the view that a sufficient explanation of abstract music's eminence as an art resides in its ability to express emotion. For, apart from any other considerations, if expressive perception consists in one or the other of these experiences of music, not all valuable music is, or is intended to be, perceived as expressive of emotion. In fact, there is a striking lack of correspondence between valuable music and music that is properly heard as expressive of emotion.[40] How much valuable music is heard as sounding the way an emotion feels? How much engages the imagination to imagine the occurrence of emotion? Not very much. The perception of emotional qualities in music plays only a minor part in musical appreciation. Much of our experience of abstract music is not impregnated with the idea of types of emotion in any of the ways demanded by the various conceptions of the expressive perception of music I have outlined, but is of a purer kind. It is a 'purely musical' experience in the sense that it is devoid of the audible emotional content that characterizes the expressive

perception of music: the listener does not hear kinds of emotion in the music.[41] Although Bach's Ricercar in six voices in *The Musical Offering* is wonderful music, its appeal resides not in its being an expression of various kinds of emotional state, but in the masterly way in which Bach handles the voices, which intertwine harmoniously in ever-changing patterns, so that the listener's auditory world is one of constantly changing multiple developments in an ordered structure of unusual clarity and complexity. In Western music of the last few hundred years emotional qualities are most frequently heard in music only in the cross-categorial likeness sense, which, as I have indicated, is manifestly inadequate as a foundation for music's artistic value. Moreover, as I have already insisted, we value the expressive aspect of music not in itself but only as realized in the music. Unless the music that bears the emotional aspect is (as such) valuable to listen to, its expressive aspect is not sufficient to redeem it. Furthermore, there are few works that sustain for any length of time the imagination of music as being an occurrence of emotion.[42] Hence music's capacity to express emotion does not explain its high artistic potential.

It might be thought that this conclusion has been reached only because of the adoption of an over-stringent conception of music as an abstract art. By artificially restricting music's capacity to express emotion so that it will be consonant with this conception, there is little prospect of explaining music's power as an art by reference to its capacity to express emotion. But perhaps this is only because very little, if any, valuable music falls under this conception, and a more generous conception of music as an abstract art will not only usher in the great mass of valuable music but so widen music's expressive capacity that it can now explain music's artistic potential. But the situation is not materially altered if we relax the restrictions on music as an abstract art by dropping the requirement that it should not encourage perceived resemblances or imagined identifications with any directly audible phenomena, that is to say, sounds or sequences of sounds. Admittedly, this now allows in a whole host of conceptions of expressive perception based on perceived resemblances or imagined identifications with the impassioned

human voice or some *sui generis* bodily means of sound production.[43] But however widely such conceptions apply – my own view is that their application is exceedingly narrow – even when they are supplemented with the previous more abstract conceptions of expressive perception, their extent falls far short of the entire field of valuable music. Moreover, if we further relax the restrictions on music's abstract nature by allowing cross-modal perceived resemblances or imagined identifications with perceptible but non-audible or only indirectly audible phenomena, such as dancing or skipping movements, or stately or dignified manners of movement, and thus admit further conceptions of expressive perception, although we draw in more valuable music, we still do not capture all or even most of it. The truth is that music's capacity to express emotion, even when harnessed to other valuable qualities, is insufficient to explain the artistic value of music, for it plays no role in the explanation of the value of many musically impressive passages, and no or only a minimal role in the explanation of the value of many musical works. So the expression of feeling is only part of the explanation of music's value as an abstract art.

DIFFERENT KINDS OF EXPLANATION

We can now return to the idea that the power of abstract music as an art stands in need of explanation. This idea is no clearer than the notion of explanation it operates with. What kind of explanation is this supposed to be? Let us distinguish psychological from what might be called constitutive questions about value. Whereas a constitutive question seeks a specification of the nature of the value or the nature of its varieties, a psychological question seeks an account of why those people who are responsive to the value or its various forms are so responsive. The science of psychology attempts to specify the nature of the stimulus and the nature of the subject in ways that fit into a law, ideally a causal law, that relates the subject's response to the stimulus. Accordingly, a constitutive explanation works by identifying the value or values at issue, either by a formula or by a list; a psychological explanation makes

clear why whatever possesses the specified nature affects the person who appreciates it in the way it does by indicating the causal mechanism that mediates between cause and response. Constitutive questions about music's artistic potential concern the identification of features of music in virtue of which it has whatever artistic capacities it does possess: they concern *what* it is about the art of music that endows it with its artistic potential. Psychological questions call for causal explanations of the effects that valuable features of music have on the responsive listener: they concern *why* the listener finds these features so rewarding to experience, and hence why he values them. An explanation of music's power as abstract art could be aimed at answering either a constitutive or a psychological question, and, accordingly, the form an explanation assumes, and whether it can be arrived at by reflection or requires empirical investigation, will be determined by which question it addresses.

Now puzzlement can be removed just as much by answers to constitutive as to psychological questions. If the puzzlement about music's power is merely constitutive, it can be resolved by reflection on music's nature and what has actually been achieved within the art. If the puzzlement is psychological, it cannot be resolved at present, since the science of psychology is still in a primitive stage of development. But I believe that the puzzlement often expressed about music's artistic power tends to be neither constitutive nor psychological, but a confused mixture of which the constitutive is only a part, so that an answer to the constitutive question is likely to leave a sense of puzzlement. Given the lack of a psychological theory capable of explaining the power of abstract music to affect people so deeply, it might appear that music's power must remain mysterious. This is true in so far as the puzzlement is psychological, although, it should be noted, it is not a peculiarity of music, but applies equally to poetry, architecture, painting and the other art forms, that the science of psychology is unable to explain the strength and depth of the effects the art is capable of producing. I believe, however, that the residual sense of mystery is not merely, if at all, psychological in the sense I have given to that idea, and that it can

be reduced or dissipated without recourse to the missing psychological theory. For the puzzlement is largely due to a mistaken sense of the abstraction inherent in music's art – a sense of it as being both an isolated phenomenon and one that is incompatible with its manifesting qualities that appear elsewhere in our artistic and everyday lives. It can therefore be made to disappear by undermining the sense of abstract music's isolation and by retracing the links that bind music to so much else. I believe that the appearance of an insuperable problem or deep mystery arises only if music as an abstract art is regarded in a false way that isolates it from everything else: only by forgetting how much is involved in the experience of music and music's manifold connections with extramusical properties and values will music's value as an art seem to pose a theoretical problem of unusual difficulty. What is needed to render intelligible, unmysterious, the fact that we value so highly music as an abstract art is, therefore, not only an account of what constitutes its artistic values but a vivid realization of the manifold connections between these values and our extramusical life.

MUSIC AND ARCHITECTURE

One way in which perplexity about our response to a certain kind of thing can be removed or dissipated is by comparing it with an analogue that we find unproblematic (although, admittedly, the result of the comparison might be that the sense of mystery does not evaporate but, frustratingly, extends to shroud the formerly unmysterious analogue).[44] It is true that aesthetically attractive abstract audible forms occur, with few exceptions, only in the domain of music. So music's power cannot be rendered unmysterious by reference to aesthetically attractive abstract forms presented to the sense of hearing outside the art of music. But this leaves open the possibility of analogues accessible to other senses, and in particular to sight – analogues inside or outside art.

If there were another abstract art, comparable to music and with achievements of a similar range and order of rank, it might be possible to remove or diminish the appearance of mystery attaching to music as

an art in a particularly decisive way by coming to see it as a distinctive manifestation of more general kinds of artistic value. It has sometimes been thought that there is such an art, namely the art of architecture. The especially close connection that is often believed to hold between the arts of music and architecture has received recognition in Schelling's celebrated description of architecture as frozen music. This metaphor is based on the correspondence between, on the one hand, solids and cavities, which architecture disposes in space, and, on the other hand, sound and silence, which music disposes in time: just as at any point in a building there is either filled or empty space, so at any point in a musical work there is either filled or empty time. If architecture, considered as an abstract art, stands to music in something like the relation claimed, namely as being spread out in space rather than time, then, assuming that the artistic potential of architecture is unproblematic, all that is needed to explain music's distinctive artistic potential is an account of the differences that arise from the change from the abstract disposition of material in the three dimensions of space to the abstract disposition of different material in the single dimension of time. Accordingly, a comparison with the art of architecture will so illuminate music's eminence as an abstract art that the appearance of mystery hanging over it will be dissipated.

But the metaphor of architecture as frozen or petrified music limps too badly for this to be so.

To consider architecture as an abstract art, it is necessary to approach a building in abstraction from any representational elements it may contain, such as representational paintings on its walls or sculpture in its niches or projecting from its surfaces, and in abstraction from any overall representational aspect it may present (as with the Sydney Opera House). But even given this approach, there is a dramatic breakdown in the implied comparison between the two arts over the significance of non-artistic purposes in the construction and appreciation of works of art that fall within the two domains. Whereas the appreciation of architecture involves an appreciation of a work's suitability to discharge its overall non-artistic function as a temple, a bridge, or a house,

for example, and so an appreciation of the non-artistic function of its parts, as windows, walls or roofs, the appreciation of music as a non-representational art is free from such constraints. You need to see a cathedral *as* a cathedral and a chimney *as* a chimney if you are to appreciate the art of architecture, for what is an impressive cathedral will not be impressive if seen as a prison or castle, and the appropriate position for a chimney is not the same as that for a door. But no similar perceptions enter the appreciation of music. As with other functional objects that display art, the manifest suitability of its form to discharging its intended function is a criterion of a building's artistic excellence. As David Hume pointed out:

A ship appears more beautiful to an artist, or one moderately skilled in navigation, where its prow is wide and swelling beyond its poop, than if it were framed with a precise geometrical regularity, in contradiction to all the laws of mechanics. A building, whose doors and windows were exact squares, would hurt the eye by that very proportion; as ill adapted to the figure of a human creature, for whose service the fabric was intended.[45]

The fact is that the art of architecture involves the artistic employment of means for the realization of the non-artistic functions a building is designed to perform, and its appreciation is a highly individual mixture of the abstract, the representational and the functional. (This does not preclude the use of normally functional elements solely for aesthetic effect, as in the work of Michelangelo and much Baroque art.) For this reason architecture, even when divested of its representational elements, differs fundamentally from the abstract art of music.

Perhaps it will be objected that I have arrived at this conclusion only because I have not really been considering architecture as an abstract art. The conception of abstraction I have been operating with opposes the abstract to the representational. But, so the objection claims, this is just one alternative to the abstract. Another is the serving of a non-artistic purpose. To consider architecture as an abstract art it is necessary to ignore not only any representational elements or aspects of a building but also the intended non-artistic purposes of the building and its parts.

(This mirrors the restriction of the consideration of music to music *as such*.) The appreciation of architecture as an abstract art requires that appreciation should be restricted, if not to the abstract geometrical form of a building, at least to the spatial disposition of coloured and textured blocks of different kinds of matter, under the influence of gravity, and reflecting the influence of light. If pure music is abstraction in time, architecture is abstraction in space only when considered from this 'geometrical-mass-space-force-colour-light-and-texture' point of view (or a point of view with an even narrower focus).

This crude formulation – as a specification of the point of view from which architecture must be seen if it is to be appreciated as an abstract art – may or may not have merit. However, its adoption would undermine the hope of explaining the artistic potential of music by reference to that of architecture. For it is unclear what the artistic potential of architecture would be if it were to be considered from a point of view we never adopt, and, moreover, a point of view that would require an imaginative feat which, even if possible, is beyond what most of us are capable of. Moreover, the situation would not be improved by inviting us to engage in an apparently easier imaginative project, namely to consider an art of building whose products are designed not to discharge any non-artistic functions but solely to appeal to the specified point of view. Such an art of building, no longer limited by requirements of utility, would cease to be the art we are familiar with – the art of architecture. For the removal of the constraints imposed by the need to serve the purposes for which buildings have been constructed would radically affect the nature of the available forms. If the only non-artistic requirement of a building were stability, then, on the one hand, the art would not be restricted by the need to use any of those shapes capable of discharging the functions of doorways, roofs or chimneys, for example, nor by the positions in which they can properly be placed, and, on the other hand, it would be free to use any shape from the entire range of geometrical forms that could be made somehow to stand up. Since the artistic potential of such a monumental abstract art has never been realized and cannot be determined a priori, it would be fruitless to appeal to it.[46]

Does this mean that architecture is simply the wrong model for the abstract spatial art-analogue of music and that a more suitable model (abstract sculpture or Anthony Caro's 'sculpitecture' or pottery or non-representational painting, for example) would substantially illuminate the artistic possibilities of abstract music? I believe not. Apart from any other considerations, in Western culture there is no other art with as good a claim to being both an abstract art and an art that contains achievements comparable in artistic value to those of abstract music. Accordingly, we must acknowledge that there is no question of our being able to *derive* the artistic possibilities of abstract music from those of any other art. What is needed is not such a derivation but a combination of the recognition of music's singularity – the fact that it is not the mere temporal analogue of any other art, but one with a distinctive nature – with the denial that its abstractness entails a deep mystery about its power as art. In fact, as I shall argue, music's abstractness and singularity *explain* its distinctive artistic possibilities and appeal.

But although a comparison with architecture cannot unlock the secret of music's power as an abstract art, it would be wrong to conclude that reflection on architecture cannot diminish the 'mystery' of music's power. In the first place, it discloses points of similarity between the perception of architecture and the perception of music: both architecture and music are dependent upon the perception of resemblances, perceptual grouping, and physiognomic or corporeal perception (the projection of bodily qualities on to the objects of perception, in particular, postural, gestural or other bodily aspects or activities that are experienced as expressive of moods or emotions). So the presence of architectural or musical values in our experience comes about through the exploitation of common perceptual processes. More important, in so far as puzzlement about music's artistic eminence is due to music's abstract nature, the manifest appeal of abstract relations elsewhere in art undercuts the feeling that there is something inherently problematic about the value of music as art. It must be admitted, however, that a comparison with the role of abstract relations in architecture – the spacing of columns or

windows, the elaborate patterning of tracery, the contrast or echoing of two- or three-dimensional shapes, the tapering of a spire or dome, the proportions of the vertical or horizontal divisions of a country house or palace, and so on – is in itself likely to do relatively little to reduce the sense that music's power is mysterious. It is true that music and architecture share some common values. For example, both music and architecture aspire to combine their materials into harmonious wholes, in the one case harmonious temporal processes, in the other harmonious spatial structures. But harmoniousness is too general a value for the identification of harmoniousness as a potential value of music, and reflection on its importance in architecture, to make a real impression on the 'mystery' of music's power; and the impression is not greatly deepened by the addition of other common values of a similar general nature, such as strength, vitality and organic growth.

DISSOLVING THE ENIGMA

But if reflection on the appeal of the perception of abstract relations in architecture is now supplemented, firstly by the realization that a vast range of our aesthetic responses are neither to representation as such nor dependent on it, secondly by considering how widespread the aesthetic attraction of non-representational forms and qualities really is, both within and outside art, and thirdly by considering both what is true of music in virtue of the fact that it is *an art* and music's distinctiveness as an art, then the feeling that music's value as art is unusually problematic should disappear (unless it is based solely on the yearning for a psychological theory that is not available).

In the first place, the feeling that music's power as an abstract art is problematic is vulnerable to the consideration that abstractness does not preclude an abstract work of art from possessing aesthetically valuable qualities of many different kinds, qualities that are not peculiar to music. These include such specifically aesthetic qualities as beauty, elegance and gracefulness. Musical works that possess such qualities in abundance are as we would wish the world to be if it existed just so that we should

exercise the sense of hearing on it, for no other end than delight in its exercise. But it is more important to stress other qualities. Consider so-called affective qualities – the quality of being amusing, for example. Not only is this quality compatible with the abstract, but there is no difficulty in the idea that abstract music should possess it. Autonomous musical humour, that is to say, comic music not based on extramusical allusions, can be achieved by bizarre contrasts of dynamics and register (as in the thirteenth of Beethoven's *Diabelli* Variations, Op. 120), by the witty reinterpretation of the musical significance of notes, that is, by musical puns (as in the finale of Haydn's D major Trio H. 7), by the music's pretending to end before the finish (as with the last movement of Haydn's String Quartet Op. 33, No. 2), by deliberate musical 'mistakes' (as when the principal theme of Chopin's E minor Piano Concerto reappears a semitone flat, a 'mistake' which is not corrected till eight bars later, or when, similarly, the first section of his F sharp Impromptu returns at first in the 'wrong' key, a semitone too low), by a capricious tempo (as with the opening of the last movement of Beethoven's First Symphony or the portentous slowings-up near the end of the Fourth), by the use of instruments unsuited to the music they play, or in numerous other ways.[47]

Secondly, the range of aesthetically appealing abstract forms and qualities is in fact widespread: it extends from simple, non-representa-tional visual patterns, such as a spiral or those visible in a kaleidoscope or a mosaic floor, through the infinite variety of the colourful forms of flowers, shrubs, trees and other living things,[48] to Islamic 'decorative' art or the decorative arts of other religious cultures which proscribe the artistic use of images. Furthermore, pure music is distinguished both from other arts in which abstraction occurs and from the natural and man-made non-artistic world in that in these latter cases it is in general necessary to *abstract from* other features of the objects perceived if abstract forms are to be in the foreground of consciousness and appreci-ated in abstraction from what they belong to – a task that is often possible only to a very limited extent – whereas music presents nothing but such forms.

Perhaps it will be objected that the parallels I have gestured towards must fail to illuminate the distinctive value of music as an art, since music is essentially an art of *time* – indeed, in so far as music is an abstract art, it is the only abstract art of time – and it is this combination of features (the presentation of abstract temporal forms) that endows music with its distinctive value and at the same time renders its value hard to understand.

It is true that music is an art of time, not only in the superficial sense that musical works are temporal processes, but also in the more fundamental sense that musical works consist of temporal *Gestalten*, the perception and appreciation of which is of a unique kind.[49] But in fact the recognition of the temporal factor intrinsic to music not only fails to diminish the power of the analogues to reduce the sense of mystery attaching to music as an art, but enables a further reduction in that sense of mystery by the exploitation of additional parallels, of a different kind, especially between the activity of listening to music and various other activities of following the unfolding of a series of events linked to one another by relations of resemblance and contrast, which involve the arousal of expectations, delay in their satisfaction, their gratification, anticipations and memories, the building to a climax, the final coming to rest, the release of tension – all of which can be intrinsically rewarding.

So an additional way in which the appreciation of music as an abstract art can be seen not to be isolated from everything else in our lives emerges if we compare (in the broadest terms) the appreciation of music with various kinds of aesthetic or quasi-aesthetic appreciation of processes outside music. For example, in a sonata for violin and piano it is characteristic for one instrument to imitate the other, for the two instruments to compete in their characterizations of a theme by endowing it with their distinctive strengths or emphasizing aspects especially suitable to them, for one and then the other to play a supporting role while the other commands attention, for the two to intermingle, to unite, to blend harmoniously or to separate, for one to initiate and the other to respond, and so on. In these and other ways, there is a marked parallel between a duet between violin and piano and, for example, a

pair ice-dancing: the pair link together in a variety of ways, the performers separate, pursue their own courses, only to unite again, one dominates the action while the other plays a supporting role, and so on. In both cases, there are two things to admire: first, the skill of the performers ('technical merit'), and, second, the artistic character of what they execute – the movements or music ('artistic impression'). Despite the obvious differences between the two activities, in some respects they offer similar attractions to spectators or listeners. (It is unsurprising that competitive ice-dancing is performed to 'matching' music.)[50]

A more significant parallel is with drama. As Tovey was fond of emphasizing, music was transformed (more or less in Johann Sebastian Bach's lifetime) from an architectural, decorative and rhetorical art to an art whose structure and power was essentially dramatic. The establishment of music as an autonomous art went hand in hand with the development, especially in the sonata style, of the dramatic possibilities inherent in key relationships as structures in which melodies of contrasting characters are embedded and subjected to melodic, rhythmic and harmonic change. In virtue of the resources available to abstract music, especially tonality, dynamics, speed, musical mass and texture, melodic character, emotional and other expressive qualities, and the range of qualities common to music and those physical movements that are embodiments of actions (dancing, for instance)[51] – rhythms of all kinds, goal-directedness, calm or restlessness, awkwardness or grace, gentleness or violence, decisiveness or indecisiveness, vigour or lethargy, completeness or incompleteness, and so on – it is possible to compose musical processes that possess to the highest degree the quality of dramatic action, as was realized supremely in Beethoven's music. Consider the colossal first movement of his 'Eroica' Symphony. By the use of such features as harmonic progressions and instrumental colourings, violent rhythmic figures, changes in momentum and urgency, development of material, anticipations, backwards references, melodies of contrasting character, recombination of elements, vehement syncopated accents, dissonant juxtapositions of tones (the famous dissonance in bar 7), interruptions, pauses, gigantic leaps, silence, explosions of sound, varied

dynamics, crescendo and decrescendo, Beethoven builds a gigantic musical structure in which a series of dramatic conflicts engendering tremendous tensions and climaxes is worked out, the music ending with a final resolution of the elements of the conflict. Furthermore, it is characteristic of the experience of great dramatic music with which one is familiar not merely that the music, heard as having the dramatic character it possesses, fills one's consciousness as it unfolds in time and affects one accordingly, but that one enters the music in one's imagination and inwardly enacts the music's tonal and chordal motion, so that one undergoes imaginatively the kinetic and other qualities of the music – or, in T. S. Eliot's words, 'music heard so deeply / That it is not heard at all, but you are the music / While the music lasts'.[52] It could hardly be thought surprising that such an imaginative identification with music results in an experience of an exceptionally compelling and rewarding character.

But the most vital consideration, implicit in the parallel with drama, for dissipating the sense that music's value as an abstract art is enigmatic is not so much the comparisons made possible by the fact that music is an art *of time*, but what is true of music in virtue of the fact that it is *an art* of time, and the distinctive nature it is endowed with in virtue of the elements that compose it. For abstract forms encountered outside art have not been designed with the intention of maximizing their aesthetic appeal, in themselves and in relation to other surrounding or overarching abstract forms. Furthermore, in virtue of its materials and our sensitivity to minute differences in them, music is distinguished by the number and variety of the abstract forms and relations that can be present in a composition. A sophisticated musical work is characterized by a number of levels of organization of its elements, the interlocking of the rhythmic, melodic and harmonic structures into which its elements are grouped, the possibility of tonal and chordal motion of limitless variety, simplicity and complexity, and the artistic use of numerous other musical variables (texture, dynamics, orchestration, accent, tempo, and so on). It would be a Herculean task to attempt to describe all the musical relations we hear when we listen to a musical masterpiece – Beethoven's String Quartet in

C sharp minor (Op. 131), for example. Accordingly, the distinctiveness of music's materials and music's freedom from the constraints governing the creation and perception of architecture or other functional arts make room for an extraordinary intensification of the appeal of pure abstract relations in art. Is it any wonder that the embodiment of abstract forms in music and the remarkable enhancement of their appeal when composed *with art* should result in a colossal magnification of their power?

MUSICAL EXEMPLIFICATION

But this is not quite the end of the story, for so far I have been working within a highly restricted conception of what is available to an abstract art. A reconsideration of the idea of an abstract work of art as one that 'represents' or refers to nothing outside itself brings into focus important features of music that serve to explain its artistic potential. For how is the idea of the representation of or reference to something 'outside itself' to be understood? Apart from obscurities in and differences between the concepts of reference and representation, the idea of something 'outside itself' that a work is *of* or *about* is ambiguous. It could be understood in an absurdly strong sense, so that abstraction rules out reference to or representation of non-relational properties that the work possesses or relations amongst its parts -- properties or relations that are also possessed by or hold amongst other things. Alternatively, it could be understood to rule out reference to or representation of anything other than non-relational properties of the work itself or relations amongst its parts.

If it is understood in the weaker way, it allows in a characteristic feature of works of art that Nelson Goodman has rightly drawn attention to, namely the exemplification of properties.[53] A work of art exemplifies a property if it both (literally) possesses and refers to it, as a sample both possesses and refers to whatever properties it is a sample of. By extension, a work can be said to exemplify a relation or relational property if one part of it stands in this relation to another part and the work refers to this relation. Clearly, music's abstract nature is not

compromised by allowing abstract music to be about something, if what it is about is itself abstract. Consider the relational property of *imitation*. A common device in music is for one instrument (a piano, say) to play a passage and another (a violin, say) to imitate it; and if an appreciation of the music requires the listener to hear the sound of the one *as* an (intentional) imitation of the other, the work can be said to be about the property of imitation (as well as much else, presumably). A common form in music is that of theme and variations. Since an appreciation of a work of this form requires the listener to hear the variations *as* variations of the theme, the work can be said to be about the relational property of similarity in difference – the listener understands the work only if his experience of the music is imbued with this idea. Again, in the development section of a movement that answers to the traditional characterization of sonata-allegro form,[54] the listener is required to perceive all manner of relationships between what he hears and the subjects of the movement – that what he now hears is a fragment of the first subject, for example; and in the recapitulation he must hear the subjects as returning in their original shape as the music returns to the home key, so that his experience of the music is impregnated with the ideas of recurrence and coming back. The reason the listener must hear such a movement in accordance with the conceptions of *exposition*, *development* and *recapitulation* if he is to understand it is because the movement is about the development of original materials of contrasting character leading to a return to the original state, more or less, in which the tensions generated in the movement are resolved.

What these illustrations serve to bring out is the fact that the appreciation of music is infused with the perception of relations between parts *as* such relations, and that these relations are not specific to music but obtain outside it. Furthermore, if the idea of the exemplification of properties by works of art is extended to what can be called 'make-believe exemplification', by which I mean that the work both refers to a property and possesses it make-believedly, then the range of properties that musical works can be about is greatly extended. The neglect of these facts contributes greatly to the feeling that music's abstract nature

renders its power to engage and reward our interest theoretically problematic.

A final point. An especially significant form of musical exemplification is the exemplification of *values*.[55] One general value exemplified by many fine musical works is the unification of diverse materials, the harmonious reconciliation of multiplicity within a unity, so-called 'unity in diversity' or 'organic unity'. Such a unification can be effected in many different ways, and particular musical works that possess organic unity and refer to the organic unity they possess exemplify not only organic unity but their own species of that value. Other values that can be exemplified in music include beauty, gracefulness, wit, imagination and mastery.[56] Unblemished musical works that exemplify these values are paradigms of perfection, appreciated as such. How could anything more be demanded of music as an abstract art?

Notes

1. This idea is certainly as indefinite as the idea of a particular work of art, which in the case of the performing arts allows for different performances of the same work, and in the case of prints, etchings and engravings, for example, for different impressions of the same work, these different instances exhibiting aesthetically significant differences amongst them. Thus a musical work can be performed compatibly with the score, the performance traditions of the composer's musical culture, the composer's intention, and any other standard of correctness, in different ways – ways that endow the work, as so performed, with different aesthetic qualities. Although this limits the precision of the idea, it does not affect its primacy in an account of artistic value.

2. This assumption, in the case of representational works of art, would presuppose that certain questions about the representation, questions about the relations between the content of the representation and reality, or between the response to the content (as represented) and the appropriate response to such a content in reality, are irrelevant to questions of artistic value. It would thus prejudge important issues in the philosophy of criticism – issues of truth and realism, for instance.

3. Contrariwise, the experience a work offers can be such as to be conducive to harmful effects, as when a work caters or panders to undesirable appetites or attitudes and by doing so not only provides satisfaction for them but is liable to encourage, strengthen or perpetuate them. But even in a case of this sort, it is the nature of the experience, not what influence it might actually have, that determines the artistic value of the work.

4. On a simpler level, an experience the nature of which involves a heightening of consciousness, our being more intensely alive than we normally are, is liable to have a tonic effect or influence (something that outlasts the experience itself), so that we return from the world of

art quickened and refreshed. But the experience of art may have a short-term devitalizing effect, as a result of emotional exhaustion, for example, as with a work as demanding as Wagner's *Tristan and Isolde*.

5. Yvor Winters, *In Defense of Reason* (London: Routledge & Kegan Paul, 1960), pp. 28–9. Compare Shelley's well-known statement in his 'A Defence of Poetry': 'A man, to be greatly good, must imagine intensely and comprehensively; he must put himself in the place of another and of many others; the pains and pleasures of his species must become his own. The great instrument of moral good is the imagination; and poetry administers to the effect by acting upon the cause.'

6. The crudity of Bentham's hedonistic conception of value and his understanding of human life is never more cruelly exposed than in his reflections on poetry (and the other arts). It is well known that he asserted that 'prejudice apart, the game of push-pin is of equal value with the arts and sciences of music and poetry. If the game of push-pin furnish more pleasure, it is more valuable than either.' (*Works*, II, p. 254, quoted in C. K. Ogden, *Jeremy Bentham 1832–1932* (London: Kegan Paul, Trench, Trubner, 1932), p. 66.) Less well known is his remark (quoted in Ogden, p. 87): 'Poetry: no more reason for teaching it than chess or cards.' In fact, Bentham believed that the immediate pleasure derived from poetry is more than offset by the ultimate pains which it is liable to give rise to by the 'misrepresentation' intrinsic to it, so that in the scales of the hedonic calculus it is outweighed by push-pin.

7. There are two ways in which art might be assessed by a moral (religious, social) yardstick. The first, exemplified by Tolstoy in *What is Art?*, is to define art in such a manner that a work's artistic value is determined by its contribution to morality (religion, society). The second, exemplified by Plato in his famous critique of art in the *Republic*, is to assign a work's artistic value no weight in comparison with the moral harm the work might do by encouraging socially undesirable attitudes and feelings in those who delight in the work.

8. Friedrich Nietzsche, *The Birth of Tragedy*, §5. Compare Nietzsche's later remark, 'As an aesthetic phenomenon existence is still *bearable* for us', and the wonderful continuation of the section in which it occurs (*The Gay Science*, §107). It should be remembered that in his later thought Nietzsche is recommending the adoption of both an aesthetic (spectatorial) and, especially, an artistic (creative) attitude, rather than (just) a moral attitude, *towards ourselves*.

9. See especially Kendall Walton, 'Categories of Art', *The Philosophical Review*, Vol. LXXIX, 1970.

10. For an excellent defence of the view that to appreciate a work of art is to appreciate the artistic achievement it represents, see Gregory Currie, *An Ontology of Art* (Basingstoke/London: Macmillan, 1989).

11. It is a trivial truth that the only *access* to the value is through acquaintance with the work. But this does not imply that your judgement of a work is not properly a judgement of its artistic value unless you are acquainted with it.

12. Although standardly you will judge that a work possesses artistic value only if you find it intrinsically rewarding to experience, I have not argued, and it would be mistaken to do so, that you must find a work intrinsically rewarding if you are rightly to judge that it possesses artistic value. A fortiori, I have not argued that your judgement of a work's artistic value must reflect the nature and degree of your affective response to it. In fact, you can have good grounds for judging that a work you do not find intrinsically rewarding to experience offers an experience that is intrinsically valuable. Most of us are aware that we are not ideally sensitive aesthetic spectators, and that there are forms of art that leave us cold but which are found intrinsically rewarding by other people whose aesthetic sensitivity is not less than our own. Moreover, we can sometimes make fairly accurate discriminations of artistic value amongst works none of which interest us. So we can fail to appreciate works we properly judge to be valuable. This will generally be because when we interact with the work we do not undergo the experience the work offers. But there is also the possibility that although we undergo the right experience, we fail to find it rewarding, either at all or to the degree it merits.

13. 'The experience of the work' must here be understood with a certain latitude in order to accommodate cases in which you value the experience of the work, although there are certain aspects of the work that displease you and that you regard as detracting from the work's merit, or there are aspects of the work that you are indifferent to and that you regard as not enhancing the work's value.

14. As it stands, the doctrine appears to require an artist to create a work of art with the intention of communicating something to a particular individual or group of people or with the hope that somebody will experience the work and understand its message. If the reference to an

individual in this requirement is restricted to someone other than the artist, the requirement is often violated. But perhaps an adherent of the doctrine would allow the reference to include the artist and would claim that in creating a work of art the artist must assume the role of spectator and judge her product from the point of view of its suitability to communicate the message it contains.

15. My friend's letter may not only communicate her thoughts but give an impression of the process of her thinking them out. I ignore this complication.

16. The conclusion that the communication conception of artistic value fails to do justice to the experience of the work itself can be extended to cover the more general functional conception. Whatever function a work of art may perform, it is not the performance of this function that determines the value of a work of art as a work of art. The denial that the particular 'message' communicated by any valued work could be communicated by anything else, and the assertion that what a valued work communicates is *itself*, are closely related distortions of thought caused by the compulsion to use the model of communication but an unwillingness to accept the implications that flow from the notion. The motivation is to secure the indispensability of the experience of a work, but the strategy is misguided.

17. David Hume, *Essays, Moral, Political, and Literary*, ed. Eugene F. Miller (Indianapolis, Ind.: Liberty *Classics*, 1987, pp. 226–49).

18. Hume, 'Of the Standard of Taste', loc. cit., pp. 231–4.

19. In what follows I ignore Hume's tendency to locate secondary qualities in the mind of the observer, as intrinsic, non-representational characteristics of the observer's experience. This is certainly a mistake, but is inessential to Hume's strategy. I also ignore the question whether secondary qualities are properly conceived of as powers to induce distinctive kinds of (non-representational) experience in sentient creatures. Hume's inclination to think of colours as non-representational features of visual experience endows his much-quoted formulation of a 'projective' conception of taste with an additional appropriateness: '[Taste] has a productive capacity, and gilding or staining all natural objects with the colours, borrowed from internal sentiment, raises in a manner a new creation.' (*An Enquiry Concerning the Principles of Morals*, App. I.)

20. The analogy with colour that Hume seeks to exploit would be more

perfect if Hume had identified the determinant of an object's colour as the person who can make the most subtle discriminations of colours, not the healthy man.

21. This explains Hume's insistence, elsewhere, on the complexity of the process necessary to issue in a proper sentiment of a work's beauty: 'But in order to pave the way for such a sentiment [of beauty], and give a proper discernment of its object, it is often necessary, we find, that much reasoning should precede, that nice distinctions be made, just conclusions drawn, distant comparisons formed, and general facts fixed and ascertained. Some species of beauty, especially the natural kinds, on their first appearance, command our affection and approbation; and where they fail of this effect, it is impossible for any reasoning to redress their influence, or adapt them better to our taste and sentiment. But in many orders of beauty, particularly those of the finer arts, it is requisite to employ much reasoning, in order to feel the proper sentiment; and a false relish may frequently be corrected by argument and reflection.' (*An Enquiry Concerning the Principles of Morals*, Sect. I.)

22. Although Hume's account is focused on the appreciation of literature, it is intended as a model for all kinds of artistic value. But there is no presupposition, either within an art form or across different arts, that someone who satisfies the requirements for one kind of art will also satisfy them for another. Rather, the idea of a true judge needs to be relativized to the various kinds of art, which demand different sorts of sensitivity and require knowledge of different bodies of work.

23. Without the proposition that certain qualities are 'naturally fitted' to give pleasure to the human mind, Hume would not be able to defend the intersubjectivity of judgements of artistic value: judgements of artistic value would have no greater claim to intersubjective validity than judgements about the niceness or nastiness of tastes and smells. In fact, Hume gives no better reason for accepting this proposition than might be given for believing that certain tastes or smells are 'naturally fitted' to give pleasure to human beings.

24. In fact, Hume believes that if the source of variation in people's responses is a difference in their ideas of *morality and decency*, a response based on a false morality must be condemned. Hence he should have imposed an extra condition on his true judges, namely that they should have sound moral opinions or sentiments. But Hume is right to insist

that in so far as the deliverances of faultless sensibilities need not coincide – in so far as sensibilities may vary across people without defect of any kind – the claim to universal validity of an aesthetic response cannot be justified: judgements of artistic value are premissed on the supposition of a community of sentiment and cannot be imposed on those who diverge faultlessly from it.

25. This feature of Hume's position is more or less forced on him by his mistaken identification of a person's judgement of the artistic value of a work with the sentiment it arouses in her. For this implies that a judgement of relative artistic value is identical with the person's preference, that is to say, the more pleasurable sentiment. Hume did not require his true judges to discount the increment or diminution their sentiments receive from the two allowable sources of variation, because he thought this was in general a difficult or impossible task. In fact, what pleases you more may not be what you credit with the higher artistic value: you can derive more pleasure from a work that you do not judge to be better than another – that, perhaps, you judge to be less good; moreover, you can be emotionally dead to an over-familiar work of high quality, and you can recognize a defect in your sensibility which prevents you from appreciating forms of art you have good reason to accept as fine. Furthermore, a judgement of relative artistic value arising from and reflecting one of Hume's allowable sources of variation is based on an aesthetically irrelevant consideration and so is likely to be mistaken.

26. What Hume needs is an account of the supposed common affective nature and a demonstration that only this element of a subject's nature could be responsible for the subject's response, if the subject satisfies the criteria for being a true judge and operates under the right conditions. Given the number and variety of differences – differences of gender, race, class, education and culture – compatible with being a true judge, Hume's complacent assumption is insecurely founded.

27. John Stuart Mill, *Utilitarianism*, Ch. II.

28. So artistic value does not have the status of a secondary quality. In addition to the considerations already advanced, artistic value is distinguished from secondary qualities by the fact that, although the ascriptions of each cannot be adequately understood except in terms of subjective states, whereas the ascription of a secondary quality must be

understood in terms of an experience with an intrinsically representa-
tional character, the ascription of artistic value must be understood in
terms of an experience with a non-representational character.

29. Immanuel Kant, *Critique of Aesthetic Judgement*, First Book, First
Moment, §7. It is a notable feature of Hume's approach that the kind of
basis it provides for assessing judgements of artistic value, namely the
(uniform) affective response of those capable of the most sensitive
discriminations, is no different from that which might be given for
assessing judgements of the niceness of tastes and smells or other
secondary qualities, even simple ones.

30. There is no room for such a question with simple, undifferentiated,
structureless sensory qualities of objects. If an object is not of such a
nature as to have an experience of it altered by reasons for experiencing
the object under a certain description, the experience does not allow of
education and, accordingly, does not admit the possibility of one
person's response being better suited to the object than another person's.
Only structure introduces the possibility of understanding or misunder-
standing, of the appreciation of aesthetic qualities dependent on relations
amongst elements and of good or bad taste.

31. Presumably, these rules or principles of taste relate sentiment-
independent properties to artistic value, claiming that these prop-
erties necessarily constitute aesthetic merits of any work that possesses
them – as possessing a powerful shot is necessarily a merit in a soccer
player, whatever defects he may suffer from. Hume's view is that any
such rules are subservient to the standard of taste defined by the
sentiments of true judges. That is to say, any proposed principles of
taste that are not in accordance with the standard of taste are
incorrect. It is a moot point whether there are any non-trivial principles
that link sentiment-independent properties or non-evaluative properties
to artistic value. See, for example, Monroe C. Beardsley, 'The General-
ity of Critical Reasons' in his *The Aesthetic Point of View* (Ithaca, NY:
Cornell University Press, 1982); Mary Mothersill, *Beauty Restored* (Oxford:
Clarendon Press, 1984); Alan H. Goldman, 'Aesthetic Qualities and
Aesthetic Value', *The Journal of Philosophy* (Vol. LXXXVII, No. 1,
January 1990).

32. Two illuminating commentaries are Paul Guyer, *Kant and the Claims of
Taste* (Cambridge, Mass./London: Harvard University Press, 1979),
which is restricted to the topic of the intersubjective validity of

judgements of taste, and Mary A. McCloskey, *Kant's Aesthetic* (London: Macmillan, 1987).

33. This mirrors the requirement of Kant's moral philosophy that an action for which you are morally praiseworthy is not performed for the sake of satisfying one of your desires: both morally praiseworthy action and the experience of beauty require you to consider something in abstraction from your desires. Since Kant must allow for the possibility that your pleasure in seeing an object is both interested and disinterested – as when you are pleased to find what you are looking for and also delighted by its beauty – pleasures must be individuated at least partly by reference to their intentional objects, by reference to what it is that the pleasure is pleasure *in* (alternatively: pleasures are interested or disinterested only under a description of their intentional objects).

 Kant imposes the additional requirement on your pleasure being disinterested that it should not engender a desire for something *directly* (i.e., not through combination with something else) *as a matter of necessity*. But this imposition is unnecessary: it is motivated by Kant's concern to distinguish delight in the beautiful from delight in the merely 'agreeable' and delight in the good; Kant's claims about delight in the agreeable and delight in the beautiful are unwarranted; and the condition that a disinterested pleasure should not give rise directly to a desire as a matter of necessity is irrelevant to the question of the intersubjective validity of pleasure in the beautiful.

34. Colours, for example, might be represented to different people by different intrinsic features of their visual experiences – or so Kant thought; and even if colours are seen by means of visual experiences of the same kind, colour preferences need not coincide. It is essential to Kant's strategy that the perception of form differs from the perception of 'matter' in both these ways: the form of an object is represented (in a given sense-modality) to people by the same intrinsic features of their experiences, and it is not a contingent fact that disinterested affective responses to a certain perceptual form are uniform.

35. Kant, *Critique of Aesthetic Judgement*, op. cit., §23.

36. ibid., 'General Remark on the First Section of the Analytic'.

37. There is a notorious ambiguity in the idea that delight in the beautiful arises from the mere apprehension of an object's form, 'apart from a concept'. This could mean either that the object is not experienced under any concepts (except those directly implicated in its being seen

as the specific formed matter it is seen as), or that the pleasure is not experienced in virtue of the object's being experienced under whatever concepts it is experienced under. Although Kant in places appears to come dangerously close to embracing the first alternative, the second not only secures all the arguments he erects on the idea but is required by much of what he writes.

38. Kant recognized that you can be mistaken about the ground of your pleasure, so that a judgement of taste, although sincere, can be mistaken. Perhaps he thought that you could never *know* that a judgement of taste really was properly founded, i.e., on a disinterested pleasure in an object's form. (This would mirror his belief that you can never know whether you are morally praiseworthy for an action you perform, that is, according to Kant, whether you perform an action *for the sake* of duty.)

39. There are obscurities and infelicities in Kant's account of judgements of dependent beauty; and he fails to make clear *which* intention that an artist might have about the nature of her work determines the concept of what kind of thing it is intended to be (and so what it is to be a satisfactory instance of that kind). Clearly, not any intention will do, especially an intention to create a work with a certain aesthetic value. If the intention is to create something that is the expression of a certain aesthetic idea, there is a problem about an artist's ability to have that intention. See note 43.

40. Kant, *Critique of Aesthetic Judgement*, op. cit., Introduction VII and §§9, 21, 38.

41. I leave on one side Kant's tendency to embrace an over-strong formalistic position not implied by the basic aspects of his conception of a judgement of taste. If the perceptual form of an object is the structure of its perceptible elements, then relations amongst colours are just as much part of an object's perceptual form as are its shape and inner contours. And even if, as Kant thought possible, colours are represented to different people by different intrinsic features of their visual experiences, the relations amongst these intrinsic features will track the relations amongst the colours perceived. Hence the appreciation of an object's perceptual form does not require abstraction from the colours or other sensuous qualities it displays.

42. Kant, *Critique of Aesthetic Judgement*, op. cit., §49.

43. The most immediate problem for Kant's conception of a work of art as being the expression of aesthetic ideas arises from the stipulation that

an aesthetic idea cannot be (adequately) conceptualized. For this implies that it is impossible for anyone to have good reason to believe that a work of art that she experiences as the expression of a certain set of aesthetic ideas is experienced by another person as the expression of that same set of ideas. Indeed, a stronger conclusion follows: nobody would be able to identify *for herself* the aesthetic ideas expressed by a work of art. In fact, Kant oscillates between two accounts of what cannot be adequately conceptualized, the first indicating the aesthetic idea itself, the second specifying the wealth of thought (feelings, and 'kindred representations') the aesthetic idea gives rise to. The second conception is certainly preferable, and invites elucidation in terms of the indefiniteness of the range and the incompleteness of the nature of the thoughts that fly through the mind.

44. Kant, *Critique of Aesthetic Judgement*, op. cit., §51, opening sentence.

45. In so far as Kant's position is that the communicability of the disinterested pleasure in a work's form *effects* the communicability of the aesthetic ideas it expresses, it inherits the defects of the deduction of judgements of taste.

46. Kant, *Critique of Aesthetic Judgement*, op. cit., §51, opening sentence.

47. ibid., §59.

48. ibid., §42.

49. It is clear that when Kant explores the possibility of an immediate intellectual interest in natural beauty he is *presupposing* the communicability of disinterested pleasure taken in the form of natural objects of beauty, rather than advancing an alternative or additional foundation for it.

50. Kant, *Critique of Aesthetic Judgement*, op. cit., §§59 and 60, and Introduction IX.

51. This interpretation is put forward by R. K. Elliott, 'The Unity of Kant's "Critique of Aesthetic Judgement"', *British Journal of Aesthetics*, Vol. 8, 1968, and by Donald W. Crawford, *Kant's Aesthetic Theory* (Madison, Wis.: University of Wisconsin Press, 1974). For a critical discussion of this interpretation, see Guyer, op. cit., Chapter II.

52. I have claimed that artistic value is an intersubjective value: it is built into the concept that a judgement of artistic value aspires to intersubjective validity. Note that scepticism about the possibility of vindicating this aspiration is not tantamount to rejection of the account of artistic value I have developed. All that such scepticism warrants is the claim

that judgements of artistic value involve a mistaken or unfounded 'objectification'. Even if nothing were to make one affective response more appropriate than another, so that the concept of artistic value would lack any application, the status of artistic value would still be intersubjective. Conceptual analysis is one thing; the applicability of the concept another.

53. Consider humour. There is no reason to suppose that the capacity to find something funny is common to or even widespread amongst all rational agents. It might be specific to human beings. Even if it is not, different species might not find the same things funny, to the same degree.

54. A reductive analysis of the concept of the artistic value of a work in terms of its power to induce intrinsically rewarding experiences in subjects fails to do justice to the evaluative component of the concept, as do other dispositional accounts of value that omit reference to the idea of a merited response. The most sophisticated dispositional theory of aesthetic value is Anthony Savile's 'Beauty: A Neo-Kantian Account' in *Essays in Kant's Aesthetics*, eds. Ted Cohen and Paul Guyer (Chicago/ London: University of Chicago Press, 1982). An outstanding attempt to articulate an account of aesthetic (and also moral) value that does justice both to its response-dependent nature and to its intersubjectivity and that also gives content to the implicit notion of merit or appropriateness is David Wiggins's 'A Sensible Subjectivism?' in his *Needs, Values, Truth* (Oxford: Blackwell, 1991).

55. For a penetrating account of the relation between aesthetic qualities and non-aesthetic features, see Frank Sibley, 'Aesthetic Concepts', *Philosophical Review*, 68, 1959, and 'Aesthetic and Non-Aesthetic', *Philosophical Review*, 74, 1965.

56. The claim that only one understanding of a work is both correct and complete is compatible with (i) a work's being intentionally ambiguous (so that its appreciation requires that it is experienced in ways that are concurrently incompatible), and (ii) a work's meaning being indeterminate (so that, without error, it can, within limits, be interpreted in more than one way). Given this, I believe there is no good reason to resist the claim. For an excellent defence of the uniqueness claim and an analysis of the idea of a work's canonical interpretation, see Anthony Savile, *The Test of Time* (Oxford: Clarendon Press, 1982), Ch. 4.

57. The notion of understanding a work of art, and so the idea of the

experience a work of art offers, can be understood in more or less accommodating ways: so as to include, or so as to exclude, awareness of any feature of the work which requires the subject who experiences that feature in the work to respond favourably (or unfavourably) to its presence – as with beauty or insipidity, for example. It is only if the notion of understanding is given the wider, all-inclusive scope that it is plausible to believe that correctness of understanding ensures correctness of evaluation.

58. This has been emphasized by R. K. Elliott, especially in 'The Critic and the Lover of Art', in *Linguistic Analysis and Phenomenology*, ed. Wolfe Mays and S. C. Brown (London: Macmillan, 1972).

59. Even if each of the qualities for which works of art are rightly valued as art were to be a quantity measurable in terms of a common unit, artistic value would not thereby be a commensurable value. For the artistic value of a work is not the sum of the valuable qualities it contains, as can most easily be seen from the consideration that qualities that are valuable in themselves can be combined together in an incongruous way – in such a manner that they do not support or enhance one another, but clash.

II: THE ART OF PICTURES

1. Aristotle, *Poetica*, 1448b 5–19; cf. *Rhetorica*, 1371b 4–10.

2. Roger Fry, *Vision and Design* (London: Chatto & Windus, 1920), p. 197.

3. Of course, pictorial content is not a strength or virtue of pictures (as a powerful kick is a strength of a football player). But just as a parallel argument to the Formalist's would fail to establish the irrelevance of the power of a person's kick to an appreciation of his value as a football player, so the Formalist argument does not demonstrate that an appreciation of a picture's pictorial content is irrelevant to an appreciation of its pictorial value.

4. Bell made this point crystal clear: 'Pictures which would be insignificant if we saw them as flat patterns are profoundly moving because, in fact, we see them as related planes. If the representation of three-dimensional space is to be called "representation", then I agree that there is one kind of representation which is not irrelevant.' (*Art* (London: Chatto & Windus, 1914), p. 38. Fry overlooked this feature of Bell's position (as others have done): see *Vision and Design*, op. cit., p. 195.

5. I leave aside two questions about the representational content of visual experience – how the world is represented as being – the first concerned with seeing the world, the second with seeing a pictorial representation of it. The first question is whether the representational content of a subject's visual experience always has an analogue component along each of the main analogue dimensions the subject is sensitive to, no matter what category of item the subject is aware of when looking at an object – the object's shape or the melancholy expression it wears, for example. The second is whether in seeing a depicted scene the onlooker is thereby visually aware of, first, the scene's analogue content, and, second, the analogue content of the pictorial surface.

6. By the analogue content of a picture's depicted scene I mean the analogue content of the appearance that the picture's depicted scene, as depicted, presents to the beholder.

7. For Formalism, the ideal experience of a picture would be one in which the depicted scene is *seen* only under its analogue-content description, not its further description. But whereas it might be possible to *consider* a depicted scene in abstraction from anything other than its analogue content, I could not see it in such a fashion. I would not see a picture's depicted scene as having the analogue content it does have if I did not see the depicted scene under its non-analogue description. Hence the Formalist's ideal experience is a chimera.

8. Roger Fry, 'Some Questions in Aesthetics', *Transformations* (London: Chatto & Windus, 1926). His target is the final part of I. A. Richards's claim that there are 'great pictures in which what is represented is trivial and may be disregarded. It is equally certain that there are great pictures in which the contribution to the whole response made through representation [i.e., extra-analogue content] is not less than that made more directly through form and colour ... there is no reason why representative and formal factors in an experience should conflict, but much reason why they should co-operate ...'. (I. A. Richards, *Principles of Literary Criticism*, London: Routledge & Kegan Paul, 1959, p. 159.)

9. In 'Fiction and Reality in Painting', *Poetik und Hermeneutik*, X, 1983, pp. 225–38, Michael Podro controverts a related view, that he attributes to Ernst Gombrich, about the mutual antagonism of the aims of 'composition' or order, on the one hand, and naturalism or fidelity to natural appearance, on the other. The fact that he (mistakenly to my mind) represents Gombrich as restricting the appreciation of order to the

surface configuration or a fictive plane parallel to the surface does not detract from the force of his demonstration that these aims do not necessarily conflict – indeed, the attainment of the one objective can facilitate the attainment of the other. He also rightly emphasizes the idea of different levels of ordering within pictures, at the macro- and micro-levels.

10. Fry was inclined to conceive of the problem in terms of two kinds of emotion, one – the aesthetic emotion – the result of the pure contemplation of the spatial relations of plastic volumes, the other – non-aesthetic emotion – a response to the human interest of the depicted scene. Thinking in these terms, the question for him was whether these two kinds of emotion could 'fuse'. See, for example, 'Retrospect', *Vision and Design*, op. cit., pp. 198–9.

11. Fry does not explicitly consider the possibility that the formal construction of a picture might enhance the depiction of the picture's subject by being *expressive* of the depicted scene's subject. And surely he is wrong about El Greco: the plastic representation and the colour do not, as Fry maintains, introduce an entirely different mood, but perfectly express the mood of extravagant pietistic ecstasy that El Greco depicts.

12. Fry's characterization of artistic appreciation as 'the pure contemplation of the spatial relations of plastic volumes' encourages this understanding of a picture's form. But it appears to misrepresent his true position, which would be better expressed by the characterization 'the pure contemplation of the relations of plastic volumes'. This, unlike Fry's chosen formulation, which construes a picture's form, not merely as a set of relations amongst spatial items, but as a set of *spatial* relations amongst those items, accommodates non-spatial relations (colour contrasts and harmonies, for example). (A relation between spatial items is not thereby a spatial relation.) The introduction of this qualification would not affect the thrust of the argument in the text.

13. Spatial relations of the second kind are actual, but those of the first are only represented. Pictures, unlike sculptures, do not represent plastic volumes by means of plastic volumes. Fry's phrase 'the spatial relations of plastic volumes' confines a picture's form to *depicted* spatial relations amongst *depicted* volumes.

14. See Podro, 'Fiction and Reality in Painting', loc. cit.

15. The claim that pictorial value is determined by pictorial form is unwarranted if the implication is that any isomorphic structure com-

posed of different elements must have the same pictorial value. If a work's form is understood in abstraction from the elements structured, so that in principle objects composed of different elements can have the same form, pictorial form does not determine pictorial value. It is only if a picture's form is understood as *its elements as structured in the work* that pictorial value is determined by pictorial form. (The Formalist doctrine that confines the appreciation of a picture to the analogue content of the depicted scene does *not* thereby allow that pictures for which the analogue content of the depicted scene differs might nevertheless have the same 'form'.)

16. But visually indistinguishable pictures that depict exactly the same scene might nevertheless depict distinct subjects (as they may possess different meanings of other kinds). Arthur Danto has forcefully emphasized the possibility and elaborated the significance of perceptually indistinguishable works of art in *The Transfiguration of the Commonplace* (London: Harvard University Press, 1983). As he has pointed out (*The State of the Art* (New York: Prentice-Hall, 1987), pp. 137, 139), Formalism is undermined by the fact that much of the significance of works of art is invisible to the historically uninformed eye.

17. Sometimes the appeal of a picture derives almost entirely from its additional meaning. Both Chardin's *The House of Cards* and Holman Hunt's *Love at First Sight* gain from what the depicted scene means; but whereas the Hunt is otherwise uninteresting to look at, not so the Chardin.

18. See Antonia Phillips, *Picture and Object* (M.Phil. thesis, University of London, 1977), and Nelson Goodman, *Languages of Art* (London: Oxford University Press, 1969), I, §5.

19. This supposition is the correct one. The boy is the son of Jean-Jacques Lenoir.

20. If a picture is *of* a certain person, X, but it is not the artist's intention that it should be seen as being *of* X, that it is *of* X is an artistically irrelevant feature of it, importing irrelevant and potentially distracting associations into the experience of looking with understanding at the picture. Scepticism about the relevance of the artist's intention to the meaning, the correct interpretation, of his work should not go so far as to deny the significance of intentions of the above kind.

21. It might appear plausible to claim that for any case in which the beholder fails to understand a picture's meaning unless he understands

who or what the picture is *of*, the fact that the picture is *of* a certain person, place, event or whatever, is an aesthetically relevant feature of the picture. But the plausibility of this claim rests on an indefiniteness in the idea of a picture's meaning. If the claim is not to embed a tautology, the notion of a picture's meaning must not be such that if two pictures differ in what they are *of*, they thereby have different meanings. Certainly you don't understand the meaning of Tintoretto's *The Crucifixion* if you have no idea who the man is who is nailed to the cross. But there are relational pictures where the exact identity of the person depicted – whether it is St Hubert or St Eustace, each of whom supposedly saw a stag with a cross between its antlers – appears to make no difference to the picture's value, although in some sense affecting its meaning. Perhaps it is best to construe the artistic meaning of such pictures as being indefinite, it being a matter of indifference whether the picture is *of* one or another of a certain set of individuals.

22. See Richard Brilliant, *Portraiture* (London: Reaktion Books, 1991), pp. 62–5.

23. You also need knowledge of the artist if you are to identify the etching and aquatint version of his *Olympia* depicted in the cartouche and to appreciate Manet's wit in directing Olympia's gaze at Zola. There are many pictures that are, or contain parts that are, pictures *of* other pictures. There are also pictures that, although not pictures *of* other pictures, nevertheless *refer* to them in an aesthetically relevant manner, so that it is necessary to know the pictures referred to in order to appreciate the picture that refers to it.

24. One way of seeing that the fact that a picture is a picture *of* X can be relevant to its artistic value is by imagining a perceptually indistinguishable counterpart, in another culture, that is a picture *of* another person, Y, a look-alike, perhaps, but who differs from X in important ways. It is easy to construct cases in which the differences between the depicted individuals – differences in their moral worth, for example – are such that the significance of the depicted scene, and the suitability of the attitude the picture expresses towards the individual depicted, changes from one picture to another, with a consequent divergence in the pictures' artistic values.

25. See Svetlana Alpers, *The Art of Describing* (Harmondsworth: Penguin Books, 1989), pp. 69–70 and the references in note 69 on p. 248 for the

Velázquez, and pp. 119–26 for the Vermeer; and Michael Fried, *Courbet's Realism* (Chicago/London: University of Chicago Press, 1992), especially pp. 155–64, for the Courbet.

26. John Updike, *Just Looking* (Harmondsworth: André Deutsch/Penguin Books, 1990), p. 117.

27. The fact that a picture's depicted scene is to a greater or lesser extent visually indefinite in ways that reality is not means that the idea of a corresponding scene in reality must be understood with some latitude. A spectator's response to the corresponding scene in reality is the response to any real scene that satisfies the description of the picture's depicted scene, in so far as the response is to the scene under that description. That is to say, the response must not be essentially dependent on features of the scene more specific than those of the depicted scene.

28. The fact that a picture's two-dimensional nature informs the spectator's experience makes possible the appreciation of a host of features that accrue to the art of pictures in virtue of its distinctive nature. Richard Wollheim has played a major role in emphasizing this crucial aspect of pictorial experience. It is an essential feature of his account of pictorial perception in terms of the species of perception that he refers to as 'seeing-in' that pictorial perception has a twofold character, that it involves awareness of both the depicted scene and the pictorial field. See his 'Seeing-as, Seeing-in, and Pictorial Representation', supplementary essay V in *Art and Its Objects*, 2nd edn (Cambridge, Cambridge University Press, 1980), and his *Painting as an Art* (London, Thames & Hudson, 1987), IIB, §§1–11. Awareness of the way in which what is depicted is depicted in the pictorial field is essential to appreciation.

29. A picture of moving figures depicts a moment in a changing scene. But there is a sense in which such a picture may or may not depict the moment *as* momentary. It will not do so if, for example, the figures depicted are depicted as if not in motion, as if posed, say.

30. For an excellent account of the relation between awareness of depicted scene and *medium*, and of the significance of the way in which what is depicted is constituted in the medium, see Podro, 'Fiction and Reality in Painting', op. cit., pp. 225–38. It is integral to the appreciation of certain pictures that the spectator sees what is depicted as being depicted by a particular kind of use of the pictorial medium, one the

artist intends the spectator to appreciate. Although it is not always essential for the spectator to be aware of the medium – to be aware of the medium *as the material it is* – artistic appreciation always requires recognition of the way in which the artist has made use of the resources available within the art – in the case of pictorial art, the way in which the artist has exploited the available means (viewpoint, scale, perspective, format, brushwork, tonal range, etc.) to render what is depicted in the picture's pictorial field.

31. I have highlighted differences that obtain even in the case of the most naturalistic of pictures. I have ignored differences that arise only through lack of naturalism (which includes inconsistencies in the depicted space, as in Chirico's *Sinister Muses*), or through indefiniteness, or in virtue of a particular subject-matter. I also ignore depicted scenes that nobody could see – mythological scenes, for example.

32. Sometimes we do delight, as Aristotle insisted, merely in the *fact* of imitation, or the *way* in which the artist has captured an appearance in the medium, or the artist's skill (as with Jean-Baptiste Oudry's dazzling rendering of degrees of whiteness in his famous *The White Duck*).

33. The problematic nature of still life and the different modes of visual attention it can exemplify are well analysed in Norman Bryson, 'The Text of Still Life', *Critical Inquiry*, Vol. 15, No. 2, Winter 1989. See also his *Looking at the Overlooked* (London: Reaktion Books, 1990). The example of Cotán's and Zurbarán's works that follows is taken from him.

34. For an example of a picture that represents a sustained process of looking in which the eyes continually return to a few centres of particular interest, and the significance of this for the way in which the picture is perceived by the viewer, see Michael Baxandall's analysis of Chardin's *A Lady Taking Tea* in his *Patterns of Intention* (London: Yale University Press, 1989).

35. In addition to these characteristics, Chardin's *The Ray-fish* (copied by both Cézanne and Matisse), which is a wonderful depiction of what is in part an *ugly*, repellent sight, impresses in virtue of the artist's ability to face the ugly and redeem its appearance by art.

36. For the Caravaggio and Cézanne examples, see Bryson, *Looking at the Overlooked*, op. cit., pp. 77–83.

37. As Arthur Danto has pointed out (*The Transfiguration of the Commonplace*, op. cit., p. 170), a picture that depicts an individual as something the individual is not (a picture of Napoleon-as-Roman-emperor, for example)

demands a very different response from the corresponding real-life scene (Napoleon dressed as a Roman emperor). And – to give just one more possibility – a picture with an allegorical meaning, such as Baugin's *Still Life with Chequer-Board*, which is an allegory of the five senses, presents a depicted scene with a very different significance from the corresponding reality.

38. I have concentrated on naturalistic pictures because it is transparent that the character of non-naturalistic pictures – pictures that do not represent accurately the appearance of what they depict, that perhaps deliberately distort that appearance in the interest of idealization, decoration, symbolism, expressiveness, emphasis, or pictorial balance – allows for the possibility that a beholder's response to the depicted scene should diverge from the beholder's response to the corresponding reality.

39. The difference in duration is emphasized in Constable's expression of the aim of his painting as being that of monumentalizing 'one brief moment caught from fleeting time' (Wordsworth).

40. See Malcolm Budd, 'The Look of a Picture' in Dudley Knowles and John Skorupski (eds.), *Virtue and Taste* (Oxford: Blackwell, 1993).

III: TRUTH, SINCERITY AND TRAGEDY IN POETRY

1. Cleanth Brooks, *The Well Wrought Urn* (London: Methuen, 1971), p. 60. The passage occurs in a chapter entitled 'What Does Poetry Communicate?' For the heresy of paraphrase, see Ch. 11. A somewhat similar claim about the meaning of a poem, and the diagnosis of a related heresy – the heresy of the separable substance – is made in A. C. Bradley's 'Poetry for Poetry's Sake', *Oxford Lectures on Poetry* (London: Macmillan, 1909).

2. Brooks's conception of the poetic function of figurative language, upon which the doctrine of the heresy of paraphrase is founded, is clarified in *Modern Poetry and the Tradition* (Chapel Hill, NC: University of North Carolina Press, 1967). Stanley Cavell's celebrated treatment of the heresy of paraphrase ('Aesthetic Problems of Modern Philosophy', *Philosophy in America*, ed. Max Black (London: George Allen & Unwin, 1965), reprinted in Cavell's *Must We Mean What We Say?* (New York: Charles Scribner's Sons, 1969)) suffers from a number of defects, above all the failure to realize that Brooks's doctrine is based on a conception

of the poetic function, not specifically of metaphor, but of all kinds of figurative language (and also such common features of poetic language as metre and rhyme). His attempt to adjudicate the conflict between Brooks's claim that a fine poem cannot be adequately paraphrased and Yvor Winters's claim that a poem that cannot be paraphrased is thereby defective is also flawed, most nobably by the failure to realize that Brooks and Winters operate with different conceptions of a paraphrase of a poem: whereas Brooks includes the poet's attitude in such a paraphrase, Winters excludes it. See Winters, *In Defence of Reason*, op. cit., pp. 19–20.

3. Brooks, *Modern Poetry and the Tradition*, op. cit., p. 28.

4. In fact, Brooks slides from a weaker to a stronger thesis. The weaker, and unobjectionable, thesis is that metaphor in good poetry functions to articulate the poet's attitude to his subject-matter and audience. But this does not imply that what the poem 'says' (where this includes the poet's attitudes) could not be 'said' without the use of (that very) metaphor. All it implies is that it is not 'said' in the poem in any other way than by (the) metaphor. But Brooks needs the stronger thesis, which he helps himself to: 'All of the subtler states of emotion ... necessarily demand metaphor for their expression'; 'figurative language is the indispensable tool of the poet. There are nuances of attitude that can be given in no other way than by the aid of the qualification which the metaphor or simile produces'; '[Ransom's] poems are as little amenable to paraphrase as are any poems that one can think of. It is probably because he is able to transmit so definitely shades of attitude which can be perceived and yet which defy exact description in prose commentary'. (*Modern Poetry and the Tradition*, op. cit., pp. 6, 30, 95.)

5. Brooks, *Modern Poetry and the Tradition*, op. cit., pp. 15–16.

6. Brooks's position would have been stronger if he had confined it to his claim that valuable poetry has a characteristic structure, based essentially on such features as ambiguity, irony, paradox and metaphor, and that each fine poem achieves a reconciliation of disparate and apparently conflicting attitudes – a complex harmony or unity of experience communicated by the poem to the reader through its temporal pattern of resolved stresses.

7. See *Biographia Literaria*, ed. J. Shawcross (Oxford: Oxford University Press, 1907), II, pp. 6 and 107, and *Coleridge's Shakespearean Criticism*, ed. T. M.

Raysor (London, Constable, 1930), I, pp. 200–202. Whilst Coleridge's remarks were directed primarily at the drama and at poems that have supernatural subject-matter, he did not restrict their significance to these two kinds of art. See M. H. Abrams, *The Mirror and the Lamp* (Oxford: Oxford University Press, 1976), p. 324.

8. T. S. Eliot, *Selected Essays* (London: Faber & Faber, 1934), p. 138.

9. See Wayne C. Booth, *The Rhetoric of Fiction* (Chicago: University of Chicago Press, 1973), pp. 70ff.

10. Of course, the words do not have to be imagined as being spoken aloud rather than internally.

11. My use of this term diverges from the use that Booth favours. See *A Rhetoric of Irony* (Chicago: University of Chicago Press, 1974), p. 181n.

12. The qualities of the actual author are not *ipso facto* qualities of the implied author, and they can be contraries. But the divergence between the qualities of the actual and the implied author is constrained by what is possible: whereas an intelligent, sensitive person can write an unintelligent, insensitive poem (on purpose, for example), the converse is not possible. So if the implied author of a poem is intelligent, the poet must be so too. For such qualities as these, the qualities of the implied author are qualities of the actual author, and reference to the implied author is tantamount to reference to the actual author (as she displays herself in the poem). Compare Colin Lyas, 'Aesthetic and Personal Qualities', *Proceedings of the Aristotelian Society*, Vol. LXXII, 1971/72, 'Personal Qualities and the Intentional Fallacy', *Philosophy and the Arts*, ed. G. Vesey (London: Macmillan, 1973), 'The Relevance of the Author's Sincerity' in *Philosophy and Fiction*, ed. Peter Lamarque (Aberdeen: Aberdeen University Press, 1983).

13. Two of the best-known examples of poetic irony of this kind are Browning's dramatic monologue *My Last Duchess* and T. S. Eliot's *Gerontion*.

14. Coleridge, *Biographia Literaria*, Ch. 1.

15. Consider the well-known example of Housman's poem *1887*, which invites the ironical reading given it by Frank Harris but angrily rejected by Housman.

16. T. S. Eliot, 'Goethe as the Sage', *On Poetry and Poets* (London: Faber & Faber, 1969), pp. 222–3.

17. I am not suggesting – what is certainly false – that reference to the actual author of a poem is always critically irrelevant.

18. See I. A. Richards, *Practical Criticism* (London: Routledge & Kegan Paul, 1964), pp. 94–5, 280ff.

19. T. S. Eliot, *After Strange Gods* (London: Faber & Faber, 1934), pp. 28–9.

20. Some of the complexities in the notion of sincerity are explored in an interesting fashion by Stuart Hampshire in 'Sincerity and Single-Mindedness' in *Freedom of Mind and Other Essays* (Oxford: Clarendon Press, 1972), pp. 232–56.

21. In giving expression to one's feelings it is possible to fail to do justice to them – to misrepresent them. But it is also possible to distort them by feeling after some conventional manner represented in their expression, allowing them to be moulded in accordance with stereotypes or paradigms of one's culture. In 'The Autonomy of Art' in *Philosophy and the Arts, Royal Institute of Philosophy Lectures 1971–2* (London: Macmillan, 1973), pp. 65–87, John Casey examines how the way in which one expresses one's feelings in words – to others or to oneself – can impose insincerity on them; and how the inability to express one's feelings sincerely can carry with it an inability to feel sincerely.

22. *Scrutiny* (Cambridge: Cambridge University Press, 1963), Vol. XIX (1952–3), pp. 90–98, reprinted in *A Selection from Scrutiny*, comp. F. R. Leavis (Cambridge: Cambridge University Press, 1968), Vol. I, pp. 248–57.

23. See Michael Tanner, 'Sentimentality', *Proceedings of the Aristotelian Society* (1976–7), pp. 127–47.

24. Compare Cleanth Brooks: 'The sentimentalist takes a short cut to intensity by removing all the elements of the experience which might conceivably militate against the intensity' (*Modern Poetry and the Tradition*, op. cit., p. 37).

25. See Anthony Savile, *The Test of Time* (Oxford: Clarendon Press, 1982), pp. 239–40.

26. D. H. Lawrence, 'John Galsworthy' in *Phoenix* (London: Heinemann, 1961), p. 545.

27. See I. A. Richards, *Practical Criticism* (London: Routledge & Kegan Paul, 1964), pp. 261–2.

28. T. S. Eliot, 'Dante' in *Selected Essays* (London: Faber & Faber, 1934), pp. 237–77. See Section II and the note to that section.

29. Eliot moves freely between understanding or appreciation and enjoyment because he takes understanding a poem to be enjoyment of it for the right reasons. One should not enjoy bad poems unless their badness is amusing. See *On Poetry and Poets*, op. cit., p. 115. Eliot expresses

reservations about his position, and in fact it contains inconsistencies. He says, for example, that Keats's line 'Beauty is truth, truth beauty ...' strikes him as a serious blemish on a beautiful poem, and that the reason must be either that he fails to understand the line *or that it is a statement which is untrue.*

30. Eliot's position was forcefully controverted by John Crowe Ransom: 'I can see no necessity for waiving the intellectual standards on behalf of poets. If Dante's beliefs cannot be accepted by his reader, it is the worse for Dante with that reader, not a matter of indifference as Eliot has argued. If Shelley's argument is foolish, it makes his poetry foolish.' (John Crowe Ransom, *The New Criticism* (Norfolk, Conn.: New Directions, 1941), p. 208.)

31. T. S. Eliot, *The Use of Poetry and the Use of Criticism* (London: Faber & Faber, 1959), Ch. V.

32. It is difficult to reconcile with Eliot's admission that he can still enjoy FitzGerald's *Omar Khayyám*, though he does not hold 'that rather smart and shallow view of life'. For a shallow view of life is not one that is mature and founded on the facts of experience; and a shallow view of life does not appear to differ in any relevant way from one that is childish or feeble – at most it differs in degree.

33. If we subtract the idea that a poem's view of life must be founded on the facts of experience, Eliot's position comes to much the same as that of Cleanth Brooks and Robert Penn Warren, who require a poem's view of life to be 'serious and intelligent'. (Cleanth Brooks and Robert Penn Warren, *Understanding Poetry* (New York: Holt, Rinehart & Winston, 1976), p. 269.)

34. Eliot returned to the problem of belief in 'Goethe as the Sage', *On Poetry and Poets*, op. cit., but his treatment is unhelpful.

35. I. A. Richards maintained that 'There is a suppressed conditional clause implicit in all poetry. If things were such and such then ... and so the response develops.' (*Principles of Literary Criticism*, op. cit., p. 276.) But it would be silly to think of Lucretius's poem as intended to present a merely possible world and to argue for what the right attitude to life should be in such a world; and there is no good reason for a reader to take the beliefs the poem expresses less seriously than Lucretius did.

36. T. S. Eliot, *On Poetry and Poets*, op. cit., p. 174.

37. Henry James, 'Charles Baudelaire', *Selected Literary Criticism*, ed. Morris Shapira (London: Heinemann, 1964), p. 30.

38. Cleanth Brooks, 'Implications of an Organic Theory of Poetry', *Literature and Belief*, ed. M. H. Abrams (New York: Columbia University Press, 1958).

39. Intelligent discussions of the problem of belief include Erich Heller, *The Disinherited Mind* (Edinburgh: Penguin Books, 1961), pp. 135–9, M. H. Abrams, 'Belief and the Suspension of Disbelief' in *Literature and Belief*, ed. Abrams, op. cit., and George Orwell, 'Politics vs. Literature: An Examination of *Gulliver's Travels*' in *The Collected Essays, Journalism and Letters of George Orwell*, Vol. IV, eds. Sonia Orwell and Ian Angus (London, Secker & Warburg, 1969), pp. 220–23.

40. Aristotle, *Poetics*, 14, 1453b 10–14.

41. Aristotle, *Poetics*, 6, 1449b 22–8.

42. The classic statement of the pathological interpretation of Aristotle's conception of *katharsis* was a pamphlet by Jacob Bernays, reprinted in *Zwei Abhandlungen über die aristotelische Theorie des Drama* (Berlin, 1880), the main part of which is translated as 'Aristotle on the Effect of Tragedy', *Articles on Aristotle: 4. Psychology and Aesthetics*, eds. Jonathan Barnes, Malcolm Schofield, Richard Sorabji (London: Duckworth, 1979).

43. Compare the passage in Aristotle's *Politics* (VIII. 7, 1341b 32–1342a 18) from which this interpretation derives support. If the pathological theory were a correct interpretation of Aristotle's thought, as Nietzsche throughout his life thought it was (*The Birth of Tragedy*, §22; *The Antichrist*, §7), Aristotle's response to Plato would be open to the objection Nietzsche brings against it in *Human, All Too Human*, namely that even if in each instance fear and pity are mitigated and discharged, nevertheless they might be intensified in the long run through frequent satisfaction in the experience of tragedy. (Nietzsche, *Human, All Too Human*, trans. R. J. Hollingdale (Cambridge: Cambridge University Press, 1986), Vol. I, §212. See also *The Will to Power*, ed. Walter Kaufmann (London: Weidenfeld & Nicolson, 1968), §851.)

44. There is a well-known, and recently much discussed, problem in the philosophy of art about the sense in which it is possible to feel an emotion towards a fictional event or character. For either there is no such character (as in the case of Ophelia), or the character is not actually present to the spectator (as in the case of Richard III), or if the character is actually present (as when an actor or actress plays him- or herself), the emotional reaction is not to the character *as really present to*

the spectator, but only *as represented to the spectator*. I believe that the sense in which it is possible to feel an emotion towards a fictional event or character is best elucidated in terms of imagination and make-believe, in something like the manner advocated by Kendall Walton. See Kendall Walton, 'Fearing Fictions', *Journal of Philosophy*, LXXV, No. 1, January 1978; Malcolm Budd, *Music and the Emotions* (London: Routledge & Kegan Paul, 1985), Ch. VII, §10; and the revised version of Walton's account in his *Mimesis as Make-Believe* (Cambridge, Mass./London: Harvard University Press, 1990), Ch. 7. In brief: if you feel an emotion E towards an artistically represented event or character you are emotionally affected by making-believe or imagining the event, under the direction of the work, in the same manner as you would be if you were to experience E not imaginatively but really; what you *feel* is the same in the two cases, in the first being caused by your imagining or making-believe that a certain situation obtains, in the second by your believing that a like one does.

45. See S. H. Butcher, *Aristotle's Theory of Poetry and Fine Art* (London: Macmillan, 1911), Ch. VI. In fact, Butcher combines a pathological and a purificatory interpretation of *katharsis*, so that the pleasurable tragic 'effect' is an intrinsic character of the experience of tragedy but also of the after-effects – as with sexual intercourse.

46. Hume, 'Of Tragedy', *Essays, Moral, Political and Literary*, op. cit., p. 216.

47. Hume's problem is not merely to account for the pleasurable nature of the experience of a well-written tragedy or even for the pleasure a spectator of a well-written tragedy receives from passions that are in themselves disagreeable and uneasy. The problem, as Hume understands it, is to explain a pleasure that retains many of the characteristics of disagreeable emotions but that lacks any of the unpleasurableness intrinsic to the experience of these emotions when they are aroused by real, rather than artistically represented, tragic incidents. So it would not be enough for Hume to indicate a source of pleasure in the experience of a well-written tragedy, or a pleasure which stems from the arousal of passions that are in themselves disagreeable and which compensates for the pain or unpleasantness suffered in undergoing such passions. He must attempt to explain how a negative emotion is transformed into a positive emotion, rather than merely add a specified pleasure to the negative emotion. (Although Aristotle identifies the pleasure appropriate to tragedy as one that derives from pity and fear,

which he understands as being intrinsically painful emotions, he does not, as Hume does, conceive of the spectator's experience as being painless.)

48. op. cit., p. 221. Fontenelle, and also Du Bos, thought that the spectator's awareness that she is responding to a representation, not reality, softens her negative emotion by diminishing its negative hedonic quality, and *by reduction* converts it into a pleasure. Hume substitutes *redirection* for reduction.

49. The points made in the text are elaborated and defended in Malcolm Budd, 'Hume's Tragic Emotions', *Hume Studies*, Vol. XVII, No. 2, November 1991. It is clear that Hume's own problem, although focused upon tragic drama, was not thought of by him as being restricted to that art form, and his solution to the problem, apart from the inessential use of the agreeableness of 'imitation', would apply to *all* cases in which someone responds to a work of art she values with a negative emotion, since it exploits only (i) delight in the manner of representation, (ii) the arousal of negative emotion (no matter of what kind) by what is represented, and (iii) transformation of the weaker into the stronger emotion. Accordingly, the various attempts to delineate the features that have been thought to be *distinctive* of tragedy, or essential to its supposedly distinctive effect or its highest artistic value, do not figure in Hume's essay and play no role in his account of the seemingly problematic pleasure of the spectator.

50. It presupposes the Cartesian doctrine of animal spirits as the physical embodiment of the emotions, and it is not supported by the supposed illustrations Hume adduces in its defence.

51. For simplicity's sake I have ignored the fact that if the spectator feels pity or fear for a fictional character, she will experience the emotion for the character make-believedly, not really. This makes no difference to the present point: if, in witnessing real events, the experience of negative emotions directed at those events is not essentially painful, neither is the experience of negative emotions in make-believedly witnessing such events.

52. Because these issues would remain even if the experience of negative emotions is not essentially or normally or typically unpleasant, I leave aside the question whether there really is an intrinsic connection between unpleasantness and the experience of negative emotions, and, if so, what exactly the connection is.

53. These issues are specific versions of two more general problems: (i) How is it possible for a person to derive pleasure from the arousal of a negative emotion directed at what a work of art represents? (ii) What explains the fact that a person can find intrinsically valuable an experience that involves undergoing a negative emotion directed at the represented content of a work of art? The answer to these questions is that they have no answer, that is to say, neither of them has a single answer. For there is more than one way in which a negative emotion directed at the represented content of a work of art can be a source of pleasure and more than one reason for finding an experience of a work of art that involves undergoing negative emotions directed at the unhappiness or misfortune of the represented persons intrinsically valuable. It should be obvious, I believe, that there is no reason to expect there to be a unitary explanation in either case. For given the diversity both of spectators and representational works of art which elicit a negative emotional response to their representational content, there are many possible explanations of each of the facts that are to be accounted for. The explanations do not need to confine themselves to the features *in common* to the class of experiences they concern, but can reach into the different psychologies of their subjects and also the different natures of the objects to which these subjects react with forms of suffering in aesthetic responses that they find pleasurable or intrinsically valuable. The proper methodology is therefore a case by case, or at least type by type, examination.

54. George Santayana, *The Sense of Beauty* (New York: Dover Publications, 1955), p. 138.

55. ibid., p. 136.

56. Friedrich Nietzsche, *Beyond Good and Evil*, §229. Nietzsche turned Schopenhauer's doctrine, that pleasure in tragedy arises from the resignation that comes from the recognition that life is not worth enduring, on its head. For Nietzsche, the strong, healthy individual will acknowledge the terrifying and meaningless character of existence, even the necessity for suffering, catastrophe and evil in human life, and so, in tragic cruelty, be 'hard enough to experience suffering as a *pleasure*' (*The Will to Power*, §852). See also *Twilight of the Idols*, 'Skirmishes of an Untimely Man', §24.

57. See Susan Feagin, 'The Pleasures of Tragedy', *American Philosophical Quarterly*, Vol. 20, January 1983. Although such a meta-response is

possible, I am unconvinced by Feagin's argument that, unlike such a response to witnessing real tragedy, it cannot properly be criticized as being complacent. More important, such a response is not an essential component of the experience offered by a fine tragedy, and makes no contribution to the intrinsic value of the experience.

58. It is highly probable that a spectator's emotional reaction to the theatrical representation of a tragic incident will not be as intensely painful as her emotional reaction to a similar incident that she witnesses in real life, for her theatrical experience is one in which she is aware that she is not really witnessing suffering or the loss of valuable life and that there is no question of her acting to prevent or ameliorate what is represented. No matter how much I react with horror to Oedipus's or Gloucester's blinding, I would be much more horrified by the experience in reality of someone tearing out his own eyes or having them forced out by another's heel.

59. Perhaps a rival interpretation of *katharsis* to those I have rejected forms a theory of this kind. This interpretation sees *katharsis* as a specific experience of pleasurable relief that comes from the experience of the tragic emotions. This relief is dependent on the spectator's realization that she is witnessing an artistic representation of tragedy, not tragedy itself, and it consists of three additional realizations. The first is that the world in which a tragedy of the Aristotelian kind occurs is a meaningful, not a chaotic, world. The second is that the tragic individual falls through her own error, so that 'the world as a whole is absolved'. The third is that individuals, even when they are responsible for their own misfortunes, are capable of conducting themselves with greatness of soul. Accordingly, 'Even in tragedy, perhaps especially in tragedy, the fundamental goodness of man and world are reaffirmed.' (Jonathan Lear, 'Katharsis', *Phronesis*, Vol. XXXIII, 1988.) I believe, as Nietzsche did, that a moralistic conception of tragedy misrepresents its value. Neither man nor the world is 'fundamentally' good; and if tragedy affects our perception of the world, it is more suited to enabling us to dispense with a universe that answers to our moral wishes than to reassure us that at bottom the world is as we might wish it to be. The requirement that tragedy should provide a moral uplift of the kind indicated is little better than Dr Johnson's notorious defence of the underlying Nahum Tate's revision of *King Lear*. (See *Johnson on Shakespeare*, ed. Walter Raleigh (London: Oxford University Press, 1959), p. 161.)

60. This is not to acquiesce in the traditional ranking of tragedy as a higher form of art than comedy. Whatever the potential values and comparative worth of the two art forms may be, clearly the great tragedies possess artistic value to a high degree.

61. This is not to accept that ancient Greek tragedies formed a uniform class. On the contrary, although there is an emphasis on extreme states of mental suffering, of conflict, remorse, passion and despair, even those relatively few works that have survived are of disparate natures.

62. Flint Schier wrote two outstanding essays on philosophical problems about tragedy: 'Tragedy and the Community of Sentiment', in *Philosophy and Fiction*, ed. Peter Lamarque (Aberdeen: Aberdeen University Press, 1983), and 'The Claims of Tragedy: An Essay in Moral Psychology and Aesthetic Theory', *Philosophical Papers*, Vol. XVIII, No. 1, May 1989. But he operates with a notion of tragic art that includes Goya's depictions of the horrors of war, for example; and I believe this weakens the plausibility of certain aspects of his account of the reasons for which we value in itself the experience of tragic works of art.

63. Leaving pity aside, there is a problem about the fear that, according to Aristotle, is intrinsic to the experience of tragedy – a problem about what its object is. Aristotle's definition of tragedy in terms of pity and fear is often understood to imply that the spectator's emotional response is not single but double, consisting of sympathetic emotions, one being anticipatory, the other reactive: the spectator experiences pity and fear for the protagonists (rather than merely participating empathically in their suffering). But there are ancient Greek tragedies that the (modern) spectator experiences with no form of apprehensiveness for the principal characters – as with Aeschylus's *Prometheus Bound* or *Sophocles's Philoctetes* – so that at most one of Aristotle's two emotions is aroused in the spectator's breast. An alternative understanding of the fear that tragedy is allegedly designed to arouse construes it as the spectator's fear for herself – fear that she might suffer such a fate. Although Aristotle thought of fear and pity as being correlative emotions (*Rhetoric*, 2, 1382b 26–7), in the sense that the kinds of thing that we pity others for are those that we fear should happen to ourselves, self-regarding fear is not characteristic of the (modern) spectator's experience of tragedy.

64. Friedrich Nietzsche, *The Gay Science*, trans. Walter Kaufmann (New York: Vintage Books, 1974), §80. Compare the earlier thought that 'the

language of Sophocles' heroes amazes us by its Apolline precision and lucidity, so that we immediately have the feeling that we are looking into the innermost ground of their being, with some astonishment that the way to this ground should be so short' (*The Birth of Tragedy*, §9).

65. In 'How can we be moved by the fate of Anna Karenina?' (*Proceedings of the Aristotelian Society, Supplementary Volume*, Vol. IL, 1975), Colin Radford argues that if we respond with emotion to the fate of a (merely) fictional character, we suffer from incoherence, inconsistency or irrationality, because we are aware that the character does not really exist. But his argument faces a dilemma: either the content of the charge that an emotional response to the fate of a fictional character is irrational amounts to no more than that it is directed at what is known not to exist or it has a pejorative implication. Clearly, the charge is significant only on the second horn of the dilemma. But if the emotional response is appropriate, given the nature and content of the work, the charge has no force.

66. If, as I have asserted, Nietzsche's interpretation of 'the painful voluptuousness of tragedy' as 'the spiritualization of cruelty' turns on the idea that the spectator delights in making herself suffer, it fails to hit the nail squarely on the head. It would be better to insist that the reason a spectator finds it intrinsically rewarding to submit herself to a process that involves her suffering over imagined tragedy is that she values acknowledging truths about and possibilities inherent in human life, no matter how unpleasant they may be – truths that, in everyday life, whenever possible, she is liable to push to the fringes of her consciousness.

67. Henry James, 'The Art of Fiction', *Selected Literary Criticism*, ed. Morris Shapira (London: Heinemann, 1964), p. 66.

68. Friedrich Nietzsche, *Twilight of the Idols*, 'Skirmishes of an Untimely Man', §24.

IV: MUSIC AS AN ABSTRACT ART

1. For a detailed (although philosophically unpenetrating) account of the origins, history and different conceptions of the idea of absolute music, see Carl Dahlhaus, *The Idea of Absolute Music*, trans. Roger Lustig (Chicago/London: University of Chicago Press, 1991).

2. The tendency, especially associated with Romanticism, has been to assign to absolute music some grand metaphysical or emotional extra-musical meaning or value, whose credentials supposedly rival the religio-moral value that had been attributed to vocal music and other serious art forms. I shall argue that there is no need to search for such a 'hidden' value, for the artistic value of music lies open to view in its audible surface.

3. Arthur Schopenhauer, *The World as Will and Representation*, trans. E. F. J. Payne (New York: Dover, 1969).

4. Wilhelm Worringer, *Abstraction and Empathy*, trans. Michael Bullock (London: Routledge & Kegan Paul, 1953).

5. A simpler claim would be that no aesthetically valuable qualities of what is non-abstract can be possessed by an abstract composition of elements that are specific to an art form – or, at least, not sufficient, or sufficiently important qualities to enable abstract music, in virtue of those qualities, to impress us as powerfully as it does. But the claims in the text articulate the principal line of thought that encourages the belief that the artistic power of music is enigmatic.

6. For an excellent account of what a listener may need to know, and the sense in which he must know it, if he is to hear music with understanding, see Jerrold Levinson, 'Musical Literacy', *Journal of Aesthetic Education*, Vol. 24, No. 1, Spring 1990.

7. This assertion must be understood in such a way that it does not imply that a work's intramusical meaning is entirely self-generated, independent of the history of music. It is an obvious truth that the meaning of any work of art is a product of the meaning of previous works of art.

8. Not only does it not identify either the pictorial or the sculptural relation, it does not attempt to identify the scope of similar relations – whether it includes the relation in which an actor stands to the character he plays, for example. It is loose in other ways too. Musical works can exploit the extramusical associations of particular instruments, or use, quote or refer to melodies set to words or melodies that have other extramusical associations, or refer to other musical works that do such things. A strict understanding of the idea of abstract music will rule out such features of a musical work. My later argument makes no use of them. The most sophisticated analysis of music's abstract nature is Kendall Walton's 'What is Abstract about the Art of Music?', *Journal of Aesthetics and Art Criticism*, Vol. 46, No. 3, Spring 1988.

9. The intention of the composer, and the answering experience of the listener, can go beyond a mere experienced resemblance between the music and some extramusical sounds or sounding object. The resemblance might be designed to encourage the listener to imagine that his experience of the music *is* an experience of the represented sounds: in hearing the music he imagines himself to be undergoing a different experience, that of hearing what is represented, by imagining *of* his experience of the music that it is that different experience. See Kendall Walton, *Mimesis as Make-Believe* (London: Harvard University Press, 1990), pp. 333–7.

10. I have concentrated on the musical representation of extramusical perceptible things or aspects and have ignored the musical 'representation' of qualities of other kinds, abstract qualities, for instance. Although the idea of musical representation is loose enough to accommodate a great variety of phenomena, it is unhelpful to group together the disparate collection the idea is often used to cover.

11. The case is best made by Roger Scruton, 'Representation in Music' in his *The Aesthetic Understanding* (London: Methuen, 1983). It is vital to realize that Scruton's thesis is predicated on the basis of a highly specific concept of representation. In fact, he wavers between a stronger and a weaker claim about the understanding of representational music. The stronger claim asserts that awareness of the music's representational content is unnecessary for full musical understanding. The weaker claim maintains that a 'major part' of musical understanding is independent of the representational content of a musical work: there is 'little place' for awareness of what is represented in the appreciation of music.

12. Jenefer Robinson, 'Representation in Music and Painting', *Philosophy*, Vol. 56, No. 217, July 1981; Peter Kivy, *Sound and Semblance: Reflections on Musical Representation* (Princeton, NJ: Princeton University Press, 1984), Ch. 8.

13. Musical understanding, as it figures in Scruton's argument, is fundamentally a matter of understanding musical structure. The fact that Kivy also operates with this concept of musical understanding is manifest in his claim that 'one cannot fully understand the musical structure [of Weber's *Invitation to the Dance*] without knowing the subject of the musical representation'.

14. This difference is due to an important disanalogy between the two

kinds of representation: depiction, unlike musical representation, consists in the two-dimensional representation of the three-dimensional.

15. The best account of the scope and limits of musical representation is Peter Kivy's *Sound and Semblance: Reflections on Musical Representation*, op. cit. On any natural understanding of the notion, there are few musical works that *are* representations, rather than merely containing one or more musical representations; and a musical representation characteristically conveys minimal information about its subject as represented.

16. I am indebted to Hubert Eiholzer-Silver for discussions that sharpened my thoughts about musical representation.

17. This conception of the musical expression of emotion has often been proposed. For example, in his *Critical Reflections on Poetry and Painting* Abbé Dubos maintained that 'Just as painting imitates the forms and colours of nature, music imitates the tones, the accents, the sigh, the modulations of the voice, in short, all the sounds through which nature itself expresses feelings and passions.' Quoted in Carl Dahlhaus, *The Idea of Absolute Music*, trans. Roger Lustig (Chicago/London: University of Chicago Press, 1991), p. 71. The conception has recently been resurrected by Peter Kivy in his *The Corded Shell* (Princeton, NJ: Princeton University Press, 1980), extensively supplemented in his *Sound Sentiment* (Philadelphia, Pa: Temple University Press, 1989).

18. See Jerrold Levinson, 'Hope in *The Hebrides*' in his *Music, Art, and Metaphysics* (Ithaca, NY/London: Cornell University Press, 1990).

19. Two issues that are often run together, but must be kept apart, concern, on the one hand, the cause or explanation of why music is heard as being expressive of emotion and, on the other, what is constitutive of the experience. It is one thing to ask what features of a musical passage M cause the listener to hear it as being expressive of emotion E, and another to ask what it is for the listener to hear M as being expressive of E. Hence even if a resemblance between M and the expression of E in a person's voice, posture or behaviour is partly responsible for the listener's hearing M as being expressive of E (and so for the listener's readiness to characterize M in terms of E), it does not follow that the listener's hearing M as being expressive of E is the listener's hearing M *as* resembling the vocal, postural or behavioural expression of E. And hence also the conception of abstract music does not disallow such resemblances from figuring in the causal explanation of the listener's

experience of hearing M as being expressive of E. The crucial philosophical issue about the experience of hearing music as being expressive of emotion concerns the nature of the experience, not the features of the music that generate it.

20. This distinction has been emphasized by Alan Tormey, *The Concept of Expression* (Princeton, NJ: Princeton University Press, 1971), and by Kivy, *The Corded Shell*, op. cit.

21. Arthur Schopenhauer, *The World as Will and Representation*, trans. E. F. J. Payne (New York: Dover, 1969), Vol. I, p. 261. For a full presentation and critique of Schopenhauer's theory of music, see my *Music and the Emotions*, op. cit., Ch. V.

22. Compare Carroll C. Pratt's well-known interpretation of the description of music in terms of mood and emotion, which is encapsulated in his claim that music merely sounds the way emotions and moods feel (Carroll C. Pratt, *The Meaning of Music*, New York: McGraw-Hill, 1931, p. 203). But Pratt operates with a diminished concept of the nature of emotional feelings, and in consequence unduly restricts the aspects of the emotions that music can express by mirroring those aspects. His leading idea is that when we experience an emotion or mood what we feel are processes which involve movement of or within our body, and his claim that music merely *sounds* as emotions or moods *feel* asserts that the so-called embodiment of emotions in music comes to no more than that musical processes sometimes resemble the movements we feel when in the grip of an emotion or mood. I consider Pratt's interpretation at length in my *Music and the Emotions*, op. cit., Ch. III.

23. By the perception's being non-creative I mean to rule out cases where a perceived resemblance is not due to a common property, but where the dependence is the other way round – the occurrence of the perception of likeness is constitutive of the items' possession of a common property.

24. The representation in an emotional experience can be a representation of a particular or a state of affairs, and it can be more or less definite. Some cases of so-called 'objectless' emotional occurrences (sadness that is not 'about' anything, for instance) are ones in which the thought intrinsic to the emotional state (the thought of loss, say) assumes no more definite form.

25. It has often been claimed that each emotion is characterized by a distinctive (non-intentional) feeling different in kind from any of those

I mention – the counterpart in the domain of the inner world of the emotions of colour (hue) in the external spatial world. But the nature of the postulated kind – what is felt and the sense in which it is felt – has never been explained.

26. A mood (of despair, confidence, irritability, melancholy, gay abandon) is a tendency to react in certain ways and to experience certain emotions and feelings. The treacherous concept of a feeling covers an indefinite number of different categories of psychological phenomena, including the categories of desire, inclination to believe, the experience as of acting or as of something's happening to you, and perceptions or sensations experienced as pleasant or unpleasant.

27. My account of expressive perception as a form of cross-categorial likeness perception emphasizes the way an emotion *feels*. But, as the word 'feel' is standardly used, this is a simplification of the account I favour. For in addition to how an emotion feels, there are other aspects of what it is like to be in an emotional state – other aspects of the state's 'phenomenology' – that music can be heard to sound like. Consider depression (sadness, dejection, melancholia). A depressed state is characterized by relatively slow and confined mental processes, lack of energy, lack of determination, passivity, and difficulty in changing one's state. These aspects of the condition are experienced by the subject, but cannot all be said to be felt. But there are just as much audible musical analogues of these experienced but non-felt aspects as there are of felt aspects: the tempo of music can be slow, music can be quiet, confined within a narrow tonal range, rhythmically flaccid, and lacking in momentum. So the account should be extended from perceived resemblances to how emotions feel to perceived resemblances to how emotions are experienced: music can sound like what it is like to be in a conscious emotional state.

It should also be extended in another way, not from felt to other aspects of the phenomenology of emotional states, but from emotional states to certain kinds of non-emotional states (brooding, being in high spirits or a good humour) which have a phenomenology and which, even if they can be felt, are not felt in the same sense as emotions are. The possession or 'expression' by music of qualities that can be perceived in it in the cross-categorial likeness sense is not confined to the field of the emotions but extends much more widely – to attitudes of various kinds, to certain qualities of character or manners of action

(gentleness, tenderness), for example. (This is one reason why the location of music's artistic value exclusively or primarily in its ability to express emotion is wide of the mark. The view that music's value derives largely from its expressive qualities – phenomenological qualities that music is heard as sounding like – would be considerably more plausible, although still mistaken, if these qualities were not restricted to qualities of emotion.)

28. The importation into music of any emotional state of a different or more specific kind than is warranted by a perceived likeness to the emotion is either illegitimate or legitimately prompted by additional considerations (such as the music's context or title or the composer's intention) or not a matter of mirroring emotion itself (but, perhaps, its expression in the voice). Note that even if an emotion lacks a distinctive feeling, so that music cannot mirror it specifically, it is still possible to hear music as resembling that emotion, rather than any other.

29. This correspondence is the foundation of Carroll C. Pratt's account in *The Meaning of Music* (op. cit.) of the apparent embodiment of emotion in music. In so far as the musical mirroring of movement in space – even movement abstracted from the nature of any moving object and restricted to a single dimension – is thought to detract from music's abstract nature, it can be deleted from music's expressive resources without substantially affecting the argument in the text.

30. Felix Mendelssohn, letter to Marc André Souchay, Berlin, 5 October 1842.

31. Deryck Cooke, *The Language of Music* (London: Oxford University Press, 1960), p. 23.

32. This is also true for the other conceptions of musical emotional expression I later develop.

33. Stravinsky's well-known, hyperbolic anti-expressionist claim in fact misrepresents his real position: 'I consider that music is, by its very nature, essentially powerless to *express* anything at all, whether a feeling, an attitude of mind, a psychological mood, a phenomenon of nature, etc. ... If, as is nearly always the case, music appears to express something, this is only an illusion and not a reality.' (Igor Stravinsky, *An Autobiography* (New York: W. W. Norton, 1962), p. 53. See also pp. 162–3.) Stravinsky believes that listeners are often distracted from the music itself by an exclusive preoccupation with the nature of what is expressed. Such listeners, Stravinsky maintains, are unaware that music's expressive

aspect is a matter of mere suggestion, personal association, or social convention, and accordingly they are blind to music's essential nature, which requires an appreciation of its intrinsic value independently of what it may happen to suggest. Stravinsky's true position is not really a blunt denial of music's expressive capacities, but an uneasy combination of the following three thoughts about the expressive aspect of music: (i) it is not the sole point of aesthetic interest; (ii) it is irrelevant from the aesthetic point of view; and (iii) it is a matter of mere suggestion. The first of these contentions is clearly true, but the other two are wide of the mark.

34. There is an ambiguity in the notion of the emotional qualities of music. A piece of music might be said to have a certain emotional quality merely because it sounds the way that emotion feels. But the emotional qualities of music, considered as an art, must be those that can be heard in it when it is experienced correctly and, in consequence, figure in the appreciation of the music. I have built correctness of perception into the concept of the musical expression of emotion, that is, into the idea of music's emotional qualities.

35. It is always possible for a listener to identify the music's persona with the person of the composer and respond to the make-believe experience of emotion as if it were an experience of the composer. Perhaps the composer intends the listener to respond to his music in this way. But it is usually, perhaps always, unnecessary for the listener to know much, if anything, about a composer's life-history, character, political allegiance, etc., in order to be able to hear in the music the emotion it is express- ive of; and even if some such knowledge is needed, it is not manda- tory for the listener to conceive of the music's persona as the real-life composer.

36. If you experience an emotion that matches the emotion you hear in the music, this is not because you imagine *yourself* experiencing the emotion that is make-believedly being experienced. You imagine the emotion *from the point of view of the music's persona*, and do not bring to the experience your own character and situation.

37. Compare Budd, *Music and the Emotions*, op. cit., pp. 67–8.

38. Not only are the different conceptions not competitors, but we can (without error) sometimes fluctuate between one mode of expressive hearing and another in the course of a single piece, or hear the same piece first one way then another.

39. There is little agreement in musical aesthetics about how the term 'expression' and its cognates should be used. For some thinkers (notably Roger Scruton), the fact that what I have called the basic and minimal sense of the musical expression of emotion is not in itself an aesthetic achievement or merit disqualifies it from being properly thought of as expression: music that falls under the concept is not *expressive* of the emotional qualities it possesses. But if you consider César Franck's music to be characterized by a factitious religiosity (see Wilfrid Mellers, *Studies in Contemporary Music* (London: Dobson, 1947, p. 11)), and regard that as a defect in the music, you might well say that that is what it is expressive of.

40. Compare the conclusion of Edmund Gurney's investigation of the musical expression of emotion in *The Power of Sound* (London: Smith, Elder, 1880), Ch. XIV, §9.

41. This is not to claim that the experience is free of 'affect', especially of the tension and release integral to the creation and development of musical expectations and the ways in which these are frustrated and realized.

42. Music that does sustain such a mode of engagement (the Adagio introduction to the last movement of Mozart's String Quintet in G minor (K. 516), the Cavatina of Beethoven's String Quartet in B flat (Op. 130)) tends to be music that is heard as being expressive of psychological states of unusual seriousness, which reveal an attitude of reconciliation with or acceptance of the fact of painful experience – as with the fluctuations in resigned anguish of Mozart's and the yearning, striving, urgency, fragility and acknowledgement of loss of Beethoven's music. The listener who is enticed to imaginative identification with music, or to the imagination of music, as a stream of feeling (or other phenomeno-logical aspects of emotional states) is likely to think of the music he engages with in such a manner as being supremely *expressive.*

43. One advantage of such conceptions is that they most easily accommo-date criticisms of music on the ground that the music's expression of emotion is overemphatic, exaggerated or self-dramatizing. See Budd, *Music and the Emotions*, op. cit., pp. 139–40.

44. This is similar to the strategy that Wittgenstein advocated for dissipating a sense of puzzlement about the aesthetic character of a work of art. See Malcolm Budd, 'Ludwig Wittgenstein', in *A Companion to Aesthetics*, ed. David Cooper (Oxford: Blackwell, 1992).

45. David Hume, *An Enquiry Concerning the Principles of Morals*, V, Pt I.

46. It would be easy to push the argument further. For the idea that the artistic potential of music as an abstract art can be determined by considering the transformation of the artistic possibilities of an abstract art that disposes elements in the three dimensions of space to one that disposes elements in the single dimension of time overlooks the radical differences of, first, the elements and complexes of them, second, the factors that determine the composition and perception of the elements, and, third, the aesthetically relevant features of musical works and architectural works considered from the abstract point of view. In particular, it is clear that the structures created by the presence or absence of musical sounds are not isomorphic with those created by the presence or absence of matter. But perhaps it is unnecessary to demonstrate this.

47. For the first three examples, see Charles Rosen, *The Classical Style* (London, Faber & Faber, 1971), pp. 95–7, 139; for the fourth, see Gerald Abraham, *Chopin's Musical Style* (London: Oxford University Press, 1960), p. 34. Rosen's book cites and analyses many other examples of purely musical comedy; see especially his account (pp. 141–2) of the opening of Haydn's String Quartet Op. 54, No. 3. Perhaps the best-known example of musical humour is Mozart's *Musical Joke* (K. 522). But the work is a study in musical incompetence (as when in the finale the tempo becomes faster and faster while the phrasing becomes slower and slower) and it is not very funny. For a contrast between the musical humour of Mozart and that of Haydn and Beethoven, see Hans Keller, *The Great Haydn Quartets: Their Interpretation* (London: Dent, 1993), pp. 179–82.

48. It is true that our delight in the perception of beautiful living things is dependent upon our seeing them *as* forms of life; but it is not exhausted by their vitality. Although we might take less pleasure in an inanimate replica of a beautiful flower that perfectly imitates the flower's structure and colours, that colourful structure remains intrinsically rewarding to the eye.

49. See Gurney, *The Power of Sound*, op. cit., Ch. VIII, §8; Victor Zucker-kandl, *Sound and Symbol: Music and the External World*, trans. Willard R. Trask (London: Routledge & Kegan Paul, 1956).

50. Or consider a simple phenomenon – the intensification produced by the repetition of the same metrical wave: 'What almost physically

overwhelms the listener in certain compositions by Bach and Beethoven – the opening chorus of the *St Matthew Passion*, for example, or the Gloria fugue in the *Missa Solemnis* – is the effect of the metric waves, which roll down upon us, broad and powerful, with ever-increasing impact, each new wave driven on by the concentrated force of all those which have preceded it, and in turn driving another before it, irresistibly and inexhaustibly, until finally it becomes impossible to conceive how this surging flood could ever be stilled, and we feel that we are seized and borne along by eternal motion itself.' (Zuckerkandl, *Sound and Symbol: Music and the External World*, op. cit., pp. 174–5.)

51. In 'Notes on the Meaning of Music', *The Interpretation of Music*, ed. Michael Krausz (Oxford: Clarendon Press, 1993), Roger Scruton highlights certain features of dancing in an attempt to present an account of the aesthetic response to music as a 'truncated dance' in which we respond sympathetically to the human life we imagine in the sounds of the music. If this is intended as a general model for the aesthetic response to music, I believe its merits are exaggerated.

52. T. S. Eliot, *Four Quartets*, 'The Dry Salvages', V. The make-believe truths generated by an abstract musical work of a dramatic kind or by the listener's mode of engagement with it – about movement, momentum, energy, for instance – will be of a highly abstract nature, to the effect only that *something* is moving, gathering momentum, collapsing, and so on. Such abstract truths do not compromise the abstract nature of music. Compare Kendall Walton, 'What is Abstract about the Art of Music?', op. cit.

53. Nelson Goodman, *Languages of Art*, op. cit., Ch. II, §3. (I have ignored Goodman's nominalistic preference for predicates rather than properties.) For the application of the idea of exemplification to architecture, see 'How Buildings Mean', *Reconceptions in Philosophy and Other Arts and Sciences*, Nelson Goodman and Catherine Z. Elgin (London: Routledge, 1988).

54. Charles Rosen offers a much more sophisticated and accurate characterization (of what he calls 'first-movement sonata form') in *The Classical Style* (London: Faber & Faber, 1971), p. 99.

55. Compare Robert Nozick, *Philosophical Explanations* (Oxford: Clarendon Press, 1981), p. 428.

56. The acknowledgement of make-believe exemplification will extend the range of values music can exemplify to include, for instance, the ability

to remain acutely conscious of suffering but to withstand it, even to affirm the value of life in the face of it – as is characteristic of Beethoven's finest works.